THE VISUAL EFFECTS ARSENAL

VFX Solutions for the Independent Filmmaker

Bill Byrne

ELSEVIER

AMSTERDAM • BOSTON • HEIDELBERG • LONDON • NEW YORK • OXFORD
PARIS • SAN DIEGO • SAN FRANCISCO • SINGAPORE • SYDNEY • TOKYO
Focal Press is an imprint of Elsevier

Focal Press

Focal Press is an imprint of Elsevier
30 Corporate Drive, Suite 400, Burlington, MA 01803, USA
Linacre House, Jordan Hill, Oxford OX2 8DP, UK

Library of Congress Cataloging-in-Publication Data
Application submitted

British Library Cataloguing-in-Publication Data
A catalogue record for this book is available from the British Library.

ISBN: 978-0-240-81135-2

For information on all Focal Press publications
visit our website at www.elsevierdirect.com

Printed in Canada

09 10 11 12 5 4 3 2 1

CONTENTS

Dedication

To my wife
Suzanne whose love, encouragement, and guidance made this project possible.

To my father
Tom Byrne, who guided and encouraged a mind to love technology and creativity.

To my mother
Marie Byrne, who has given me so much and expected nothing in return.
 In loving memory of James J. Byrne who I wish would have been around long enough to see a copy of this book.

Acknowledgments

Jonah Goldstein, for all his help by supplying footage, his directorial knowledge, and being an interview subject. Tisha R. Johnson, and Monika Mozynski for acting in Jonah's footage.

Bryan Wetzel, for getting me into the world of commercial postproduction, where I learned many valuable lessons, and for being an interview subject.

Larry Caldwell, for his acting and advice on being a writer.

Jerron Smith, Jeff Martini, Phil Matos, Roger White, Randy Dottin, Mark Evoski, and Colin Stackpole for being great interview subjects.

Matthew Lancit for providing footage and Joshua Loring for his performance in that footage.

Andrea Paldy, Stephen Pite and the rest of my former colleagues, and students from New York's Katharine Gibbs School's Digital Filmmaking department. It was the questions from my students that became the primordial soup for this book.

Paul Del Vecchio for being an interview subject and the book's technical editor.

John C. Byrne, Ph.D, for his support, valuable advice and an introductory education provided a young age that helped shape my career.

Dean Carol Kelley for bringing me on board at the Art Institute of Austin and students for waiting patiently for grades while I wrote this book.

Maury Loeb, JJ Lask, John Zieman and everyone at PS 260 and Brandname.

Charles Traub and the MFA in Photography and Related Media department at New York's School of Visual Arts.

Bob Forward from Detonation Films for allowing me to use his great fire footage.

Andre Cuello, and Anais Wheeler for all their help.

Focal Press, Dennis McGonagle and Paul Temme for making this happen.

HOW TO USE THIS BOOK

When I teach classes in visual effects, I made an observation about what motivates students to learn. As I lay out to them what they will learn in my class, they don't get excited about terms such as *fractal noise, rotoscoping,* and *particle systems.* Why would they, unless they know what those things can do for them?

When I teach my lessons, it's not the tool they get excited about, it's what the tool can do for them. So, I realized what is the problem in teaching software. Too often students are taught *how* to use a piece of software without being taught what to do with the software.

This book does not teach readers how to use the software. This book is meant for people who have a solid understanding of Adobe After Effects or something like After Effects, a nonlinear editing software and Adobe Photoshop. What this book does teach is technique. I gathered the material and lessons here to be a compendium of problems solved.

Most of the time, students who wait until class is over don't wait to ask me about the inner workings of *motion tracking,* they are waiting to ask me "How do I create an explosion?" or "How do I make it rain?"

Often they can go Google a tutorial, which is not a bad approach; I often do that to see if there's a technique I did not know about. However, there are tons of Web-based tutorials out there; many of them are top quality, such as the great material on Creative Cow (creativecow.net) or Video Co-Pilot (videocopilot.net). Often though, you will run into a tutorial that is too old, poorly or incomprehensibly written, or simply doesn't work.

I decided to go through my own techniques, ones I've gathered from years of reading on the Web and things I have been taught and put together a collection of problem-solving techniques for a large variety of visual effects. I tried to cover as broad of a range of issues that could be solved with common, off-the-shelf software without expensive third-party plug-ins. I also decided that it was important not to focus on a single application but rather to teach the techniques and how something similar can be achieved cross-platform.

In many cases if there's a silver-bullet absolute method to doing something, that's what I demonstrate. In most cases, I am sharing the best technique I have found for something, which may change or you may find another method that works better for you.

The most important thing about learning to use any piece of software is this: learn the techniques first, they don't change. Students and even pros are often very nervous about putting a ton of time into learning software, thinking, "what happens when there's a new piece of software

that becomes the industry standard, what will I do then?" If you know the core techniques of your field, then learning another piece of software is much easier.

Look at it this way, let's say that tomorrow someone introduces a new raster-based image editor and Photoshop becomes obsolete. This is very unlikely, as no one has been able to remotely compete with Photoshop, but let's just say this for argument's sake. Since most people have been using Photoshop, all the same questions you would likely have will be applicable to most users, so therefore the new software would have to meet the capabilities of Photoshop. So essentially, it's the same set of capabilites, the buttons would just be in different places.

In fact, something like this is going on right now. Apple's Shake looks like it will be discontinued at some point. So while researching this book, I stumbled upon many guides to users about how you would switch from Shake to Eyeon Fusion or Nuke.

The overall point I'm trying to make here is this: the techniques have a longer shelf life than software, and as software moves very quickly, the techniques will more than likely be the same for a very long time. Most of the techniques discussed in this book have been around longer than computers themselves. The computer has only been implemented because it's a faster, easier way of pulling off these effects.

Sections

Each tutorial is broken up into sections; some will appear in every tutorial, whereas others will appear where appropriate. I wanted to treat these tutorials like recipes, as there are lots of similarities between the two.

Ingredients—These are what you will need to create your version of this technique should you need a special kind of footage or prop. In some cases I will recommend that you use elements created from another tutorial.

The Shoot—In this section you'll get some quick advice on things to look out for during the shoot or ways to advise the director of photography.

The Design—Consider this to be the Photoshop section. It will discuss preparing the needed elements for an effect in Photoshop. As you will see throughout this book, you can't underestimate the importantance of using Photoshop just because it's not meant for working with moving footage. It's one of the most powerful tools we have.

The Effect—This is the heart of each tutorial; each of these will be done in Adobe After Effects. I'll go through all the techniques for using this software to solve the major issues of visual effects. Even though After Effects is a very basic compositer, I decided to focus on After Effects because of its market share. If most users have a piece of visual effects software already, it is probably After Effects. In most cases, for young filmmakers the cost of Nuke or Fusion is too crippling to a budget to make it feasible.

The Options—The effects techniques in this book are mostly cross-platform, and I will show you the same or similar technique and how to achieve it in an editing software package (Final Cut Pro), another motion graphics package (Motion), or a basic compositing package (Combustion).

Visual Effects

Visual effects are processes used to manipulate imagery in the now mostly digital postproduction process. Often abbreviated as VFX, visual effects have taken over creating the kinds of imagery that were once dominated by the process of creating *special effects*. Special effects are effects either created on the set or within the camera.

Both of these processes are employed to take advantage of technology to make imagery that is impossible to find in the real world or far too difficult, dangerous, or expensive to achieve without the use of visual or special effects.

Before the 1990s there were two major special effects categories. *Optical effects* are techniques such as multiple exposures, glass shots, or mattes.

Also in this category were the effects achieved through the optical printer, where footage could be rephotographed. Optical printing effects are the basis for the software-based effects of today. The second category is *mechanical effects*, which are effects created on set, in front of the camera, such as with models, props, and make-up.

In the late 1980s, *digital compositing* emerged. *Compositing* is the act of combining two different imagery sources; a process that was once done on an optical printer is now enhanced with the greater control allowed by computers, at a greatly reduced cost. The early 1990s saw the beginning of wide usage of what is commonly referred to as *CGI* or *CG*. CGI or computer-generated imagery combines the process of animation with the use of photorealistic textures to create characters, scenery, and whatever else the mind can imagine to create what cannot be shot.

In today's visual effects world, two major sets of techniques are used to solve most issues. Can the shot a director needs be achieved by generating graphics, combining different sources of footage, or employing both processes?

Digital Compositing

The use of digital compositing has become so commonplace in modern entertainment that it will often go completely under the viewer's radar. An example of everyday compositing is your TV weatherman. Your weatherman is standing in front of a *green screen* (or *blue screen*), which is removed and replaced with computer-generated maps.

Green screens and blue screens are used in a process called *chroma keying* or *color keying*. The use of keying began in the 1930s when a painstaking chemical process, aside from a difficult sync shooting process, was employed at a great cost of time and money. However, with the use of video and digital compositing, the process has become quick and inexpensive.

Essentially, an actor, or subject, is photographed in front of a screen that is either blue or green. The color does not have to be blue or green, but blue and green are used most often because they are in the range of colors most opposite to human skin. Blue, the opposite of yellow, was the traditional choice, which switched over to green when digital compositing became the norm because digital cameras respond better to the higher luminance values of green. When a film or non-digital video camera is in use, blue is often preferred. Green is often used when a shoot takes place outdoors because of the sky.

The color screen background can then be removed. When footage is captured digitally, information is stored in separate *color channels*. These would be red, green, and blue. In addition, there is a fourth channel, the *alpha channel*. The alpha channel controls the transparency of the color channels, and in a composite shot the compositor can specify the color range that will receive either a reduced transparency or removal. Then a separate piece of footage can be put behind the color-keyed shot and the combined shot is complete.

Keying is not the only method of employing the use of alpha channels. The use of *garbage mattes* is often necessary to aid where color keys are too difficult. Garbage mattes usually refer to the process of hand drawing the area that will have a reduced transparency. The adjective "garbage" refers to the fact that it is usually temporary or used as part of another technique.

When this is not employed as a temporary or supportive measure, the compositor is said to be *masking*. The reason why this process is not used more often than color keying is due to the fact that it usually requires adjustment frame by frame. Treating footage with a hand-drawn process frame by frame is called *rotoscoping*.

Rotoscoping is the process of reshaping a matte, but it can also be used to describe a shot that includes a hand-drawn or adjusted technique that requires attention for each individual frame. So, some quick math, a movie has 24 frames per second (fps) whereas a TV show or commercial has approximately 30 fps. Even on a 30-second commercial that would be 900 separate images that a rotoscoper must attend to, which is not always desirable in the quick turn-around entertainment environment we live in.

The digital compositing world comes equipped with little helpers to reduce the need for rotoscoping. One of these is *motion tracking*. An area of an image can be tracked by the computer so that some other process can be employed to that area. For example, the tutorial called *Digital Dismemberment* in Chapter 8, we paint out and replace half of an actor's arm. To avoid rotoscoping, we put a black dot with a marker on our actor's arm that the computer is able to track and then something could be attached to that point in its place.

Another technique explored in Chapter 7, where we recreate the look from the films **Waking Life** and **A Scanner Darkly**. This tutorial discusses *batch processing*. A batch process is when footage is broken down into its individual still images and then an image editor, Adobe Photoshop, is used to treat each individual image following a user-specified set of commands. However, even with these techniques the process of rotoscoping cannot always be avoided.

Computer-Generated Imagery

Often combined with compositing, the other category of techniques used to solve most visual effects problems is the creation of *CGI* or *CG*. What this will entail is either building two- or three-dimensional digital models that, unlike live actors or real world locations can be changed and moved easily around to achieve the desired scene.

While the use of CGI scenes began in the late 1970s, what marked the arrival of what has become very common in today's visual effects is the 1993 movie **Jurassic Park** where CGI dinosaurs were convincingly

integrated into scenes with live actors. Now, that is not the exception, it's the norm.

Very often, not just Pixar characters but even sets, helicopters, buildings, and explosions are commonly created through the use of computer-generated graphics that are composited into scenes. This book discusses techniques for creating 2D and 3D graphics in After Effects as well as Apple's Motion and Autodesk's Combustion, but these programs can only scratch the surface of the 3D graphics world, as there are quite a few dedicated programs for the purpose of creating and animating 3D characters and worlds.

Three-dimensional character animation has largely replaced the traditional hand-drawn animated characters. In fantasy-genre films, such as the recent **Star Wars** prequel trilogy, **300**, **Sin City**, and the **Lord of the Rings** trilogy, actors were mostly shot in blue or green rooms to have 2D- and 3D-rendered sets replacing the screen backgrounds. The ease of control and the range of possibilities have made 3D-rendered sets an ideal choice over the old-fashioned system of using scale models. Even when scale models are chosen by the production teams, 3D graphics are employed to enhance the models.

Particle systems are used to recreate natural phenomena such as smoke, fire, rain, snow, and dust. Essentially, like a flowing fountain of pixels, these particles can be controlled to respond to real-world physics at the discretion of the VFX artist.

The Underrealized Power of Available Software

One of the most commonly used tools by VFX artists is something you probably have on your computer already, **Adobe Photoshop**. Originally written by Thomas Knoll while he was a doctoral student, the idea caught the attention of his brother John Knoll, who was working for Industrial Light and Magic. John Knoll has become an academy award winner for his VFX work on the recent **Pirates of the Caribbean** films and is recognized for his work on many other films that rely on VFX.

However, in addition to Photoshop's lineage as having a connection to the world of visual effects, it has practical use as a tool for VFX artists. Considered to be the foundation software for editing any image on a computer, it's often used in conjunction with **Adobe After Effects**. After Effects reads the separate layers of a Photoshop document and allows the user to apply keyframe style animation to them. For painting style effects, users will edit images from After Effects in Photoshop to take advantage of Photoshop's unequaled strength with painting tools and then return the image to After Effects. The original vision of software designers of After Effects was to take what Photoshop does and put it on a time line.

Aside from Adobe, Apple has packed their computers with a great number of amazing, professional software packages. Apple's **Final Cut Pro Studio** started as an alternative editing system that took the postproduction world by storm. Many VFX shots that once would have required a trip out of an editing package can be executed in Final Cut Pro, which uses a similar keyframing engine to After Effects. Saving time and money many VFX issues can now be resolved in the same program that the edit would take place in.

Apple introduced **Motion** in 2004, which later became part of the Final Cut Studio. Designed at first to help alleviate the need to leave the Final Cut environment, Motion has grown into a capable competitor to After Effects. It has some limitations, so it's not quite a true replacement for AE yet; however, it has the strong advantage of tight integration with Final Cut.

These programs are commonplace among a variety of users, but often their true potential goes unnoticed because the user doesn't know the techniques to take true advantage of these programs. The tutorials in this book will push users into the sub-sub menus to make these packages do more than just the initially obvious.

2

YOUR TOOLBOX

There's basic equipment that VFX artists will need to solve the day-to-day issues of visual effects.

Hardware

A Digital Video Camera

Most independent filmmakers rely on the digital video (DV) medium to get their productions made, to make them look and feel professional, and to contain them in a budget. The great appeal of DV lies in the light, transportable size of the cameras, the affordability, and the tight integration with desktop computers.

For VFX artists working on a film, it's often a necessity to have a DV camera on hand to shoot test shots, to take a practice attempt at getting a piece of footage, and to look for potential unanticipated problems.

Visual effects supervisors will often go to the set armed with knowledge gathered from the test shoot to guide the production team through avoiding potential mistakes. This might be a nice time saver on a big Hollywood production, but it can be an essential measure to save time and money on a smaller indie shoot.

In addition to having it available for test shoots, the VFX artist needs a camera to gather additional elements to bring into his or her computer. For example in Chapter 5, we have a tutorial on creating a *Driving Shot*. The VFX artist would be responsible for replacing greened windows with driving footage, and often it makes sense for the VFX artist to gather this footage on their own without the bulk of a crew.

When it comes to buying a DV camera, there are so many options out there that you may become overwhelmed. Do you need a DV, HD, or Red camera? If you feel like a standard digital video camera is all that you'd need, make sure that you get one with manual focus, manual exposure, and shutter control. Shutter control is important, as 1/30 shutter speed on a DV camera will start to mimic the shutter speed of film.

If you plan to set up a green screen, some considerations need to be made here. The standard DV camera shoots with a chroma subsampling ratio of 4:1:1, which makes it more difficult to do green screen compositing. The compressed image of a camera using 4:1:1 will lead to jagged aliased edges without very careful keying. It's not impossible, but it makes your job as compositor tougher.

HDV cameras have a ratio of 4:2:0, which is better, but ideally you want 4:4:4 or at least 4:2:2. DVCPRO50, DVCPRO HD, and HDCAM SR all shoot at 4:2:2. Also, the new line of Red cameras that shoot in RAW formats leave the chroma subsampling as raw data to be processed later on the postproduction side, making it an appealing option for VFX artists.

A Digital Still Camera

As a backup for the DV camera, a digital still camera is very handy. Many situations that call for the gathering of elements will not require them to be in motion. Also, it will sometimes require a larger image size so that it can be scaled without distortion.

Here's a sample workflow from a situation where a digital still image was processed in Photoshop and used as an animated element in Adobe After Effects (AE).

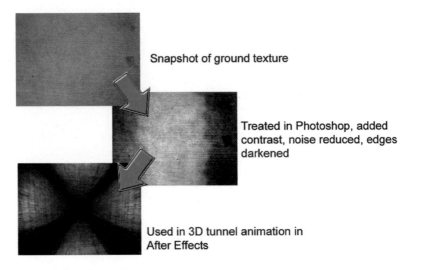

Snapshot of ground texture

Treated in Photoshop, added contrast, noise reduced, edges darkened

Used in 3D tunnel animation in After Effects

I have a small Canon Power Shot camera that I can keep in my pocket. Thanks to its convenient size, I take it with me when I'm just going about my daily business and take shots of anything I think I might want to use later.

In the figure above, it begins with a snapshot of a ground texture, which I then painted over in Photoshop and finally used in After Effects as the walls for a 3D tunnel animation.

Tripod

You need a tripod. Everyone does and VFX artists are no exception. Simply because, if nothing else, for a large number of visual effects shots it is much easier if you can just treat the image without having to chase what you are trying to apply an effect to around the screen like you would with a hand-held shot.

Also, don't just hop over to local big-box retailer and grab a tripod; you need something that is not flimsy. An unstable tripod can give you footage that has difficult to deal with bumps and vibration from wind. You definitely want to avoid the possibility of tipping over and destroying

that camera. We will discuss how to use software to stabilize a shot, but why spend time doing that if you know the shot will have to be stable?

There are plenty of options for tripods out there, but a rugged, well-supported aluminum tripod with a bubble level and a fluid head are definite requirements.

Computer

In order to do VFX, you need a computer, that much is clear.

But what do you get? Mac or PC? Well that's largely up to you and your personal preferences. The guiding rule is to get the platform that you know and feel comfortable using. The other rule would be to get the platform that runs the software you want to use.

Adobe's software comes in both Mac and PC versions. Do some research as to what the differences are, as there are differing hardware requirements (for example with the CS4 version, Photoshop maxes out at 32-bit images on a Mac, but on a PC it can go up to 64-bit). Adobe threw me a bit a surprise while I was writing this book. After Effects CS4 is Intel only, meaning I had to say goodbye to my G5. So I would definitely recommend getting at an Intel Mac.

Apple's software is obviously Mac only. However, Final Cut Pro, the dominant DV editing software is not the only game in town. Avid Media Composer and Adobe Premiere Pro are available on both platforms, and equal to (in the opinions of some loyal users better than) Final Cut. If your plan is to go into deep compositing and/or 3D software, there are choices for both platforms.

Many of Autodesk's applications are both Mac and PC, but not all (3DS Max, the most widely used commercial 3D application, is PC only). Either way, all your needs are covered in both formats, so it's really up to you and what you feel most comfortable using. Also if you purchase a new Mac, it's built with Intel chips, meaning you can set it to run Windows and OSX getting the best of both worlds (and while you are at it why not throw a Linux distro in there?).

What is of the highest importance are the capacity and the performance of your machine. You'll need a good amount of RAM to get optimal performance from your machine with fast render times and the ability to run multiple applications simultaneously. Adobe states that 1GB of RAM for DV and 2GB for HD are sufficient, but I believe that if you can afford to get 8GB you should, but I wouldn't go for less than 3GB. Adobe also recommends using an NVIDIA card.

You will need lots of disk space so it's wise to have two internal hard drives at a large capacity. Internal drives perform better than external ones and less likely to crash. You will benefit from having more than one, as video is a real space eater. Also, some programs such as Final Cut just about require you to load footage onto a separate drive than the one it is running the software from.

Other Considerations

You may want to look at a lighting kit, although it is recommended that you shoot in natural light as much as possible. Now, since the subject of this book is visual effects, setting up a green screen is something you may need.

This IKEA shower curtain is a good option for a DIY green screen.

You would be hard pressed to find a more useful piece of software than Adobe Photoshop.

There are very expensive green screens made for chroma keying out there, but they aren't necessary. All you need is a solid color green background and a good amount of space so that you can light the subject separate from the green screen. There are some do-it-yourself solutions, such as building a frame from PVC pipe and draping it with green fabric.

Software

Image Editing—Adobe Photoshop

When I begin an introductory computer graphics or digital imaging class, I tell the students that to be a creative professional without using Photoshop is like being an administrative assistant that doesn't use MS Word. That is what it has become in the creative industry.

Photoshop CS4 is the 11th version of the software, and since Adobe began its Creative Suite, they have been packing PS with great tools for filmmakers. In its latest incarnation it will now read footage as video layers, generate 3D objects, and there's a time line that looks and works like the one from After Effects. However, what will make it most valuable to VFX artists are its traditional strong points, layer-based workflow, strong cross-platform compatibility, batch processing, and powerful painting tools.

A sample of Photoshop's powerful painting tools.

Motion Graphics Software

Motion graphics has become a catch-all term that includes digital animation, broadcast design, and visual effects. The software package that has emerged as the industry standard is Adobe After Effects. The Adobe Creative Suite is tightly integrated, and if you need to hop to Photoshop quickly you can with a simple keystroke, make a change and After Effects will update immediately.

After Effects is a *keyframe* animation package. A keyframe is a term used by animators to describe a frame that determines a change in the action. If our character starts at point A and then walks to point B, the first frame that determines point A is a keyframe and the last frame that determines point B is a keyframe.

Now, because video moves at roughly 30 frames per second and film at 24 frames per second, all the frames between our keyframes at points A and B are called *inbetweens*. In a digital animation program like After Effects, the user defines the keyframes and the software creates all the inbetweens; this is often called *tweening*.

When it comes to VFX, After Effects is capable across a broad spectrum of generated imagery and compositing needs. However, although many experts in the field acknowledge that AE has become more and more powerful with each version, they will often say many issues are better handled by a dedicated piece of compositing software (such as Apple's Shake, The Foundry's Nuke, Eyeon Fusion, or Autodesk's Combustion/Flame/Inferno line).

After Effects used to have major limitations on the 3D front, as objects could not be turned in 3D space. However with Photoshop and After Effects CS4 you have Photoshop's primitive 3D engine, for generating objects you can then use in After Effects. (A company called Zaxwerks makes an After Effects plug-in called 3D Invigorator that can extrude volumetric images from bezier paths.)

As shown throughout this book, AE is quite powerful. It's also the most widely used VFX software package, and there's a huge amount of Web-based, print and video resources for the program. Most common VFX shots can be realized with After Effects.

Aside from After Effects, there's a new motion graphics software package on the block that has got some great selling points. Introduced in 2004, Apple's Motion is now in its third version and has quietly grown into being a pretty powerful application. It hasn't really taken away much of AE's user base, as Apple stopped selling it outside of the Final Cut Pro Studio. However, you will see through-out this book this overlooked application is quite powerful.

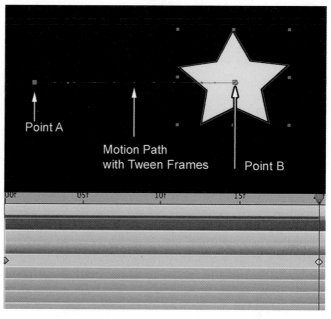

Think of After Effects as Photoshop on a time line.

Adobe's After Effects uses keyframe animation, which allows users to define two points and the software will generate every frame in between.

Apple Motion has become a very powerful VFX tool.

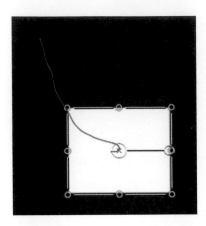

Motion has the advantage of using preset animations, known as Behaviors.

Final Cut Pro
Academic

© 2003–2008 Apple Inc. All rights reserved. Apple, the Apple logo, and Final Cut Pro are trademarks of Apple Inc., registered in the U.S. and elsewhere. See www.apple.com/legal/trademark for more information.

Apple's Final Cut Pro has arguably become the industry standard for editing digital video.

Its most impressive feature is its tight integration with Final Cut Pro. Anyone who edits and designs motion graphics can tell you why it's handy to have the ability to jump from one program to another without exporting. In its first incarnation, Motion felt fairly lightweight, but with its latest version it feels capable of doing most of what After Effects can do, often in a similar manner.

Its workflow appears to have a similar layer-based setup to AE. Apple did include a nice feature where you can create Groups on the fly, making nesting/precomposing a more native aspect of the environment. Also, rather than forcing the user to keyframe animate everything, Motion has the option of using preset animations called Behaviors. The user can apply the Behavior and add keyframes to adjust to their needs. With version 3, Motion now has quite possibly the most user friendly motion tracking tool on the market.

While still lacking some equivalents to After Effects' more advanced tools, it's definitely one powerful alternative.

Video Editing

The last of our software essentials, video editing is a hotly contested market, with lots of arguments about which is the best. Non-Linear Editing software is a very valued companion to a motion graphics software package. Though After Effects and Motion are capable of editing, you would not want to edit in them as it can be quite frustrating.

The editing software associated most commonly with the greatly expanded professional video market and the DV medium is Apple's Final Cut Pro. It's based on Apple's widely adopted Quicktime format. Since it's designed by Apple for their equipment Final Cut is quite stable and powerful and it caught on with users quickly.

For VFX artists, if you happen to be editing and creating effects for the same project, Final Cut has a host of tools for creating keyframe animation in a similar way to how it would be done in After Effects. Extensive VFX projects should be done in a software package that is dedicated to effects, as the constant need to render in FCP will slow you down.

If you don't own a Mac, there are still great alternatives to Final Cut, which is not available for Windows and is not likely to ever be available in a PC format. Sony's Vegas software offers comparable capabilities to Final Cut and a pretty solid footing in the industry. Adobe has developed a powerful competitor for FCP in its cross-platform Premiere Pro CS4.

Adobe Premiere Pro CS4 is a new version of the Adobe's Premiere software, which was rewritten in 2003 as Premiere Pro. Final Cut's introduction took over the market Premiere once held. Because many VFX users need a strong integration with editing software, Premiere Pro is very alluring to After Effects users because the same time line can be preserved between the two programs.

CS3 marked the first version of Premiere Pro that has been made available in both Windows and OSX formats.

However, the competition between Apple, Sony and Adobe has yet another party involved, the once industry standard (as to whether or not it's still safe to call Avid the industry standard is a popular debate in forums) Avid line of products. Avid still has about a quarter of the market and their user base has not fallen off; it's just there are a lot more editors in the market place and new users appear to gravitate to Final Cut.

Avid Media Composer (now their main product, the free version, and DV line have been discontinued) is the NLE system of choice for most high-end professionals. It may lack the user-friendly features of Final Cut Pro, which has helped Apple appeal to new users. However Avid makes up for it with rock-solid stability, excellent support, and a great reputation in the industry.

Avid did dominate the video editing market for a long time for a reason: they have a solid video editing system. VFX artists will like the excellent choice of effects.

I won't state my preference for video editors, as, honestly, they are all of equal power. I used Final Cut Pro for the tutorials in this book because it has the most users and the techniques are the same (the buttons will be in different places) in all of the big name NLEs.

Optional Software

Compositing

Although it's very capable, After Effects is not the only player on the field when it comes to compositing. In fact, most professional compositors recommend a software package that uses a node-based schematic workflow, which is common among professional compositing software packages, something After Effects does not have.

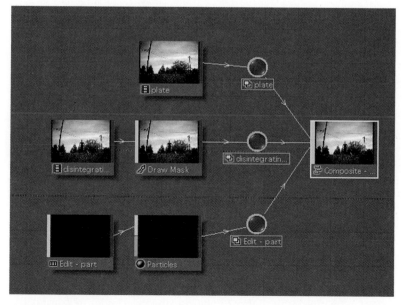

Node workflows work like your entertainment center, each box has an in and out and lines representing cables connect one to another.

Node systems show a schematic process where each step of a complex series of processing is represented by an object representing the instance of an effect with a line or cord extending out from one effect into another.

Autodesk's Combustion is a longtime standard of the VFX industry.

Autodesk's Combustion is a compositing software package capable of many similar aspects of After Effects' feature set with some very handy extra tools filling out its tool box. Combustion is famous for its excellent tools for rotoscoping, particle effects, and painting. Combustion also features a similar interface to its high-end professional older brother systems Flame and Inferno. These dedicated systems are out of the price range of many amateurs and professionals, but Combustion is far more affordable. Autodesk also makes the 3D software packages Maya and 3DS Max, which integrate well with Combustion.

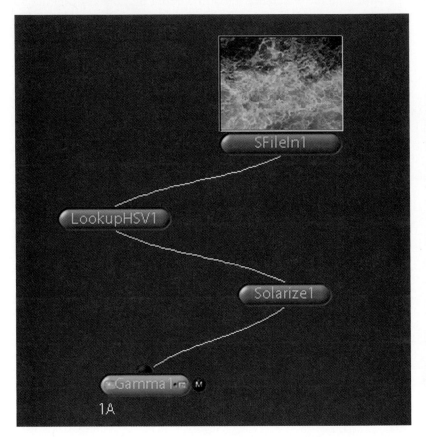

While we wait for Apple's rumored new compositing software, Shake is being sold at a great low price.

Apple has recently entered the high-end compositing market with its very powerful software Shake. Most users consider Combustion's node system to be inferior to that of Shake's, as the layer order in Combustion cannot be controlled in the node setup. Shake also takes advantage of Apple's hardware and is known for its stability.

However, because Shake is about to be discontinued, I refrain from giving an endorsement of this product. Apple is rumored to be discontinuing Shake in lieu of an exciting all-new product, so keep an eye out for it. In the meantime, Shake is now bargain priced at $499. If Apple stops

supporting this software completely, at least it is far less expensive than many of its competitors (it wasn't that long ago that Shake was around four times this price).

Another big name in the game is Eyeon's Fusion software. It's PC and Linux only, but its best selling point is its long-running list of feature films and television broadcasts that use it. I have not used this software, but from what I understand, its feature set is similar to Shake.

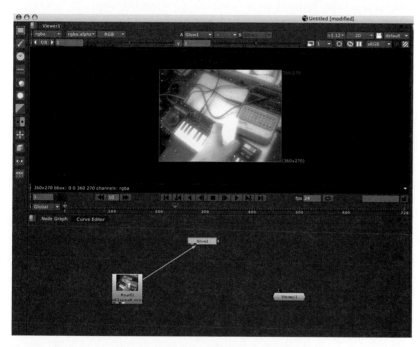

The Foundry's Nuke has won an Academy Award for its abilities.

Finally, and certainly not least, is the Foundry's Academy Award-winning Nuke. One of the youngest software packages discussed here, the Foundry has garnered itself an impressive reputation for their plug-ins for Autodesk and Adobe software. Nuke is a node-based environment with an impressive array of professional compositing effects available to users. This comes, of course, at a very hefty price tag.

Three-Dimensional Software

Motion and Combustion are capable of using 3D space, but you can't create volumetric objects. After Effects CS4 can import Photoshop's 3D objects but you are limited to primitive shapes. When your needs exceed the above software's limited capabilities, there are numerous choices out there that vary greatly in price and in capability.

The traditional industry standard software for 3D animation and graphics is Autodesk's Maya. Maya has been used on countless film productions and is very popular among users. Autodesk also publishes 3DS Max, although it's Windows only. Autodesk appears to be in competition with itself, but the two packages have appeal in different industries.

Although 3DS Max has a larger user base, those users are more in the realms of TV and other industries outside entertainment, whereas Maya is used mostly in the film industry. Maya's abilities come at a cost; it also has a reputation of being difficult to learn. 3DS Max and Maya both carry a high price tag.

This is due to the ability to export 3D data that can be read easily by AE and FCP. Cinema 4D is also known for its ease of use for a high-end 3D application. It also has a much lower price tag than the packages listed previously.

A 3D cube in Blender.

Also worth mentioning is the freeware 3D application Blender. Even though it is free, Blender has a similar list of capabilities to the top-tier 3D animation packages and has the largest user base of any 3D application (that's no surprise). There's a good amount of online resources and tutorials. Blender's biggest downside is that it has a fairly significant learning curve.

Although this book does not cover 3D applications, I think it is valuable to consider the options. Also, I will show you how to identify situations where a 3D package would be needed to achieve certain effects.

Third-Party Plug-Ins

After Effects can't really be discussed without going over the issue of third-party plug-ins. Much like audio software, After Effects allows for users to expand the capabilities of the program by adding in outside elements or plug-ins. Since part of this book is about keeping one's costs down, I decided that the tutorials provided would not include third-party plug-ins.

Why? Well, first, while there are incredible plug-ins for After Effects, they can sometimes cost you a small fortune; there are some that cost as much as or more than AE itself! Beginning with version 6.5, Adobe has bundled the famous Cycore plug-ins with After Effects which was a great boost to the available effects in the software. However, there are more useful plug-ins out there worth considering.

Trapcode

When Trapcode makes a plug-in, people take notice. Famous for making plug-ins that nail something perfectly, many are lost without them. Although all of their plug-ins are very useful, I think that Particular, a fully capable 3D particle engine, and 3D Stroke, a stroke effect with amazing 3D capabilities, are very exciting and useful.

Knoll Light Factory

This set of light designing plug-ins is one of the oldest and most widely used sets of plug-ins. It's from the same ILM guys who invented Photoshop, and many find this set of lens flares and lighting effects essential.

Magic Bullet

Magic Bullet's Looks and Misfire line gives you a great way to control the look and feel of your footage. People will always be looking for ways to make their video work look more like film and these Magic Bullet plug-ins are great for that.

Zaxwerks 3D Invigorator

Much loved by some, maligned by others, it's the only game in town for creating volumetric shapes without leaving After Effects. It has got a learning curve, but it really is like having an entire 3D application inside of After Effects.

Final Thoughts on Software

Before you go out and buy expensive software, try a demo, if available. Explore all your pricing options; if you are a student or someone in your crew is a student, there are significant education pricing reductions available for many of the software packages discussed here.

I don't know who to credit for this quote, but I once read "...the best software is the one you know how to use." That's great advice; don't force yourself to try to learn everything, and also keep in mind that it's not the software you use that people take notice of, it's the effect that was created.

3

PREPARING FOR YOUR VISUAL EFFECTS SHOT

This chapter discusses tips and techniques for preparing a VFX shot. The amount of time spent in preproduction can save valuable *hours* on the production and *days* in postproduction.

A great example is something like this. Let's say you're working on a shoot that requires a sunny day, but in preproduction the weather reports were not checked and it's overcast. On the set, they waited for the clouds to spread, but the clouds don't, so they shoot anyway. Now despite many attempts to cut around the overcast footage, the editor needs the shot. A compositor is called in to replace the clouds and brighten up the footage to make it look right. Depending on the shot, it could take hours, but if there's lots of motion, it could take longer. Now, had the weather been checked, the problem could have been worked around.

Now every problem can't be anticipated, and schedules have to be met. However, what should be avoided are things that can be taken care of easily on the preproduction and production levels. Ever hear the old joke "we'll fix it in post?" Well, it's not a joke to too many, and while many problems can be fixed in postproduction, why do that when it can be fixed by just changing the frame or, better yet, just going into production with a better thought-out plan.

Tips for VFX Artists in Preproduction

Here are a few tips on how to help your VFX shot run as smoothly as possible.

Storyboard the Effect

Film students have this oil-and-water relationship with storyboards. It's unfortunate because planning is pretty crucial, and if you can visualize it, early problems can be anticipated. This chapter demonstrates using Photoshop to create storyboards

There are some distinct advantages to storyboarding an effect digitally; using Photoshop you can come up with something much closer to the final shot than stick figures.

Grab Your Camera and Do a Test Shoot

It's strange how some postproduction folks never leave the office. In my editing and motion graphics classes many of my students would sit

there and fight bad footage for hours before even considering a reshoot or a pick-up shot.

When I worked in TV postproduction, one of our frequent clients, a director, had an idea for an effect he wanted to create. He came in with test footage, we brought in our VFX artists, and we did a test. When asked, the director was not actually doing this test for a specific project, he said "I'll use it for something." He did eventually.

If you know that you have an effects shot coming up, why not try it out? Grab your camera and create a test shot. You should have some idea of what you are going to be getting and to give yourself the opportunity to anticipate problems. Is it important that the shot be hand-held or locked off? Is lighting going to be a problem? Will you need track points?

Make an Appearance on Set

Some directors, if the shot is going to rely on an effect, will insist on a VFX person being present during the shoot. Big-budget Hollywood movies do this, and there's no reason for an indie to be any different.

Especially if the VFX artist has done tests already, now he or she can advise on how everything is being done. Knowing where the problems will come, you can shout to the director that perhaps a retake is in order, provided of course that the production team is open to this, as some will, some won't.

Research the Technique

When I am handed a visual effects project I usually have some idea about how to go about it. Although, why stick to what you know when you have a world of knowledge at your fingertips?

Hop over to Google and do a little quick research. How do people solve this problem? If you follow a time-honored technique for creating a certain effect, has the technique changed?

Traditionally, character animation in After Effects was done by taking the character into Photoshop, cutting all the parts up into layers, and then importing all those layers into After Effects, changing all the Anchor Points, and using a complex Parenting scheme. Sound like a lot of work? It is.

When After Effects CS3 came out, it seemed like a minor upgrade, wrong! One new effect has completely changed the process of character animation, the Puppet Tool. Now you can have full control over a character on a single layer.

Aside from the possibility that you may not have the best technique for creating an effect, the best techniques often change.

Get a Commitment from the Producer or Editor on the Final Output Settings

I was working on VFX shots for an indie feature and when I started the job, I sat down with the director and producer and asked what the output would be. They told me DV. This sounded strange because it was shot on 16mm, and I just couldn't imagine why someone would transfer 16mm just to go out to digital video.

My fears turned out to be just. As festival deadlines came up, I got a phone call from the producer that we had to redo everything at HD settings.

Luckily, I had most of the effects at a larger size to begin with, so it wasn't that big of deal, but remember that video is raster-based graphics, meaning that if you scale up, you will be distorting your footage. I realized that this situation could have been much worse, so from that point on, every project I work on I have an early meeting to make sure that I am working at the resolution that is needed for the final output.

Be a Very Organized Project Manager

This chapter shows you a way to organize an effects project so that you never lose a file again. Clients hate sitting there watching you look for a file.

Creating a Digital Storyboard

In this tutorial, I'll go through the steps involved in creating a storyboard using Photoshop.

Shot begins with Plant on table

Plant fades and reshapes to dog

Dog fades up and reshapes from plant

Plant is now completely gone and dog is fully visible

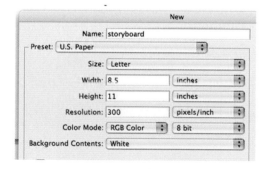

Step 1—Create a new Photoshop document using the standard U.S. letter-size paper preset.

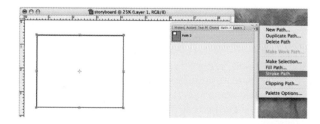

Step 2—Use the *Shape Tool* to make a rectangular path. Use the *Shape Tool* in the *Paths* mode. Create a new layer and open the

Paths palette. Set your Paintbrush to a 9 pixel brush and set the foreground color to black. In the *Paths Palette Options*, choose *Stroke Path* and then choose *Brush*.

Step 3—Rename the layer that has our rectangle "cell 1," duplicate it three times, and then rename the copies "cell 2" and this step is repeated for the amount of cells that are created in the figure.

Shot begins with Plant on table

Step 4—Merge the cells into one layer. Now create a layer montage of how your frame will look. In this storyboard, I planned the tutorial footage for the lesson on *Morphing* from Chapter 10. Using photos, I plan out what will happen. Don't make a careful digital photo-montage here, do this quickly to get your plan out on paper. Create text underneath so that what is happening in the frame is explained. Make the contents of each cell its own layer group.

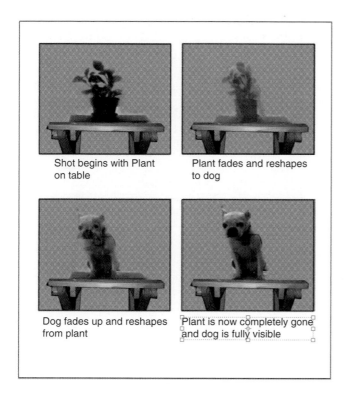

Done—Plan out each step, with its own layer group, and explain each step with text below; if you need more cells, make more pages of our storyboard. I've included a blank storyboard template with the extras on the DVD.

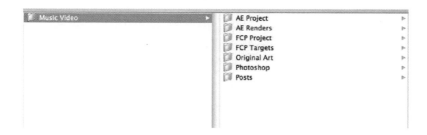

Project Management

Being able to find everything related to your project at any point in time is crucial. I learned and adapted this method of project management from my professional experience and I have not found anything that works better.

I am demonstrating this on a Mac, but it can be done easily on a PC as well.

Music Video

Step 1—Make a folder for your project, not all of your projects, just the one you will be working on; I chose the name *Music Video*, but name it appropriately for your project. Do this *before* you start the project.

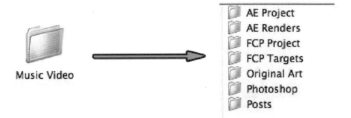

Step 2—Inside this folder make the following folders:

AE Project—Save your After Effects project, the .aep file, in here.

AE Renders—From After Effects, render your movie files here.

FCP Project—Save your Final Cut projects to this folder.

FCP Targets—When you set your Final Cut scratch disks, send the files to this folder.

Original Art—Use this folder for research elements, test shots, or artwork provided by your client; if you manipulate it, save it from Photoshop to the Photoshop folder, as the original art folder should contain the unaltered original artwork.

Photoshop—Collect all of your altered artwork here and compositions that are going to be imported into FCP or AE.

Posts—Exported compressed Quicktimes for the client that will posted on the Web or given to the clients.

Done—This is just a basic framework; if you are only using After Effects, there's no need to create FCP folders. Also, customize to fit your needs if you are making something that requires Adobe Illustrator and not Photoshop; make an Illustrator folder instead.

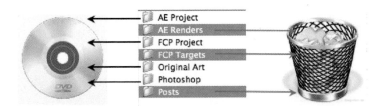

When the project has been completely finished, now comes the time to back things up. First, trash the FCP Targets, AE Renders, and Posts. Why? These can all be reexported should you need to return to the project. Unless those renders took days, you can always rerender them. Also, if the archive is smaller, you will be more likely to archive sooner, as it won't take too long to burn. Take the remaining folders—AE project, FCP project, original art, and Photoshop comps—and burn those to a CD-R or DVD-R.

PRO*files*

Randall Dottin: Director

Randall Dottin received his directing MFA from Columbia University. His thesis film, **A-Alike**, won the Student Academy Award in 2004 for Best Narrative Short. His second short film, **Lifted**, was sponsored by Fox Searchlight's program for emerging directors, the Fox Searchlab. **Lifted** premiered in April 2007 and has screened at over 25 film festivals and has won eight film festival awards. Recently Randall completed principal photography on his first feature film, **Indelible**, which tells the story of a scientist who races to find a cure for a rare disease that killed her husband and threatens to kill her teenaged son. For **Indelible**, Randall was awarded the $100,000 Alfred P. Sloan Feature Film grant for first time writer/director teams who are telling a story that deals with science.

1. Describe your job or position in filmmaking and how you got there.

I'm a writer/director who's made two short films and am in the middle of shooting my first feature. I started off as a playwright in the mid-1990s and when I graduated from college I taught elementary and high school English for a couple of years before entering film school. My first short film **A-Alike** won the Student Academy Award in 2004 for Best Narrative Short and was licensed by HBO for 2 years. **A-Alike** is the story of two brothers from opposite sides of the social spectrum who must learn to reconcile their estrangement in order to save their family and themselves. After **A-Alike**, I was recruited by Fox Searchlight to participate in a program for emerging directors called the Fox Searchlab. In the Fox Searchlab, you sign a first look deal with the studio and then make a short film that serves as an audition piece for Fox executives. If they like your short they request you send them feature scripts you want to make. My Fox Searchlab short is called **Lifted,** which has screened at over 25 festivals and has won eight festival awards since its premiere in the spring of 2007.

Lifted is the story of a young mother/dancer who finds herself trapped in a subway station after she abandons her child. In the spring of 2004, I won the $100,000 Alfred P. Sloan Feature Film Grant, which is given to first-time writer/director teams who are making their first features that realistically deal with science. The film I am directing, **Indelible**, is the story of female scientist who races to find a cure for a rare disease that killed her husband and threatens the life of her teenaged son.

2. What was the one moment when you knew for certain that this was going to be your career?

I knew when I saw Spike Lee's **Do the Right Thing** for the first time that I wanted to be a filmmaker. When I watched that film I felt like finally here is a filmmaker who is telling stories that reflect my experiences and background in a passionate, smart, complex and often funny way. What I love about Spike's films, especially his earlier work, is that he was unapologetic about expressing both the good and bad and the ugly about issues of race and growing up Black in America. Additionally, I feel like his characters usually have a very deep humanity as opposed to being just a mouthpiece for his political views.

3. What software (or equipment, whichever is more applicable) do you use?

When I write screenplays I use Final Draft. When I cut my movies I use Final Cut Pro. On my last film, the special effects program I used was After Effects.

4. What movie do you wish you worked on? In what capacity?

This is such an unfair question. . . because there are about two or three movies that I wished I worked on. It's probably a toss up between **Lord of Rings: Return of the King**, **Eternal Sunshine of the Spotless Mind**, and **Star Wars: A New Hope**. Who wouldn't have liked to work in the special effects department on the first Star Wars film? They were pioneering effects that used movement and space to make the ships look like they were really flying through space! What they were able to accomplish with the dogfights was incredible considering the technology that was available—in fact as many of you probably already know, they had to create the computers and machines that actually do the work. I probably would have liked to have been in the miniature and optical effects unit. I love the special effects in the original Star Wars because the world seemed so much more organic than

in the prequel trilogy. I feel like in the original trilogy they truly used special effects as a storytelling tool. I think when you use too much CG, the world tends to look a little too synthetic and fabricated. I tend to like special effects that are more organic and rooted in reality.

5. Is there a shot technique used in that movie that really made an impression on you?

 I loved how they used compositing and motion to create the battle in the Death Star trench.

6. Where do your ideas come from? What inspires you?

 Reading, watching people just do their everyday thing. Movies definitely inspire me. I'm also very influenced by African American folklore and late 1980s and early 1990s hip-hop music.

7. Share a visual effects technique that you use with our readers. Tell us why you like it so much. This can be anything from something that you do in a visual effects software package, editing software package, or something on the set, in camera, anything you'd like to share with the readers.

 Recently, I've really gotten into the work of Michel Gondry. He has a way of finding that which is fantastic in what seems to be very ordinary. I love the special effects work in **Eternal Sunshine of the Spotless Mind**. So much of that movie is a combination of old camera tricks, special effects, and sleight of hand. There were some great scenes when Jim Carrey is telling a story and he just walks from one location to the other.

 In my film **Lifted** there is a sequence where a guardian angel walks behind a series of pillars and disappears behind one and appears out from behind another pillar all in one shot without cutting. We called this the "whack a mole" sequence, because every time the main character, Deena, thinks she's about to grab him, he disappears and pops up from behind another pillar.

 To achieve the effect we used After Effects to erase the character once he went behind the pillars and then we whip panned to the next pillar from which the character would reappear. By the way, we shot **Lifted** using the Panasonic Varicam

HD camera. So, to take you back to production … the camera followed the spiritual guardian who walks behind the pillar, we then whip panned to the next pillar and then we cut. We rolled camera again and whipped from the old pillar to the new pillar and the spiritual guardian walked out from behind the new pillar. When we composited the two shots, it looked like we never cut the camera.

8. Is there a resource that you use, like a book, magazine, or Web site, to get ideas for techniques?

 Most of my ideas I get from watching movies or just from my imagination. I say to myself, "This is what I want to do. Now how do I do it?" However, if I keep making films with special effects I probably should subscribe to some magazines or buy this book when it comes out!

9. If you were going to give our readers a homework assignment, what would it be?

 I would tell them to create a shot sequence of their choosing where they know they will need to use a special effect. Then I would have them do the special effect in two ways: I would have them do it completely CG and then do a version of the same scenario using as little to no CG in order to discover the many different ways to do the shot.

10. Do you have any career advice for up-and-coming filmmakers?

 I think in order to become a good filmmaker and a working filmmaker, you need to have a very thorough understanding of and appreciation for good storytelling. During the summer of 1993 I worked for Spike Lee's company 40 Acres and A Mule in the story development department reading scripts. I read a lot of bad scripts but the experience was very instructive. What I learned is that if you know how to write a good story, how to recognize a good story and understand how it works, and if you know how to fix a story that may have some holes in it, you have the potential to always be employed in the business. Regardless of whatever new special effects techniques or CGI that comes out years from now, it's good storytelling that always captivates the audience.

THE NEW GLASS SHOT

A *glass shot* is a technique that is extremely low tech but very effective. Simply put, when a director needs to add scenery elements and it's too costly to make set pieces, filmmakers would paint the needed extra scenery on a sheet of glass and shoot the actors with the glass directly in front of the camera.

Sounds charming and quaint, right? This technique was quite common until surprisingly recently. However, now, thanks to digital compositing software, shots that used to use these glass techniques can be adjusted digitally with more precision and greater capability. The visual effects techniques discussed in this chapter are not designed to hit the viewers over the head; rather these techniques not disrupt the scene.

After learning these techniques, it's surprising how often these are used and often go unnoticed. If the effect is done well, the audience never loses that suspension of disbelief, and these are probably some of the easiest to pull off without showing the hand of the VFX artist too much.

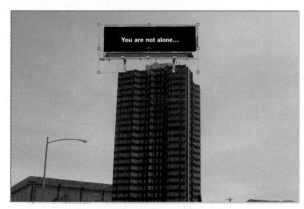

Modifying a Building

During production on a film, directors are often in the situation of needing an exterior shot that doesn't exist. Let's say we want to create a world with big messages to our protagonist so let's add a billboard to the top of a building in Photoshop.

Ingredients
- A master shot of the building that should be modified
- Another shot with the elements to be added to the building

Track Points are small points in a frame, usually an area of the frame that are either much brighter or darker than the area around them. Every effects software package has a tool that can track these points and attach an element to them. In some cases, a piece of white gaffer's tape can be used to put a track point where there is not one. In the case of this example, when the exterior of a building is being shot, it's not likely that a piece of tape can be added so keep an eye out for **track points** that already exist in the frame.

Noise is simply static. The randomness of noise can be used for tons of purposes, from creating surface textures to matching the look of video or film stock.

The Shoot

For this example we will use a still image, either from a still camera or from the camera used for the rest of the production. This effect is achieved much more easily on a still. However, if the rest of the film is being done in a hand-held shaky camera style, the shot should be moving. If this is the case, the visual effects person on set should make sure that the shot has sufficient *track points*.

When using a still that will be part of a film we will have to do a *noise* effect on the shot when it's finished in order to give it some movement.

The Design

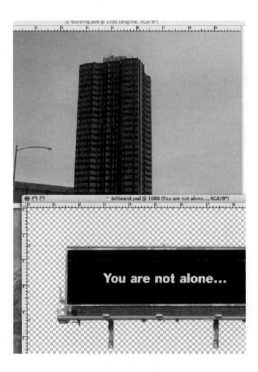

Step 1—The bulk of the effect created here is done in Pho-toshop. Open the images building.psd and billboard.psd.

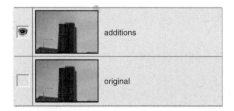

Step 2—In the building.psd image, to accommodate the size of our billboard and keep it readable to an audience we need to make it a few stories smaller. Create a duplicate of the layer named "original" by dragging it to the new layer icon at the bottom of the

layers palette. Rename it "additions." Turn off the visibility of the original layer by clicking its eye icon.

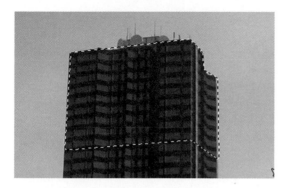

Step 3—On our "additions" layer, use the *Polygonal Lasso* to select the top 10 floors of our building.

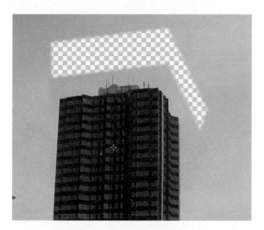

Step 4—Using the *Move* tool, drag our selection down to remove a few floors.

Step 5—Using the Clone and Paint tools, fill in the space left by the act of dragging the floors down. Looks a little stumpy now, right? Check the edges of where we dragged the building down and make sure it's clean.

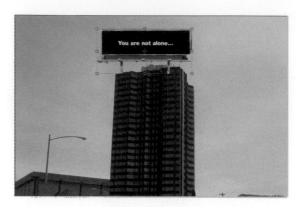

Step 6—Drag and drop the image from the billboard.psd file into our building.psd image. Use *Edit > Transform > Scale* to size it appropriately to the top of the building.

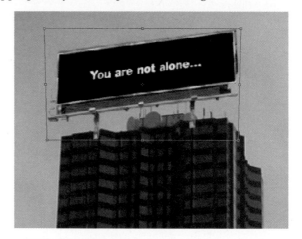

Step 7—With our billboard layer highlighted, go to *Edit > Transform> Perspective*. Use the sides of the building as guides to match the angle. When we have it right, switch to the *Eraser* and erase the bottom of the billboard's poles to make them blend well into the top of the building. Also add a little *Blur* to match the focus of the image better and darken the billboard layer.

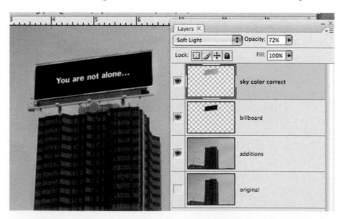

Step 8—We are almost there; we just have to match the colors of the scene with the billboard, as right now it looks like the billboard was just plopped in there. Select a small area of sky and copy and paste it to its own layer and rename the layer "sky color correct."

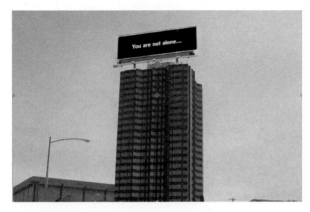

Done—Lower the sky color correct layer's *Opacity* to about 70% and set its transfer mode to *Soft Light*. It's a quick minor touch that makes a world of difference, and now we can bring it over to After Effects.

The Effect

Because we did all the CG magic in Photoshop, in After Effects we will just add some noise and grain to make this seem less like a still photo and more like real footage.

Step 1—In After Effects, put our altered building into a *composition* and set it for the duration that we need for the edit.

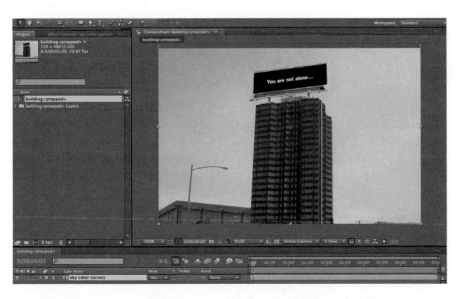

Done—With our footage layer highlighted, go to *Effect > Noise and Grain > Noise*, increase the *Amount of Noise* slightly, and uncheck *Use Color Noise*.

Also add in *Add Grain*, keeping the *Intensity* and *Size* low, around .3. Experiment here, as it will vary depending on the shot. We may want to try using the Match Grain filter, but be forewarned, it increases render time greatly. Later in this chapter we will discuss adding in moving cloud footage, which is something worth trying on this shot.

The Options

Adding noise to a still shot to make it feel more alive is a quick thing that can be solved in Final Cut.

Done—Put our building shot in the timeline and *Effects > Video Filters > Stylize > Add Noise*. Set the *Amount* low, around .05, and from *Type* choose *Gaussian Noise*. We'll have to render, but we managed to solve the problem without leaving our editor.

Adding Reflections to a Shot

Often difficult to shoot, shots containing a reflection can add a little punch and meaning to a particular scene. Reflective objects will often need the hand of the visual effects artists to make the shot land exactly as it should.

Ingredients

- A master shot of the scene containing the reflective surface
- A second shot used on the reflective surface to show the reflection we want (this is optional as there will likely be situations where the shot already contains what we need to reflect)

The Shoot

Since we know we are going to complete the shot with a visual effect, let's just get the best shot we can. Keep in mind as always to use track points if our reflected surface moves, as the reflection would have to move with it.

The Effect

Step 1—Import *rain.mov* and *killer.mov* into After Effects and put the *rain.mov* in a *composition*.

Step 2 Put the *killer.mov* footage on the layer above the *rain .mov* and create a *Mask* around the man's shape to determine what we will include in our shot.

 In After Effects, a **Mask** is used as a means of cutting a matte. In film, a matte shot is the same as a composite shot, a shot where two or more different pieces of footage are combined. The term **Mask** comes from the predigital days where most matte shots were achieved by masking out a certain area of the film emulsion. The important thing to remember about using a **Mask** is that it is used to cut an area out of a piece of footage.

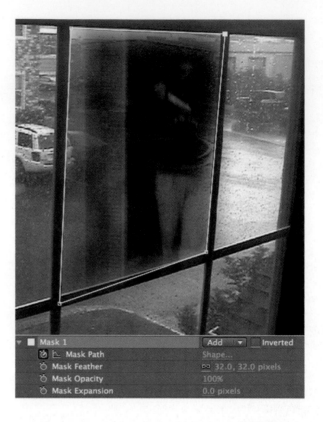

When using After Effects, to open up all the tools for a mask, highlight the layer that has the mask and quickly press the letter M twice on the keyboard.

Step 3—Adjust the *Mask Feather* and *Mask Opacity* to smoothly blend our actor into the glass. Use one of the window's panes to shape our mask. Set a keyframe for *Position* and *Mask Shape*.

Step 4—Now because the actor doesn't quite look like a reflection yet, our next step is to use *Effect > Distort > Displacement Map*, which we use to grab the contours from our rain.mov layer and use that to distort the image of the actor.

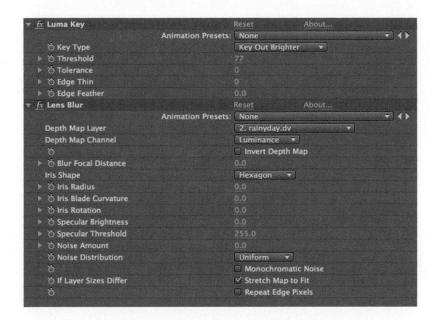

Step 5—A great technique for blending this shot into the window is to apply *Luma Key*. It will remove either the lights or the darks of shot; in this case, use *Key Out Brighter*.

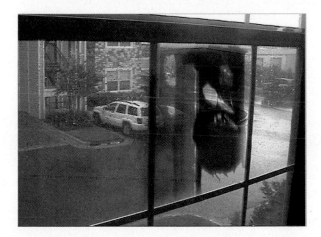

> **Keying** is the process of removing a color from a shot and replacing that color with transparency. We'll go into keys in much more detail in the next chapter, but a **Luma Key** is a key that removes color by its level of brightness or darkness or its density.

Done—Depending on the lighting situation, try adding *Lens Blur* and lowering the *Master Saturation* in Hue/Saturation.

The Options

Basically the same functions are used to create this effect in Motion.

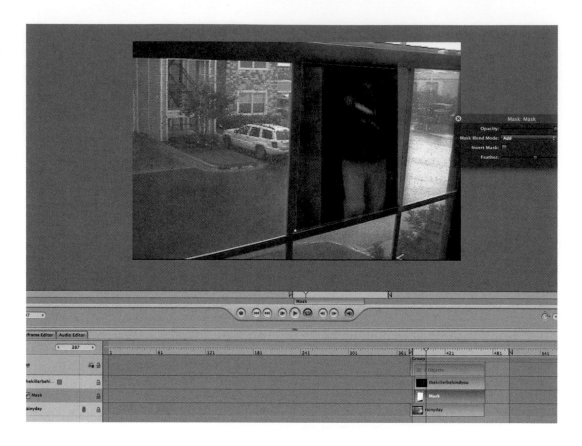

Step 1—Import our two shots into Motion and put the *killer.mov* on the layer above the *rain.mov*. Create a mask to shape our killer.mov footage.

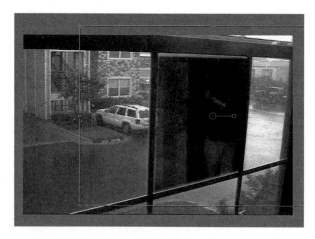

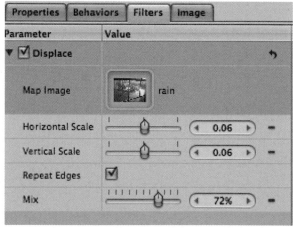

Step 2—Go to *Library > Filters > Distortion > Displace* and drag *Displace* to the *killer* layer. Drag the rain layer to the *Map Image* box.

Step 3—Go to *Library > Filters > Keying > Luma Key*. Choose *Key Out Brighter*.

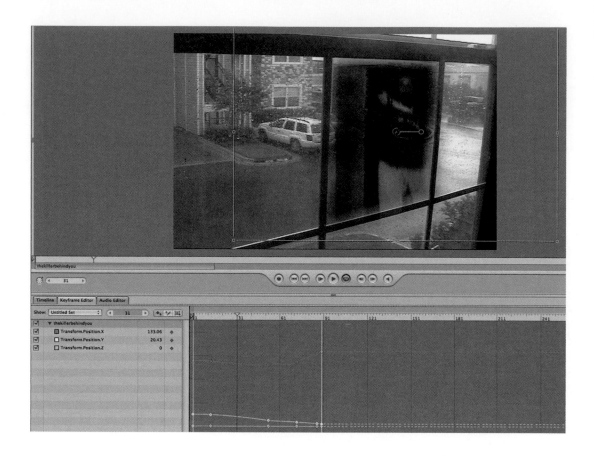

Done—Of course, don't forget to do our keyframe animation. Highlight the *killer* layer and go to the *Properties* tab. Folks who are like me, new to Motion and very comfortable in After Effects, keyframing in Motion takes a little getting used to. Mainly, when adding keyframes, get used to clicking the *Add Keyframe* button, because moving a layer does *not* automatically make a new keyframe.

Sign Replacement

Signs can be problematic or a lifesaver when it comes to establishing a location. Signs can be used to set a mood and identify a location for an audience. If a sign is poorly located or inappropriate for a film, often it will need to be replaced. Now VFX artists create the appropriate sign for a scene to capture the mood perfectly.

Ingredients

- A master shot of the sign that will be modified
- A graphic of a new sign (which will be created in Photoshop)

The Shoot

For this example we will use a hand held shot, so that means that we will use the star on the sign as a track point. Also, the horizontal lines on the building will show us the correct angle for the shot to be on. We'll make a new sign in Photoshop and then we'll use After Effects to track the movement and replace the sign.

The Design

Step 1—Make a new document in Photoshop and use the preset under Video/Film for NTSC DV 720 × 480.

Step 2—Make a square shape with the *Rectangular Marquee* and fill it with white.

Step 3—Use *Filter > Noise and Grain > Add Noise* to give it some texture (10%, Gaussian, and Monochromatic). Use *Filter > Blur and Sharpen > Motion Blur* to make the Noise look like wood grain.

Step 4—Use the *Bevel and Emboss* (Inner Bevel, Chisel Hard, Depth 71%) layer style to give the sign some 3D depth.

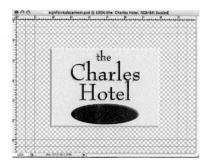

Done—Add type and any other design elements; for the type I used the Bevel and Emboss again (Emboss, Chisel Hard Depth 41%). I merged all my layers so that the Layer Styles are married to the layers they were applied to.

The Effect

Step 1—Import our replacement sign, and the shot with original sign into After Effects, and make a *composition*.

Step 2—*Use Effect > Distort > Corner Pin* to scale our new sign over the old one; as we do this, also try to match the perspective. Let's not concern ourselves with the lighting right now, we will match that later.

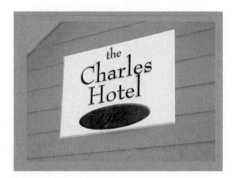

Step 3—Highlight the footage layer and select *Animation > Track Motion*. This will open the Track Motion window.

The **Motion Tracker** in After Effects looks scary but once we've got it down, it will open up a world of possibilities. We can use two different modes, one for stabilizing motion (see Chapter 7) and the other for tracking points. We can vary the type of track and the amount of trackers, but the real key to mastering this tool is selecting the best point to track.

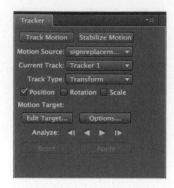

Use the outer rectangle (*Search Area*) to select the immediate area around the point we are tracking. It should be in stark contrast to the point we are tracking; if it's not, then we may need to find another track point. Use the inner rectangle (*Feature Area*) around the point we are tracking and keep the crosshair (*Feature Center*) in the middle.

The Play arrow (*Analyze Forward*) will search the whole shot, and it is hoped that our point will be tracked the whole time; if not, we may need a new point or we might need to try trimming down our shot.

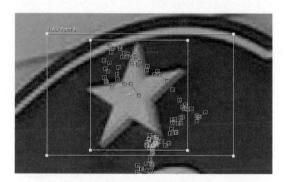

Step 4—Put the *Search Area* so that it's around the blue area next to the star and the *Feature Area* right on the edge of the star. *Analyze forward* and then apply it to our signreplacement.psd layer.

In this case we are directly applying track data to a layer. However, in most cases this is not going to be the best solution. The reason why is because you will normally need to use that tracking data over and over again, so it would be best to apply track data to a **null** object. A **null** object is an empty container that can hold layer data; anything you may need to track again later, you can just **Parent** to this **null** layer.

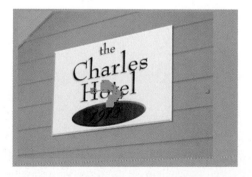

Step 5—Our new sign should travel nicely over the original. It may move the entire sign away from cover the original sign so in that case highlight all the *Position* keyframes on the sign layer and drag it back over the original sign.

Done—Add *Effect > Color Correction > Hue/Saturation* and reduce
the *Master Saturation* to about –33. Also use *Effect > Noise and
Grain > Add Noise,* set *Amount of Noise* to around 6%, and uncheck
Use Color Noise. This will help match the sign to our footage
and make it feel more realistic.

The Options

Motion Tracking is an exciting and handy tool, and it's absolutely cru-
cial to the art of compositing. Let's do the same thing in Combustion.

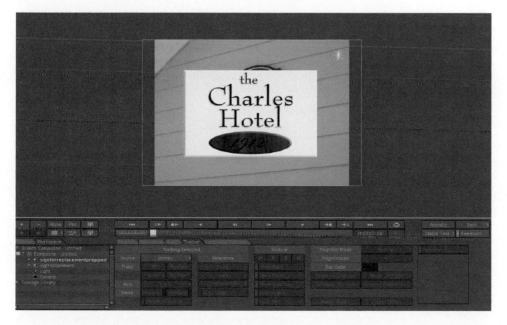

Step 1—Open a new workspace and import our master shot with the
original sign and import the replacement sign.

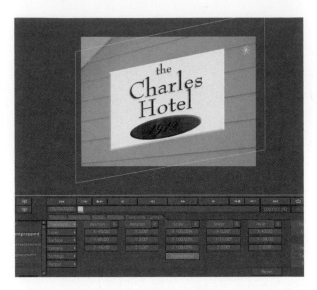

Step 2—Shape the sign to match the angle of the shot by going to the *Composite Controls* tab and choosing *Transform*. Use the *Shear* tool to match the angle.

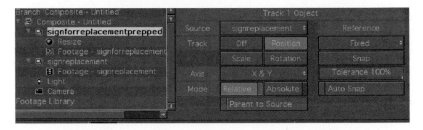

Step 3—With our replacement sign selected, go to the *Tracker* tab. Choose our original sign layer for the *Source*. Click the button for *Position*. We should see the familiar looking tracker controls; look close as it defaults to white unless we change the color.

Step 4—Turn off visibility for our new sign and move the tracker controls over the star. The bounding box should be around the star and the feature area should be on the body of the star with a little of the blue allowed in on the sides. Hit the *Analyze Forward* button and keep our fingers crossed.

Done—If it worked, then turn the visibility of the sign back on. If not, make some adjustments to the tracker controls and give it another go. Now let's do a little color correction to help it blend in. I added *CC Curves* and *CC Histogram* (CC Curves is the Equivalent of AE's Curves, and CC Histogram is the equivalent of AE's Levels) to reduce contrast and make it darker.

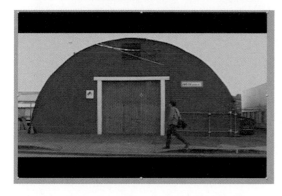

Removing Objects from the Frame

No matter how rigorous the director, the director of photography, the location scout, and the whole team are, there will undoubtedly be shots that have objects in the frame that should not be there and can be removed.

Ingredients

- Footage with an item that needs removing; in this case it's signs with logos.

The Shoot

If the shot can be achieved without including something that should not be there, then of course do so. Sometimes this is something that the director or DP did not notice or something that was unavoidable.

Also, note that the following tutorial would only apply to a static shot. If there is movement in the shot, that tracking data would be needed.

The Effect

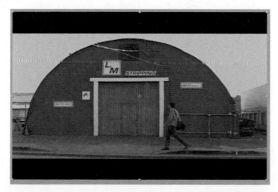

To make a composition that is the exact same length as a single footage file, drag the footage to the new composition icon at the bottom of the Project window; it looks like a little film clip.

The **Clone Stamp** and Clone tools appear in some form or another in most effects software. They are designed to allow you paint-style controls to copy one area to another. In general, you will use a keyboard command, such as pressing the Option key to determine to the copy area, and then you will use the mouse to paint.

Step 1—Import your warehouselogo.mov footage to After Effects.

Step 2—Double click the footage to go to *Layer Edit Mode* and choose After Effects' *Clone Stamp*. Now just as you would do in Photoshop Option-Click to set your target point and then paint over the area you'd like to fix.

Step 3—Be careful to avoid repeating problem areas; for example, in this case, watch the edge of the sign and the vent. I like to start with a midsized soft edge brush and then later come back in with a fine-tipped smaller brush.

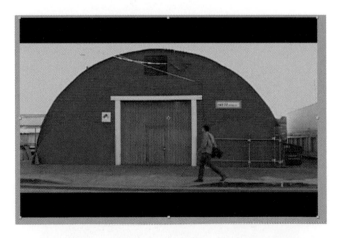

Done—With this setup, it's a pretty easy job. I went ahead and knocked out a couple of more signs.

The Options

A similar process can be applied with the same ease in Combustion.

Step 1—Set up a new workspace and import your footage. Add *Operator > Paint* to your footage.

Step 2—In *Paint Controls* choose *Clone*.

Step 3—Unlock the frame so that we can apply our cloning effect to more than just this frame and choose the crosshairs to set our source. Then you can choose an appropriate brush size to paint with.

Done—Paint out your sign, and that's pretty much it; check your time line settings to make sure that you keep the cloned area across the length of the time line.

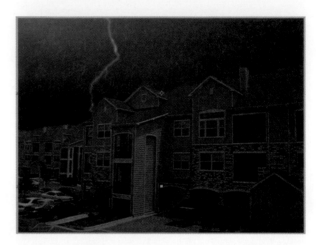

Changing the Weather

Many productions only progress at the whim of the weather. Generally, if we have a producer who's worth his or her salt they will schedule the shoot so that it takes place in the appropriate location with accommodating weather. Then again, the weather can change on a dime. Luckily the VFX artist can, in many cases, change the weather. However, it's not *every* case.

Ingredients

- Footage of the shot that needs its weather changed
- Replacement footage for the sky (if needed)

The Shoot

If you have the opportunity to shoot under ideal weather conditions, don't miss your chance by thinking that you can always "*fix it in post.*" Many times, the shots are unsalvageable even with the fanciest of plug-ins. However, there are times when it can ruin the entire production if a particular shot is not done at a particular time in the schedule. So, the battle may be worth the fight.

When picking shots for weather transformation, try to avoid the most obvious call signs of the weather we are trying to hide, such as people running with their heads covered or puddles in the act of accumulating water. Also pay close attention to the lighting situation. On very bright sunny days avoid shots with very bright glints of sunlight, as those will be tough to get out.

The Effect
Turning an Overcast Day into a Sunny Day

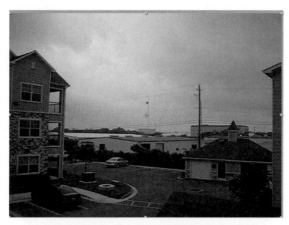

Step 1—Import our overcast footage into After Effects.

Step 2—Make a new Adjustment Layer and apply *Effect > Color Correction > Hue/Saturation* and increase the *Master Saturation*; we should see a difference immediately.

Saturation is the amount of color in a shot. When working with shots where weather is at the heart of the issue, keep a couple things in mind. First, when there's more light, there's more color, so if you want the day to appear to be sunny or sunnier, the saturation should be increased. Now, on a cloudy or overcast day, there's less light, so the opposite concept can be employed. Desaturate the image to make the weather appear more overcast. A shot that is completely desaturated is black and white.

Step 3—Now that things have got a bit more color, we should brighten things up by using *Effect > Color Correction > Levels.*

Step 4—In some situations, this might do the trick, but in this case, it's still too cloudy. What we will need to do here is replace the sky with a photo or footage of clouds from a bright sunny day.

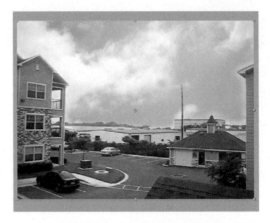

Done—Drag our sky photo or image to the layer below the main footage. We may want to add an Adjustment Layer with Levels or Exposure to give the shot an overall Brightness boost. Don't go overboard with the added saturation as it can quickly turn into a disgusting watercolor-pastel mess. Also check our Mask Feather Settings to avoid overly glowing edges.

Turning a Sunny Day into a Rainy Day

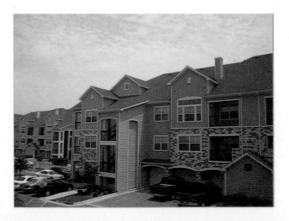

Step 1—Didn't you ever want to destroy something beautiful? Well, let's start with this lovely day. Import the sunnyday.mov footage into After Effects. Use the same techniques for color correction and apply as before, just in reverse. Make a new adjustment layer and apply *Effect > Color Correction > Hue/Saturation* and decrease the *Master Saturation.* Add *Effect > Color Correction > Levels*, remove contrast, and make it darker.

Contrast is the amount of difference between a color value and its opposite. In the case of a black and white image, a high contrast image will have blacks be very black and whites very white (think of an image that has been photocopied a few times). An image that is low in **Contrast** will be much more gray. For our overcast day effect, we should reduce the **Contrast**.

Step 2—With this shot, however, we won't be getting anywhere until we get rid of that gorgeous blue sky. Create a *mask* around the sky to remove it.

Step 3—Now that we've removed the sky, we should now bring in our stormclouds.mov footage. After we have added the stormclouds.mov footage, we may need to give our original footage a color correction change to match the new footage. Because our shot is very blue-gray, try using *Effect > Color Correction > CC Toner* or *Effect > Color Correction > Colorama*; be subtle here, I'm using Colorama with *Blend With Original* at a mere 94% (meaning that we are only seeing 6% of our color treatment).

Although this book doesn't use third-party effects (unless they are bundled with the software), I recommend purchasing Trapcode's Particular for this purpose. Particular is a 3D particle engine that is far superior than ones packaged with After Effects.

Step 4—Now let's have some fun; let's add some rain. I am intentionally avoiding using *CC Rain* (sorry Cycore) and I will steer us to another CC plug-in. I really like the results I get with *CC Particle World*; I feel like *CC Rain* lacks dimension. Really any particle engine will work for this to some extent, provided we are willing to spend some time tweaking its settings. I like *CC Particle World* for its ability to work in Z-space.

Start by creating a new *Solid* layer and make it gray; name it *rain*. Apply *Effect > Simulation > Particle World*. Under the heading for *Particle*, choose the preset for *Line* in *Particle Type*. Use the eyedropper for *Birth and Death* colors to get one light color and one dark color that match our storm cloud layer. Under the *Producer* heading, scrub the *Position* settings for each axis until it falls in place the screen correctly. Open up the radius for X and Y, spreading our rain out so that our rain covers the scene.

Under the heading for *Physics*, set it to *Viscouse*. Adjust *Gravity* and *Extra* so that our raindrops have varied appearances with some at the

top skewing on a diagonal angle. Change the *Type* to *Constant Length.* Finally, lower the *Max Opacity* so that we can see through our raindrops.

Step 5—Add *Effect > Blur and Sharpen > Vector Blur*; aside from the help it gives us in blending raindrops in, it also gives them a nice bend and twist and helps them feel more realistic.

Done—Change the rain layer's *transfer mode* to Add, *Overlay*, or *Screen*; it really depends on the individual situation we are in with the footage we happen to be working with. If we want to have some more fun with this shot, add a new *Adjustment Layer* and apply *Effect > Generate > Advanced Lightning*. Turn on *Composite on Original*. Set the *Lightning Type* to *Strike*; use a very low setting for *Glow Radius*. Add a little *Blur* for good measure. Nothing looks worse than cheesy After Effects lightning without care used in how it's composited.

The Options
Turning an Overcast Day into a Sunny Day

Particle systems are used in most animation applications with the intention of replicating movement seen in nature such as smoke, clouds, fog, dust, sand, rain, snow, and many more. Why not photograph it? The reason is most likely that these are some of the most difficult things in the world to composite; imagine having to create mattes around little grains of sand.

Adjustment Layers in After Effects are similar to **Adjustment Layers** in Photoshop, as they can hold an effect that is applied to all the layers below the **Adjustment Layer**. A handy use for this is for an effect such as Advanced Lightning or other generated effects where you will likely want what After Effects creates on its own layer without solid color pixels that come with a Solid layer.

Step 1—Let's open up the overcast footage in a new *workspace* in Combustion. *Add Operator > Color Correction > Movie Color* and turn it up nice and high; also *Add Operator > Color Correction > CC Basics* to further brighten and saturate the shot.

Step 2—With the overcast footage highlighted, choose *Add Operator > Mask*. Jump over to the toolbar and grab the *Bezier Mask Tool*. Once we've completed our mask, add some feather in *Mask Controls > Modes*.

Done—Import our sky layer and put it below our buildings shot in the layer order. We may want to add operators to brighten and saturate the shot a bit more.

Turning a Sunny Day into a Rainy Day

Step 1—Import the sunny day footage, *Add Operator > Color Correction > CC Basics*, and desaturate the image; also make sure that we really bring down the *Gamma* in the *Highlights*.

Step 2—With the sunny day footage highlighted, choose *Add Operator > Mask*. Go to the toolbar and grab the *Bezier Mask Tool*. Once we've completed our *mask*, add about 3 pixels of feather in *Mask Controls > Modes*.

Step 3—Put our *stormclouds* layer right below our *sunnyday* footage, *Add Operator > Color Correction > CC Basics*, remove saturation, and darken the clouds.

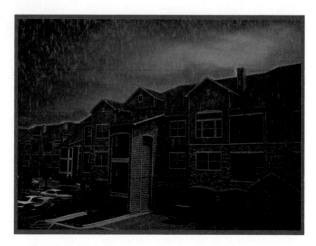

Step 4—Add an *Operator* for *Particles* to the composite. Go to *Particle Controls* > *Library* > *Natural-Organic* > *Water Jet*. With *Water Jet* highlighted, adjust the settings to spread the rain particles out and give them a blue-gray tint. Adjust the *Weight* until it falls like rain should.

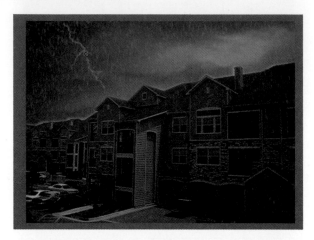

Done—The last thing left is to add lightning. *Add Operator* > *Particles* to the composite and make new *Point* emitter with the *Lightning* particle type. Give it a dark blue tint and trim it in the time line to about 5–10 frames.

Removing an Actor from the Frame

It's a common analogy among editors, much like magicians, to show the audience something that will concentrate their attention to one place so that they will be distracted by something else. However, there are many times that we will be in a position of having a great shot that would be so much better if only this thing or that thing were slightly different. Here's one way of dealing with that, covering up the misdirection.

Ingredients

- Footage of the shot that needs a new focal point
- Footage or still photo that will be used to hide or cover something

The Shoot

This tutorial is about fixing and repurposing a shot. So, therefore it was unplanned, and in an ideal world, this would be avoided. However, because we don't live in an ideal world, I share this technique as a tool in the VFX arsenal that should only be tapped when needed.

The Effect

Step 1—Import the misdirection shot into After Effects. Here's our dilemma, we've changed our minds about having this actor's face in our shot and would like to use it just as a scene so we'll need to get him out of there.

Step 2—Double click the footage to go to Layer Edit Mode and open up *Window > Tracker Controls*. Choose *Track Motion*, set our tracker's center crosshair right on our actor's eye and the two outer boxes to encompass his eye and eyebrow, and click the *Analyze Forward* button. We should get a perfect track. Create a new *Null Object* layer and apply our track to this layer.

Null layers are essentially a placeholder. It's a blank layer that has no visible properties and is used most often in conjunction with a Layer Parent or Expression.

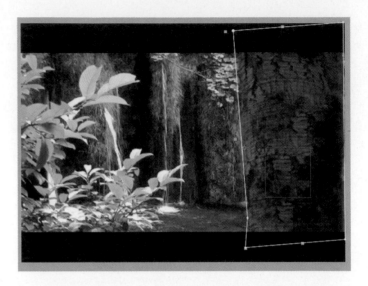

Step 3—Import the tropicaltree.psd image and put it in our time line. Reduce its *Scale* to about 50%. Use either the *Eraser* tool or the *Mask* tool to cut it down to just the tree branch.

Step 4—Move the branch to cover our actor's face. *Parent* the tree layer to the *Null*.

The reason why I did it this way is let's say we change our minds and would like to use something other than the tree to cover the actor's face, we just replace it without worrying about retracking and other unwieldy consequences of having our track with our layers. Now go to the first frame of our *composition*; if the act of parenting it to the *Null* skewed its position, drag it back to where it's covering our actor's face.

Parenting in After Effects (and other animation software packages) is a process where one layer is told to follow another layer without permanently attaching them. So, if you have a layer with *Position* animation and you want another layer to have the same *Position* animation, you can use a layer **Parent**. A **Parent** layer can have any number of *Child* layers, but a *Child* layer can only have one **Parent**. Parenting only affects the *Scale*, *Position*, and *Rotation* animations.

Step 5—Sometimes when I have a letterboxed shot like this I dupli-
cate the original layer and make a mask that removes everything
except the letterbox. Then move the layer with the letterbox to
the top so that if our tree gets too close to any edges, we'll have it
in place as a safeguard.

Done—Use *Effect > Color Correction > Levels* to darken the tree
branch as it would be in shadow given our lighting situation. As
with any situation where I have something I've added to a shot
that did not come from the same source, I use *Add Noise* to match
the DV look.

The Options

Although it's a pretty simple technique, we need to do this in a motion
graphics program because of the need to track motion; however, if we
are in a situation where the shot was on a tripod, we could do this in an
editing package.

Step 1—Import our misdirection shot and the tree image into Motion and create a *mask* around the tree. If necessary, make rectangle shapes over the tree layer to put it behind the letterbox.

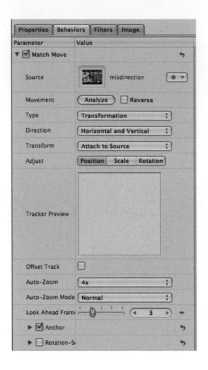

Step 2—On the tree layer, apply *Library > Behaviors > Motion Tracking > Match Move*. Set the misdirection layer as *Source*. Uncheck the visibility of the tree layer for the moment since we will track his eye like before.

Step 3—Our tracker controls are rather simplified here in Motion in comparison to After Effects and Combustion; put the tracker over his eye and click the *Analyze* button. Check the visibility of the tree layer back on; it should now move accordingly.

Done—This is basically it; use *Library > Filters > Color Correction > Gamma* to darken the tree a little (since if we were standing behind that tree it would be in the shadow area), add *L ibrary > Filters > Color Correction > Color Balance*, and increase the three *Blue sliders* to cut back the overly yellow hue on the tree image.

PRO*files*

Jeff Martini: Video Editor, Motion Graphics Designer, Sound Designer, Multimedia Designer, Educator

Jeff Martini has over 12 years experience working in the film, TV, radio, and Web industries. Although experienced in most aspects of pre- through postproduction, his strengths in production are as an audio mixer and in the field of postproduction as an editor and music composer. He also has experience managing crews and producing documentary-style productions from beginning to end. Jeff also currently works as an instructor at Parsons, The Churchill School NYC. As a lead trainer for NBC Universal's On the Set program, Jeff teaches teenagers from around the country how to work behind the camera to create public service announcements on the topic of diversity. Jeff owns his own audio production studio in Greenpoint, Brooklyn, where he composes music in several styles. Jeff enjoys creating sounds that are unique and individual for each of his clients. Jeff has worked on projects for such companies as Sony/BMG, NBC Universal, Court TV, The Sundance Channel, SELF Magazine, PepsiCo, Golf Digest, Pickerel Pie Entertainment, RoadRunner Records, PicaTrix Productions, B&Hphotovideo, AmphionMusic, SafirRosetti.com, CitiBank, and Chase bank.

1. Describe your job or position in filmmaking and how you got there.

My job is as a freelance video editor, multimedia specialist, motion graphics artist, sound designer, location sound recordist, and audio postmixer. I got to this place by never saying "no" to any job. Even throwing myself in sometimes over my head. There is so much to learn out there and the only way to learn in our industry is by doing. Don't get me wrong, I've never oversold myself. I've just taken on responsibilities that were often above what I had previously done. For example, when I first started in the business, editing on a desktop computer was a relatively new thing. No one in our department was very proficient and we only had two workstations for four videographers. I took it upon myself to come in 2 hours early every day (where I knew I'd be alone with the machine) and to stay late about the same. At that time it was the beginning of my career and worth it. I was able to take more on my plate as an editor. Nowadays I've expanded myself as an editor by becoming a pretty solid sound mixer. The only way to get good at it was to start mixing my projects even if the clients hadn't built that into their budget. It has proven a great asset to be able to have experience in several areas in the field. The same goes with my motion graphics work. I always try to create a basic graphics package for a project as a temp even if the client or producer is planning on hiring a separate motion graphics designer. In the end they often use the work that I've done instead of dealing with a third party, unless the time constraints are so tight on the project. This often works out in my favor as it keeps my motion design skills sharp.

2. What was the one moment when you knew for certain that this was going to be your career?

The moment I knew that I was going to make a career out of filmmaking was in college. This was actually before I had taken any film production classes. I had a wonderful teacher by the name of Marshall Fishwick in the communication studies program at Virginia Tech. In his pop-culture (Fishwick actually coined the phrase) class he pushed his students to think outside of the box. Not just in how we thought but how we were tested. To show we understood what he was teaching, students could make sculptures, photo collages, picture essays, and such. I chose to do a video project and, with my dad's VHS camera and my roommates VCR, I pieced together a story that got me an A+. It was rather difficult to edit from one machine to another and although impossible to edit accurately, I was able to get the story through. That's when I started taking every film class I could.

3. What software (or equipment, whichever is more applicable) do you use?

The main software I use to pay the bills (in descending order of importance): Final Cut Pro, Pro Tools, After Effects, Flash, Dreamweaver, Reason, and Photoshop.

4. What movie do you wish you worked on? In what capacity?

I would love to have assisted in editing the opening segment to **All That Jazz**. Alan Heim really influenced editors who would later make music videos. His timing is so wonderful and the opening gives you such an amazing inside look at what being in a cattle call audition is like. **Raging Bull** is also one of my favorite movies, and I think I would have enjoyed being an assistant to Thelma Schoonmaker. I think both of these film editors typify when to cut and when not to. Just being in the same room with either one on a project would really be an experience. Even though we have a lot of films today cut for what is considered a "low attention span" audience, I still like the way these older editors cut. They pretty much are subliminal when telling the story.

5. Is there a shot technique used in that movie that really made an impression on you?

The shot technique in **Raging Bull** that really impressed me is the main fight scene when Jake LaMotta fights Sugar Ray Robinson for the last time. I love every aspect of the scene. From the fact that Martin Scorsese took weeks to plan and shoot it, to DeNiro's acting, to the fact that the DP is standing in the audience (along with other assistants) shooting strobe flashes. They actually had to find older flashes that would read when the camera was up a crank (what produces slow motion in film). The editing is amazing, and the sound design really stands out. Of course back then all the post was much harder to do. So it's rather impressive that they came up with that sequence. If you've never seen it, do yourself a favor and rent the movie. Be sure to watch that scene several times to catch it all. There's also an homage to Hitchcock's **Vertigo** with one of the shots. I won't say which one but it is pretty easy to figure out if you have studied **Vertigo**.

6. Where do your ideas come from? What inspires you?

I get my ideas from trusting my gut. One of my favorite techniques on a job, especially when I have to create something from almost nothing (like in a Web site or a heavy motion graphics job) I really like to spend some time meditating by just clearing my mind of all thoughts (usually right in the morning before getting out of bed). This is a hard technique to do, especially when there is a lot of pressure to meet a deadline. But I've found that most of that stress actually slows you down. I like to get up after meditating and (anywhere from 20 minutes to an hour) and start to free write or draw the ideas that come into my head, without any judgment on whether they are good or bad ideas. If it's a story

I just write down story ideas. I try to keep going for 10 minutes or so until I've exhausted several thoughts. After all this I take a break. I usually walk around the block and then come back and start editing my ideas. Remember the power is in the editing of your ideas. But you cannot edit anything if there is nothing there. So you must throw ideas down on the page first without judgment. That's the trick that I've found that works for me.

7. Share a visual effects technique that you use with our readers. Tell us why you like it so much. This can be anything from something that you do in a visual effects software package, editing software package, or something on the set, in camera, anything you'd like to share with the readers.

Here is a visual effect that I use in Flash but I believe could be used in After Effects or other software in a noninteractive environment as well. I think it's very effectively used for a rollover but you could also use it when bringing on separate items on a screen. Take an object (e.g., on my music site, jeffmartini.com, I have an object representing all my rollovers—a martini glass for my bio, a record for music and so on …). I'm animating at 24 fps in Flash (way smoother than animating at the default 12 fps). I start the object's time line on the first keyframe (which I've now converted into a movie clip symbol) at 0% transform (scale if using AE) and at 0 Alpha (opacity if AE). Six frames later on the time line I add a new keyframe where I make the Alpha 100% and the transform 110%, thus making the object slightly bigger, but only for a moment. I then go 3 more frames (frame 9 on the time line) and add one more keyframe where I bring the transform down to 100%. This is the last frame and in Flash I add a stop action to stop the animation here. The last move I do deals with easing. Easing is one of the greatest inventions in animation (in my opinion). It allows you to control the momentum of an object's movement. Giving a small bit of real world properties to an object can give it an added layer of professionalism. So I like to use Flash's easing to set the motion tween between frames 1 and 6 as Easing In minus 100 and then set the motion tween between frames 6 and 9 as Easing In plus 100. This gives the object a bouncing effect. And when I set the object to only trigger this time line by a button rollover interaction on the site, I think it looks pretty cool. So the item comes out of nowhere and grows a bit bigger and then quickly eases to its resting size, giving it a bounce. The easing properties in Flash are the same concept as in After Effects but are applied differently. So I challenge you to recreate this with an object in AE or other animation software. This will help you understand easing much better if you've never worked with it.

8. Is there a resource that you use, like a book, magazine, or Web site, to get ideas for techniques?

I have found Lynda.com a wonderful resource for software skills. I am a full yearly member and find it helpful to continually go to her site and do tutorials.

9. If you were going to give our readers a homework assignment, what would it be?

My homework assignment would be to shoot a small interview. Assuming you have access to a small camera and some sort of editing software (it does not have to be anything major) choose a friend, a neighbor, or family member who will take this project seriously. Write a list of questions and write a small list of expectations of how you think the interview will turn out. Go out and shoot the interview. Then proceed to cut the interview into the most coherent piece that you can. Then try to say the same idea with this interview footage at exactly half the running time. Show it to a person who has not worked on the project that you trust. Ask them to be honest in what they think about it. Write down what you think about the piece. How does it sound? Can you make out what they are saying? How does it look? Does the overall message come through? What would you do to make things better? Then go out and do another one. Do not be discouraged if it does not come out the way you hoped. Filmmaking is a craft that you will be continually perfecting. If you have little or no prior filmmaking knowledge this will get you hungry to learn about techniques that could make your shooting, lighting, sound, interviewing, and motion graphics skills better. Once you feel you've got some hang of it, think of making a video collage of interviews for a family reunion or get-together. That will inspire you to do it yourself and to push your craft, especially when there is a purpose and a deadline.

10. Do you have any career advice for up-and-coming filmmakers?

My career advice for up-and-coming filmmakers is to start now. Today. The only way to get better at this is by doing. So go out and start doing. Pick simple projects to get you started. If you don't have a video camera perhaps make a photo story about your dog or cat that has music, voice-over, and titles to help tell the story. Second, collaborate. Find others who, like you, have a shared desire to be a filmmaker and are at a similar place in their career. Third, find mentors. When you are ready you need to be prepared to intern for those who have experience. It's a perfect trade. Your time and work for their knowledge. All my friends in the industry started this way. I have answered phones, swept floors, made coffee, logged tapes, shuttled media cross-town, and even driven a van to the middle of New Jersey to get food coloring for a prop. It's all part of your career.

5

GREEN AND BLUE SCREENS

When I was real young and the first Christopher Reeve Superman film was released I saw something I did not like. I pulled my mother aside and complained "Why is Superman's suit green sometimes? *It's supposed to be blue!*" My mother couldn't see what I was talking about. Is it any wonder why I'm working in this field? My question would not be answered for a couple of decades.

Flash forward to one of my early days teaching at the Katharine Gibbs School and my question received an answer from one of my colleagues. Frank Reynolds, film editor and resident Superman film expert, told me my answer, the slightly cyan version of Supe's suit was to aid the blue–screen composite shots. This was, of course, before the days of green screens.

Read any article that interviews the director of a very special or visual effects-oriented film. Even articles that just interview the actors usually reveal some sort of anger with this seemingly benign piece of the set. What do they seem to hate the most? I can't tell you how many times I've heard folks complaining about the green/blue screen stages of a production.

Green screen (or blue) is a nickname for the technique traditionally known as a traveling matte composite. The technique takes advantage of using color backgrounds to use any process that will remove that color and replace it with a different image. So we shoot our actors in nice comfortable studio settings with a green background and remove the color in postproduction (or, in some cases, during production). Why green and blue? Really you can use any color, but green and blue are used because they are the complement of the colors that make up the base colors of human skin tone.

So why do they hate it? Just imagine yourself working on a film and directing actors to respond to a location they can't see or thinking about the crucially important visuals in your film that you can only see a tiny percentage of. However, as of right now this technique is the heart of compositing and a necessity in today's increasingly growing need for visual effects-oriented films, commercials, and television shows.

Shooting and Removing a Green/Blue Screen

The basic technique I am about to go over is the core of today's compositing. It's going to require certain pieces of equipment and a large area to shoot in.

Ingredients

Equipment for the Shoot

- Two three-point lighting kits
- Green or blue background (you can use professional backgrounds or just any huge color-consistent background, understanding that professional backgrounds get a better result)

For the Effect

- Footage of the actor or actors in front of the screen
- Replacement footage for their background

The Shoot

When shooting with a green screen, you need enough room to do two lighting setups: one for the screen and one for the actor.

Ideally, you'll be able to rent a soundstage space or a shooting space designed for special effects, at least some kind of large room. We want to be able to have a large amount of depth of field so that our actors can be well focused and our green screen blurred. The actor should be 8 feet or more in front of the green.

With gaffer's tape, block off the area so that the actor knows the distance they can go forward before they exceed their lighting and the distance they can go backward before they are in the screen's light or out of focus.

Why do we want to blur the green screen? We need the green screen to be as consistently a single color as humanly possible. Any slight changes in the brightness and darkness of the green screen make our job more difficult. Blurring will reduce the number of colors and details the screen has.

For the best result, we should create two three-point lighting setups: one for the actors and one for the green screen. However, if you don't have enough lights, do your best to light the green as evenly as possible.

Now, here is some bad news. No matter how well you set this up, you may still have problems with the color key if you shoot DV. Because DV is a very compressed format, it will likely have very jagged edges, even with

the best color key plug-ins. It uses a compression ratio of 4:1:1, which basically means that it gets one pixel from the real world and repeats it four times. This will created an aliased, jagged edge.

Even if the original footage was shot on a different format it will have this problem if converted to DV. After Effect's Keylight plug-in, as well as many third-party plug-ins, have some features to help compensate for this. You can also rent a different camera, such as a Betacam, Red camera, or an HD format (careful though, some HD cameras will have the same issue as DV). Always check the camera's compression ratio, as you want something that's 4:2:2 or better.

The Effect

Step 1—Import our actor.mov footage.

Step 2—Use a *mask* to cut out our actor. Don't worry about being precise; we are creating what is called a *garbage matte*, for the purpose of reducing the amount of area on the screen we need to remove. If being very precise with the garbage matte worked well or quickly, we wouldn't need a green screen.

Step 3—Apply *Effect > Keying > Keylight*. You could try other keyers, but honestly, Keylight is the true powerhouse color key plug-in.

Masks in After Effects work like Bezier Paths from Photoshop or Illustrator. In fact, you can copy and paste a path from either program directly into After Effects. After Effects allows you the option to turn on or off Roto-Bezier. When Roto-Bezier is on, every point in a path is automatically a continuous point, meaning that it will have curved handlebars, without your having to convert them into curved points.

Keylight is made by the Foundry, makers of Nuke as well as other great After Effects plug-ins. The version of **Keylight** that's packaged with After Effects will not always be the most up to date. However, because it is a free plug-in, check http://www.thefoundry.co.uk/ for the latest version.

Step 4—Use Keylight's *Screen Color* Eyedropper to sample a good even green. Bam! No more green. Now, if you worked for some terrible cable-access program, you are done, but you are a professional filmmaker, and there is a lot to improve here.

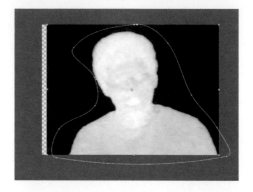

Step 5—In Keylight, switch the *View* to *Status*. This is an extremely valuable view. Let's start with cleaning up the edge; scrub the value for *Screen Pre-blur*, do this very gradually, as this will smooth out the DV compression-created jagged edges described earlier. We need our actor to be completely white and the green background to be completely black. If you see gray, then you have more work to do. Set *Clip White* to 55–60 and set *Clip Black* to 30–35 until there's no gray.

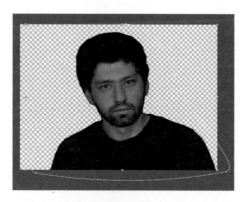

Step 6—Switch back to *Final Result* periodically to see how we are doing. Looks good, except wasn't his shirt green? To fix that we should use *Replace Method* under *Screen Matte*. Switch the mode to *Hard Color* and change the color swatch to a green that's fairly bright but down toward the gray.

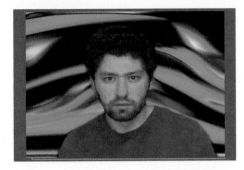

Done—If you accidentally returned some green to the background or in our actor's hair, use the *Grow/Shrink* under *Screen Matte* to take care of it. Now you can put our actor in whatever background you like!

Use levels or color balance to adjust our subjects so that their lighting will appear to match the new background they are now in.

The Option

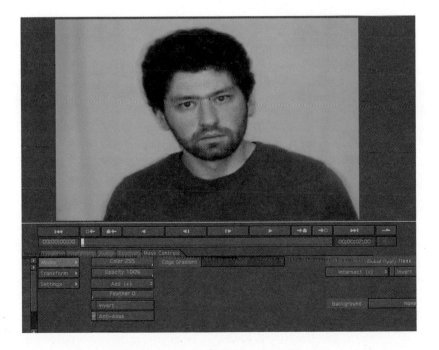

Step 1—Import our actor.mov shot into Combustion.

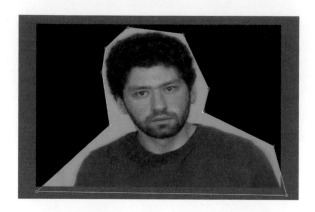

Step 2—Select the shot and apply *Add Operator > Mask > Draw Mask*. Draw a mask around the actor, a very rough one.

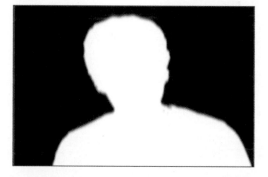

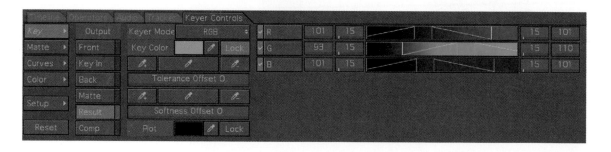

Step 3—Add *Operator > Keying > Discreet Keyer*. Combustion's built-in Keyer is quite powerful, as you'll see right away. Go to the *Keyer Controls* tab and observe the two columns. The first one determines what aspect of the key you are controlling; the second is various outputs. I usually switch back and forth between *Result* and *Matte*. Adjust the settings throughout while checking the *Matte*; just like in AE's Keylight our goal is to have his outline in white and the background in black.

Step 4—To preserve the green in his shirt, click *Color* and adjust the graph. Pull it up in the green section of the hue range and you'll see that his shirt will maintain its green.

Done—Bring in a background and place below the footage layer. If the hair below his ears gives you too much trouble with the key, just create a *Paint* object and erase it out.

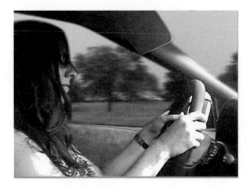

The Driving Shot

Have you ever taken a snapshot in a room where the lights are pretty dim, but there's a window in the room that's letting in bright daylight? Usually what happens is you either have a dark room with a good exposure of the view from the window or have the room well exposed but the window is blown out.

That's the typical situation directors run into when doing car shots. Here's the standard visual effects fix for this type of shooting situation.

Ingredients

Equipment for the Shoot

- A piece of green or blue background large enough to cover a car window

For the Effect

- Footage of the actor in the car, with window(s) covered in green or blue
- Replacement footage for the background

The Shoot

For the first setup with the actor, I taped a green piece of poster board over the window. If you don't have access to professional green or blue backgrounds, this approach can work if you are willing to do a little more fighting with key plug-ins. If you go in this direction, error on the side of brighter colors than darker colors when choosing your poster board background.

Do your best to light the green areas of the car evenly, as it's much harder to get an even green in such tight quarters (you can't rely on depth of field to knock the green out of focus).

For replacement footage, the best thing to do would be to sit in the rear passenger seat, expose for the outside, and let someone else drive you around while you shoot. However, in this tutorial I'll demonstrate how to fake replacement footage with still photos.

The Design

Creating the Scrolling Replacement Footage

Step 1—Open the roadside.jpg in Photoshop. Create a new document and use these settings: width, 2800; height, 480. Why so huge on the width? We are going to create a looping background and the wider the image is the more control we will have over the speed.

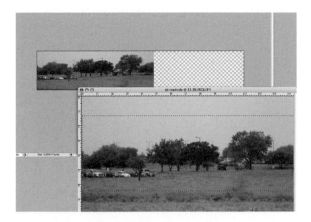

Step 2—Select an area of the image and drag and drop it into our scrollingbg.psd file.

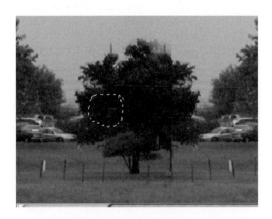

Step 3—In the scrollingbg.psd, duplicate the layer you just brought in and apply *Edit > Transform > Flip Horizontal*. Drag the flipped copy over, making sure that there's some overlap with the first layer. Use the *Eraser* tool and the *Clone* tool to hide the seam.

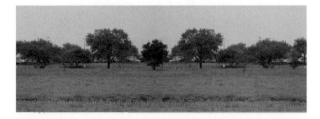

Done—Merge the layers together; you want something that looks like this, but don't expend too much energy here because there will be a significant amount of blur on this before we finish the project.

The Effect

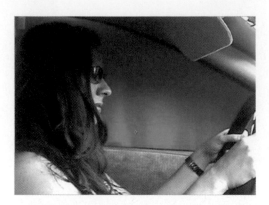

Step 1—Import our *drivingshot.dv* into After Effects and drag it to the new *composition* icon. Also import our *scrollingbg.psd* that we just created in Photoshop. Drag into the layer below our drivingshot and turn off the drivingshot layer's visibility.

Step 2—Set keyframes for *Position* and the beginning and end of the time line, dragging it to the far left-hand side for the beginning and to the far right at the end.

 Motion Blur is an effect that you can enable from the time line that creates the appearance of how a camera responds to movement. Remember those old cartoons when a character runs away so quickly that you see streaks stretching behind them? That's pretty much what **Motion Blur** will do. You will see it more distinctly when you have larger movements in shorter periods of time. Be careful, **Motion Blur** will significantly add to render time.

Step 3—Click the switch to *Enable Motion Blur* in your time line. Also enable *Motion Blur* for your scrollingbg layer.

Step 4—Apply *Effects > Blur and Sharpen > Directional Blur.* Put the *Direction* to 90 degrees. Set the *Blur Length* to 10.

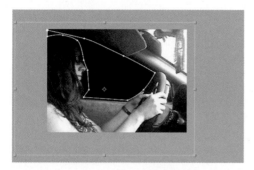

Step 5—Turn the visibility of the drivingshot layer back on and turn off the visibility of the scrollingbg layer. Create a *mask* cutting out the green areas of the window. The purpose of the mask here is to reduce the amount of green we have to key out to just the edges of the actress's head.

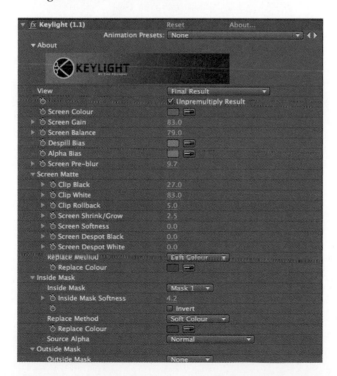

Step 6—Turn on the visibility of the scrollingbg and apply *Effects > Keying > Keylight* to the drivingshot. Switch the *View* to *Screen Matte* and adjust *Clip White* and *Clip Black* under *Screen Matte* until our masked area is as black as possible. Remember to pay the closest attention to the edges of the actress's face. Slowly increase the Screen preblur, switching back and forth between this view and the *Final Result* view.

Step 7—To cut out the part of the windshield that is in the frame, I used a second mask.

Done—Add *Effects > Color Correction > Hue/Saturation* and reduce the *Master Saturation* on the scrollingbg layer; also try adding *Effects > Color Correction > Photo Filter* with a blue filter. Windows has a graying effect, so this will help make it feel more realistic.

The Options

Step 1—Import our bgscroll.psd into Motion and add keyframes to move it from left to right, and add *Filters > Blur > Directional Blur* to amp up the appearance of driving by something.

Step 2—Import the drivingshot.mov and place it in a new layer *Group*. Create a *Mask* around the window and give it some feather.

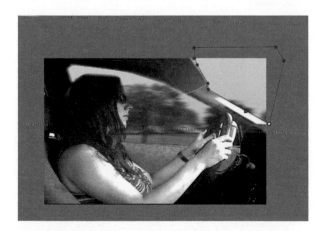

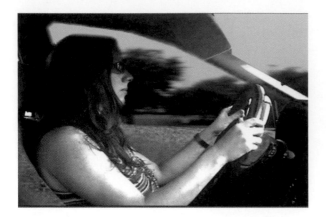

Step 3—Apply *Filters* > *Keying* > *Blue and Green Screen* to our shot and set it to *Green*. Adjust the *Tolerance* and *Color Level* until the green is cleanly removed. Add another *Mask* to take out the section of the windshield that remains.

Done—To complete this effect, add *Filters* > *Color Correction* > *Levels* and *Filters* > *Color Correction. Desaturate* to the Scrolling Background layer, this will create the darkening and graying effect on the windows.

Screen Replacement

Shot setups that include a television are a common problem. If the TV is on, due to interlace technology, the camera will distort the image and a black bar appears on the screen. Often, it's important to the plot to have something specific on the TV, and because of the problem of shooting televisions, visual effects artists will get the task of replacing the content on the TV and making it look realistic.

Ingredients

- A master shot that includes a television (tape for track points optional)
- Footage that will replace what's on TV

The Shoot

In this situation, we have to make a decision as to whether the shot should be locked-off or hand-held, because it makes a difference. If it's locked-off, just turn the TV off. In the next tutorial I'll address a situation like this with either a moving camera or moving TV in your shot.

The Design

Step 1—Create a new document in Photoshop, using the pre-set for DV NTSC 720 × 480, with *Background Contents* set to *Transparent*. Name it glasssurface.

Step 2—Make a *Rectangular Marquee* selection along the edge of the title safety guide.

Step 3—Create a black-and-white *Gradient* in the selection. Put the white part where the highlight would be on the TV screen and the black where the shadow would be.

Step 4—Use the *Bevel and Emboss* layer style to create a shallow depth. Set the style to *Inner Bevel* and *Technique* to *Smooth* and the *Gloss Contour* to *Ring – Double*. Adjust the *Depth* to be around 100.

Done—Set the *Transfer Mode* to *Screen*. Lower the *Opacity* to around 55%. Save the glasssurface.psd to your Photoshop folder. To make your life a little easier, merge the layers and save as glasssurfaceprep. That way if we want to change it later we can, because we will still have the glasssurface.psd file as well, having the advantage of the flattened version to keep our After Effects project simple.

The Effect

When you make elements like this glass surface, I highly recommend making a folder on your hard drive for elements like this glass surface, something that you will have many opportunities to use over and over again.

Step 1—Create a new project in After Effects, call it screenreplacement, and import the master shot, replacement footage, and glass-surface. Drag the master shot to the *composition* icon.

Step 2—Using the *Pen* tool, create a *mask* that goes along the inside edge of the TV screen. After you complete the mask, press MM on the keyboard to open all the mask tools, check *Inverted*, and make *Mask Feather* 3 pixels.

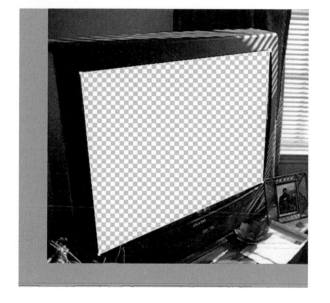

Step 3—Take the replacement footage and drag it to the *composition* icon. We are going to nest this new *composition* inside of the previous one, but first we must treat this footage. Create a new *solid* layer (*Layer > New > Solid*), make it white, and call it interlace. Add the glasssurface image on top of the other two layers, size it to fit our image, and set its *transfer mode* to *Screen*.

Step 4—On the interlace layer, add the *Venetian Blinds* effect by going to *Effect > Transitions > Venetian Blinds*. Set *Transition Complete* to 50%, the *Direction* to 90 degrees, and the *Width* to 4. On the time line, set the interlace layer's *transfer mode* to *Stencil Luma*.

Step 5—Go back to the *composition* and drag the *composition* called *Footage* into our *composition*. Put it on the layer below the master.mov shot layer.

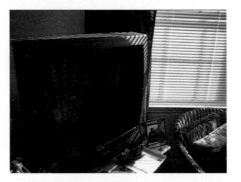

Step 6—Add the *Corner Pin* effect (*Effects > Distort > Corner Pin*) to this nested *footage composition*. Drag the corner points to the four edges of the TV screen.

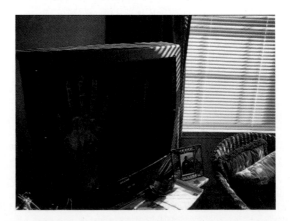

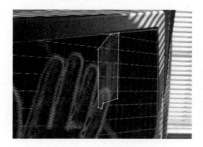

Done—We've got it now, duplicate the *Master* shot layer, open the *Mask Controls*, and check off *Inverted*. Set the layer's *transfer mode* to *Screen*. Now delete the existing mask and make a new one to cut out the reflection of the window, it'll add a nice touch or realism.

The Options

Step 1—Although we will get a better result in After Effects, creating a rough version of this same effect is not that difficult in Final Cut Pro. Start by using the same glass surface treatment used in the After Effects tutorial. Import the master shot, the replacement footage, and glass surface into Final Cut. Make a new Sequence and put the replacement shot in this *Sequence* and the glasssurfaceprep.psd on the track above it.

Step 2—Control click the glasssurfaceprep.psd layer and choose *Composite Mode > Screen*.

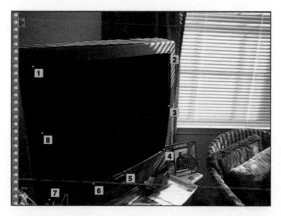

Step 3—Create another new *sequence* and drag our master shot to the V2 track. Apply *Effects > Filters > Video Filters > Matte > Eight Point Garbage Matte*. Go to the *Filters* tab and turn off *Inverted*. Drag the points around the TV's screen as shown earlier; note that points 4–7 are used along the bottom to match the curved edge of the TV's glass. Drag the TV footage sequence to the V1 track.

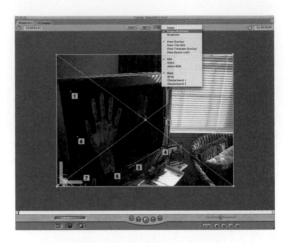

Step 4—Use the *Distort Tool* to move the edges of our TV footage sequence to match its shape to the TV. It's a big help to turn on *Image and Wireframe*.

Step 5—Just like we did in After Effects, duplicate the master shot and place it on the track above. In its *Filter* settings for *Eight Point Garbage Matte*, turn off *Inverted*. Let's use *Effects > Video Filters > Matte > Four Point Matte* and isolate the reflection shown above. Increase *Four Point Matte's Feather* to 30. Go to the *Motion* tab and drop its *Opacity* to 25.

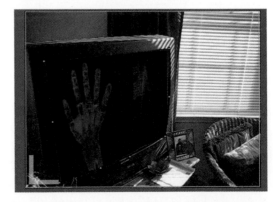

Done—Apply *Effects > Video Filters > Image Control > Desaturate* to the reflection and change its *Composite Mode* to *Overlay*. During an edit, it's more important to keep your workflow moving and perfect an effect later; this is a quick way to get a very acceptable screen replacement without closing Final Cut Pro.

PRO*files*

Photograph by Amy Bernard.

Roger White: Motion Graphics Designer

Roger White recently joined ABC creating animated graphics for Nightline and World News Tonight. He is a motion graphics designer and 3D computer artist who started his career as a traditional painter. Working on staff at NBC Rockefeller Center he created on-air graphics for Late Night and Saturday Night Live. He designed the Emmy Award nominated Late Show with David Letterman opening graphics, the Late Show logo, and the Ed Sullivan Theater marquee. His graphic design work is featured in the book *Exploring Motion Graphics*, published by Delmar Learning. His biography is listed in the 60th edition of Who's Who in America. He teaches special effects at New York University. Clients such as Newsweek, MTV, PBS, Court TV, and The New York Times have commissioned his illustrations. His broadcast design and illustration work can be seen at www.rogerwhite.com.

1. Describe your job or position in filmmaking and how you got there.

 I am a motion graphics designer at ABC television in New York, creating animated visual effects for Nightline and World News Tonight. At Parsons School of Design I earned an illustration degree and took classes in photography and animation. College gave me the ability to draw and compose a picture and that skill got me my first job as an illustrator for Late Night with David Letterman. In 1990 BC (before computers) I worked in traditional media with pencil, paint, and paper. My work was placed on a camera stand and recorded to tape.

 When computers walked in the door I updated my skills by taking Photoshop and Illustrator. The first logo I designed on a computer is the current Late Show with David Letterman logo featured on the Ed Sullivan Theatre Marquee.

 Learning 3D software gave me the ability to animate logos and create animatics for show opens. After Effects allowed me to throw in everything I learned so far and move it. Using its filter effects along with my artwork it taught me timing and how to give a project visual punch.

 Working as a freelance artist throughout my career I've been wealthy and poor, but the work on my reel got me my current job at ABC.

2. What was the one moment when you knew for certain that this was going to be your career?

 Seeing my artwork on national television sent a tingle down my spine and I knew I was in the right place.

3. What software (or equipment, whichever is more applicable) do you use?

 I use the Adobe Production Suite and Maya. For editing at ABC we use Velocity and Viz RT for real-time 3D animation without rendering.

4. What movie do you wish you worked on? In what capacity?

 Finding Nemo. I would love to work at Pixar as an animation compositor. That will require a few classes in Shake and Nuke.

5. Is there a shot technique used in that movie that really made an impression on you?

 I was most impressed by the studies created by the visual artist. Hundreds of drawings were created to capture the color and essence of ocean life. Check out the particles that float by in the CG water. They are mind-blowing.

6. Where do your ideas come from? What inspires you?

 Oh I just steal ideas. Whenever I see a strong image in a magazine I rip it out and put it in my idea folder. I make sketches of visual effects used in movies. Whenever I'm stuck on a new project, I thumb through the folder and borrow from everyone.

7. Share a visual effects technique that you use with our readers. Tell us why you like it so much. This can be anything from something that you do in a visual effects software package, editing software package, on something on the set, in camera, anything you'd like to share with the readers.

I try to mimic real-world camera techniques using a virtual camera. When animating in After Effects or Maya, I try to mimic camera effects such as distance blur and foreground blur. Shaking a camera to indicate heavy steps or dropping objects can be very effective.

8. Is there a resource that you use, like a book, magazine, or Web site, to get ideas for techniques?

My new-found resource for idea techniques is Google Images and YouTube. I used to walk to the library and spend hours looking at books and tapes for inspiration. Now I just type in a few keywords and the Web brings up great photos, illustrations, and video. I've gotten great concept ideas for a project by looking at how other artists handle a similar subject.

9. If you were going to give our readers a homework assignment, what would it be?

My homework assignment would be to make a reel. A good reel is not just a bunch of clips thrown together. It should be the best movie you have ever made. Use creative editing and audio to combine images, effects, and video into a short film. This reel will get you your next job. Put it online and send the link to everyone you know.

10. Do you have any career advice for up-and-coming filmmakers?

New filmmakers should learn writing, graphic design, and storyboarding. I see so many good effects in films that have no storyline. Make sure that you have a great story before you begin any project. Storyboard camera angles, graphics, and effects so that the cast and crew are on the same page. Allow yourself time to learn all aspects of the business.

6

LOCATION, LOCATION, LOCATION

In **Casablanca**, Casablanca itself is often cited as being a "character" in the film. In a sense, the mood, color, and energy of this Moroccan city make the movie. It defines the characters and the situation.

However, the movie was not shot *in* Casablanca. It was largely shot in a Hollywood studio, except for the final act in the hanger, which was shot nearby in Van Nuys. So the filmmakers relied on their ability to use sets, music, lighting, and cinematography to make the audience feel as if they were in this world.

Back in the early 1940s, Casablanca's budget, being just over a million dollars, wouldn't allow for a film crew to take a trip to North Africa (also, there was the little problem of World War II as well).

In more recent films and TV shows, visual effects artists constantly use software to create scene-setting shots. It happens so often now that it becomes difficult to spot every background extended shot.

With many of today's effects-driven and fantasy-oriented fare out there, the problem of getting to location is not so daunting. The real issue is the need for locations that don't exist, which is of course where the visual effects team comes in on the project.

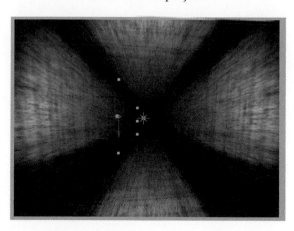

Creating a 3D Room

In most cases, this would be saved for 3D artists, but this is a great introduction in building locations in three dimensions. I'm going to take you through building a dark and grimy 3D tunnel.

Ingredients

- Close-up photos of the materials that you would use to build our 3D room.

The Design

Step 1—Open the ground texture image in Photoshop and apply *Image > Adjust > Auto Levels*.

Step 2—Use the *Burn* and *Blur* tools to darken and blur the edges of the image.

Done—Duplicate the layer three times so that you have four total. Name them "floor," "ceiling," "right wall," and "left wall." Save this file as room.psd.

The Effect

Step 1—Import our room.psd document into After Effects. Select all four layers. Flip on the 3D switch. Unlock the scale and make the "Y" scale 900, "X" scale 50, and leave "Z" at 100. Relock the scale. Make sure that each layer is scaled and has the 3D switch on.

Step 2—To give you a mental image of what we are about to do, let's say you are making a cube from four square pieces of cardboard— you have to put the floor down, you have to balance the side walls so that they stand vertically, and then put the ceiling on top. That's kind of like what we are doing here, except that After Effects thankfully has no gravity. Open the *Rotation* tool for the layers "left wall" and "right wall" and set the *Y Rotation* to 90 degrees. This will turn them so that they are in the right position. Open the *Rotation* tool for the layers "floor" and "ceiling" and set the X axis to 90 degrees. You should end up with your screen looking like mine; the bounding boxes should be in a sort of cross shape.

Step 3—Click and drag the "floor" layer to the bottom of the *composition*. Click and drag the "ceiling" layer to the top of the *composition*. Drag the left and right walls to the appropriate sides.

Step 4—Switch to the *Top* camera view, and create a *Light* layer set to *Spot*. Position it at the front of the room. Adjust the *Intensity* and *Cone Angle* however you like. Make a new *Camera* layer and position it at the front of the room as well, and change and move it around until you've got it where you want it.

Done—Set keyframes for the camera's *Position*. To have it fly through the dark tunnel, adjust the *Z Position* from −2000 at the beginning of the time line to −800 at the end. Have the light follow. Turn on *Motion Blur* and give our little fly-through some velocity.

The Options

Step 1—In Motion, open up our room.psd. Bring our room.psd to a new *Group* and go to *Object > 3D Group*. Change the *Scale* so that *Y* is 900, *X* is 50, and leave *Z* at 100.

Step 2—Open the *Rotation* tool and set "left wall" and "right wall" to have a *Y Rotation* of 90 degrees and a *Z Rotation* of 90. This will turn them so that they are in the right position. Open the *Rotation* tool for the layers "floor" and "ceiling" and set the *X* axis to 90 degrees. Drag them to the place on the screen where they should go—the "ceiling" should be dragged to the top of the screen and the other three accordingly.

Step 3—Create a new *Camera*. Switch to the *Top* view. Add a keyframe for *Position*. At the beginning of the time line set the camera's *Position* on the Z axis to be 3000 and at the end of the time line to be −3000. You'll love the smoothness with which Motion's camera operates and the little pop-up view window in the lower right-hand corner.

Done—Add a new *Light* and set it to *Spot*. Adjust the *Intensity* and *Falloff* to your taste. I intentionally went much darker than the After Effects version of this tutorial, just for the sake of experimentation. Set a keyframe for *Position* on the Z axis and have it follow the same basic course as the camera, starting at 3000 and going to −3000.

Scene Extensions

With the need for creating a scene for a fantasy film that is convincing and realistic, visual effects artists often use a technique called background, scene, or set extensions. The idea is as follows: set up a shot in a location that sort of looks like it is along the same lines as what you need and use software to marry the shots.

Ingredients

- A master shot containing the landscape that we will manipulate
- A shot containing a building or structure that we will use to alter our landscape
- A shot containing other elements that we can use to fill out our landscape

The Shoot

For a shoot like this, good planning is essential. In fact, this is the kind of shoot that is ideal for bringing representation from the VFX team. The framing of the master shot is key. I want to take elements of some shots of a field near my place in Texas, ruins I shot in Sicily, and go for an ancient fantasy-type scenario.

For the example I am going use, it requires a field and something that resembles an ancient structure in a landscape. Therefore, we need a hill we can work with, a foreground with a nice amount of room for our field, and no structures that will get in our way too much.

The Design

Step 1—Open cliff.psd in Photoshop. Let's begin by preparing our replacement elements.

Step 2—Use the clone tools (*Clone Stamp*, *Healing Brush*, *Spot Healing Brush*, and *Patch Tools*) to remove anything in the shot that might date it to the modern era. In this image there probably won't be much to address, but if there was this would be the time to take care of it.

Step 3—Open the *temple.psd* shot in Photoshop and cut it out from the background. Use the *Rectangular Marquee* to select the temple and the jungle and drag it into our scene.

Step 4—Switching back and forth between the *Move* and the *Eraser* tools, blend the temple into the jungle. When you like the size and blend of the temple, use *Image > Adjustments > Levels* to darken the layer to match the rest of the *composition*. In order to blend it in well to the jungle, you may have to copy and paste patches of the trees over parts of the temple in order to cover up areas.

Step 5—Open the ruined_tower.psd and cut it out from its background. Drag and drop it into our scene.

Done—Blend the tower in using the *Eraser* tool. Use *Image > Adjustments > Color Balance* and make the castle slightly greener. Now we are ready to go back to After Effects. To keep things simple, I removed the sky from the image because we want that to be moving. You can merge the layers and save this file as replacement_elements.psd.

The Effect

Step 1—Import the replacement_elements.psd scene we just made in Photoshop, grassy_field.mov, and replacementsky .psd into After Effects, composite them, and apply a standard color treatment for this genre of film.

Step 2—Drag the *grassy_field.mov* to the new *composition* icon and then drag in our *replacement_elements.psd* below it. Create a mask; see the tip before you do the mask around the edge of the *grassy_field.mov*, allowing our new background to come through. Place the *replacementsky.psd* below the *replacement_elements. psd* and apply a *Position* animation.

Before you mask out the background, **Motion Track** a point on the grass that we can later use for the Position of our background matte painting, as this shot is hand-held and moving.

Step 3—To make a vignette, make a new solid layer, black, and add an oval mask to it. Hit MM on the keyboard to bring up all the mask properties, check the box for *Inverted*, and set the *Feather* to 60 pixels. Hit T on the keyboard for *Opacity* and set it to around 40%. Set the layer's blend mode to *Multiply*.

Step 4—For a Lord of the Rings-style color treatment, make a new *Adjustment* layer and apply *Effect > Color Correction > CC Toner*. This will vary according to how your shot looks, but I set my highlights to a bright blue/cyan, midtones to a green/yellow, and shadows to a dark brown.

Step 5—To complete the color treatment, I add another Adjustment layer and apply *Effect > Color Correction > Hue/Saturation*. Increase the *Master Saturation* while decreasing the *Lightness*.

Done—One optional final step—add an Adjustment layer (yes, another one) and use *Effect > Noise and Grain > Noise*, turn off color noise, and set it to around 30%. Next apply *Effect > Blur and Sharpen > Directional Blur*, turn it to 90 degrees, and set the Blur Length to around 6. Set the layer's transfer mode to *Overlay*. Lower the *Opacity* to 20%. It's a nice subtle texture effect.

Use an expression to connect the matte painting we made to motion tracking data on the grassy_field footage.

There you have it now, a dumpy field in Austin has now become an ancient ruins-filled fantasy background.

The Options

Step 1—Open Final Cut Pro and place our grassy_field. mov, replacement_elements.psd from Photoshop in a new *Sequence*, import our replacementsky.psd, and place it below our replacement_elements.psd element. Use *Filters > Video Filters > Matte > Eight Point Garbage Matte*. Add a *Position* animation to the replacementsky.psd layer.

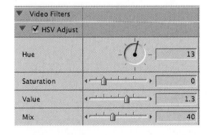

Step 2—Nest this sequence inside of another. Apply the *Filters > Video Filters > Image Control > HSV Adjust*, setting the *Hue* to 13 will create a warm yellow, increase the *Value*, and lower the *Mix*.

Step 3—To add the *Vignette*, use the generators button in the Viewer and choose *Matte > Color Solid* and change it to black.

Open the color solid in the viewer and apply *Filters > Video Filters > Matte > Mask Shape* and choose *Oval*. Size it so that it appears like the example in the figure. Then apply *Filters > Video Filters > Matte > Mask Feather* and increase the *Feather* to about 66. Lower the *Opacity* of the color solid layer to about 70%.

Done—Open our embedded sequence in the Viewer and apply *Filters > Video Filters > Stylize > Add Noise*. Switch the *Type* to *Guassian Noise*, check off *Monochrome*, and lower the *Amount* of noise to .06. Add in *Filters > Video Filters > Blur > Directional Blur* and give it a low *Amount* at 3. Then greatly reduce the *Mix* to about 18. To get it a little closer to how we did our After Effects version, you may want to add *Levels* to darken the whole shot.

My Evil Twin

This effect is very quick and will make you love tripods. Let's say you need two of the same actor in one frame. Here's how you can combine two locked-off shots into one seamlessly.

Ingredients

- Two shots of the same actor, without a change of frame.

The Shoot

Most of the success of this kind of shot depends on how well you set up the shoot. For the first step, set up the camera and frame it so that there is the right space for two actors; if you can, use a stand in one while you frame. Now, do as many takes as you need with the actor in the first costume and then have the actor change. Follow that with a second shot of the actor in a different costume, should that be necessary. If you have any major changes within the frame you should start again, as we need consistency between the two shots.

Even though I did these back to back in under 10 minutes, you can see that the lighting changed. Luckily we can fix this in After Effects.

The Effect

Step 1—Import the two shots into After Effects and create a new *composition*. Place the two shots directly above each other and trim them so that they are the exact same duration.

Step 2—Draw a *Rectangular Mask* on the top layer. You should already see the effect working.

Step 3—Now we have to fix the light shift, as you can see even a subtle change can ruin the effect. On the man#1 layer, apply *Effect > Color Correction > Levels*.

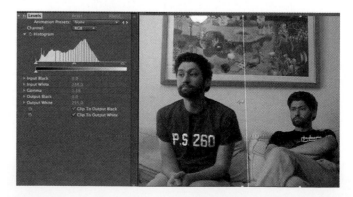

Done—With some tweaking you should get a seamless match. If you want to have some fun with this, try adding a transition effect on the man#1 layer and watch him "appear." Also try setting up a shot with three, four, or more instances of the same actor.

The Options

Because this effect is so easy there's no reason not to do it in your editing program; here's how to do it in Final Cut Pro.

Step 1—Similar to how we did this in After Effects, import the two shots, place one above the other in the time line, and trim the shots so that they are the same length.

Step 2—Go to *Effects > Matte > Four Point Garbage Matte* and apply it to the man#1 video layer.

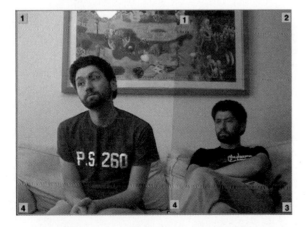

Step 3—Drag points 1 and 4 so that they cut the screen in half. Add some *Feather* to the edge.

Done—Add *Effect > Image Control > Levels* and adjust the *Gamma* until the two shots match.

Cityscape Fly-Through Animation

Most animation and compositing software offer the user *virtual cameras*. These cameras allow the VFX artist to animate the camera movement in ways that you could never move a real camera. A great example of a use for virtual cameras is to create a landscape from still photos and animate a *fly-through*.

Ingredients

- Still photos of buildings
- Still photo of asphalt for road texture
- Still photo of concrete for sidewalk texture
- Still photo of the sky for background

The Shoot

Grab your digital still camera and hit the city streets. Please note, some buildings are actually copyrighted so you will need permission in order to use a photo of the building, even if it's a photo you've taken.

The Design

Sidewalk Texture

Step 1—Open the concretetexture.psd file and make a small selection with *Rectangular Marquee*.

Step 2—Make a new document with the custom settings of width 1000 pixels, height of 2000, 72 ppi, RGB, and a transparent background. We don't use the video preset in this case because it will be larger than our video screen size.

The **Pattern Maker** effect is not included in version CS4. However you can download it from Adobe's website, or if have your install discs, check the Goodies folder for Optional Plug-Ins

Step 3—Drag the selection from the concretetexture.psd document to the new black document and open *Filter > Pattern Maker*.

Done—Inside Pattern Maker, make a marquee selection of our little concrete swatch and click Generate. If you are unhappy with the result, change the tiling offset options and Smoothness detail and click Generate again. When you are happy with the result, click OK. Save the file.

Buildings

Users who have updated their Photoshop and After Effects to the CS4 versions are in luck here. This tutorial is much easier with the new 3D features both programs are now sporting. After I go through the CS4 version, I have also included the pre-CS4 version for those who have not yet updated or want to use a different animation program other than After Effects CS4.

Step 1—Think of creating a building like creating a box—what do you need? You will need a 3D cube left and right sides, top and bottom sides, and a floor and ceiling. Luckily, we don't have to create too much since four of those six sides can look similar or exactly the same. Create a new Photoshop document with DV preset. Go to *3D > New Shape From Layer > Cube,* which will create a new 3-D Cube.

Step 2—Now use the *3D Scale* tool (hold down the shift key to *unlock* the aspect ratio) to compress the building from a perfect cube to a more rectangular shape. Save this file as *3D Building.psd.*

Step 3—Open the file building.psd. I have set up a building for you to use in this case. Take the *building face* layer and drag it into our new *3D Building* document. Line it up over the face of the cube. When lining up the building face to the cube, use *Edit > Transform > Distort* to make it match and then go to the *Layer Palette Options* and hit *Merge Down*.

Done—Bring in more instances the *building face*, and use the *3D Rotate* tool to turn the building to its other sides, and hit Merge Down to combine the texture to each side of the building. For the top and bottom of the building, I just changed the color in the *3D Scene* palette, under *Diffuse*. When you have finished, hit save.

CS3 Version

Step 1—Open the building.psd image. Duplicate the *building face* layer.

Done—To make the left and right sides of the building, make a rectangular marquee around one of the sections of the building and copy/paste it to its own layer. Do this twice: one for the left and one for the right. For this example we will create the roof and ceiling in After Effects, so you can save this file. Repeat this process as many times as you want to get a variety of buildings.

Streets

Step 1—Create a new document in Photoshop, 500 pixels wide by 2000 pixels high. Open your asphalt texture, drag it into our new document, and use *Pattern Maker* to fill the new document.

Step 2—Use the *Shape Tool* set to rectangle to make the white lines. Use Control-Click on the layer and choose *Rasterize*.

Step 3—Use the *Blur* tool to soften the edges of the line. Use the *Eraser* tool with an Opacity set to 24%, using one of the Chalk brushes on the line to give it a variety of bumpy textures.

Done—Repeat the line about two more times and distribute them evenly down the road. To make the lines on the sides of the road, duplicate the line twice again and drag it to the edges of the road. Use *Edit > Transform > Scale* to stretch it along the full edges of the street. There's no need to maintain the layers for this element so flatten the document when you are done.

The Effect

If you are like me, you get really excited about having made cool elements and you can't wait to get them into After Effects to start getting them moving. You may not be as excitable as I am, but you can admit it, you are having a blast. Import the street and sidewalk as footage. Import your buildings as *Composition Cropped Layers*.

3D Buildings CS4 Version

Step 1—Import the building.psd we made as *Composition Cropped Layers* into After Effects CS4. Now, AE will ask you to decide whether or not you want to leave Photoshop's *Layer Styles* editable, and if you want it to be a *Live Photoshop 3D* layer. Turn on *Merge Layer Styles into Layers*, and make sure that *Live Photoshop 3D* is checked.

Importing into After Effects can be a somewhat complicated scenario; first you have to deal with import types.

Footage—This setting is best used for flat images, video files, audio files, or single layers from a multilayered document.

Composition—Creates a composition for the file you are importing based on the settings that the document has, so, for example, when you pick a preset size in Photoshop for Digital Video it will translate that sizing to the Composition Settings. Each layer will be placed in the composition as a separate clip. The *Anchor Points* for each layer will be set to the center of the screen, and each layer's size will be set for the size of the composition. In most cases I use Composition Cropped Layers unless I want to apply effects such as *Shatter*, which would need the full layer size (to avoid cropping the effect), or if I am doing something that requires every layer to rotate around the center point.

Composition Cropped Layers— Same as composition except that it will automatically assign the **Anchor Points** to the center of each *layer*. The layer sizes are cropped down to just include the visible pixels for that layer.

Project—Imports all the elements from another After Effects project. Therefore, you can only use this setting with .aep files.

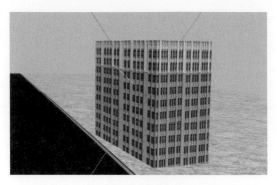

Done—Drag and drop the *composition* that AE made of your 3D building into the time line. *Scale* your building how you want it, and place it. You don't have to turn AE's 3D layer; if you want to make changes, simply double click the pre-comp to open it, and control it from the null layer named *Controller*. Inside the pre-comp, all the 3D controls will stem to the controller layer; outside the pre-comp, you will have the standard 2D options.

3D Buildings CS3 Version

Step 1—Open your building *composition* and turn on the switches for 3D layers. Create two solid layers at 1325 × 200 and turn on their 3D switches. Name one "floor" and the other "roof."

Step 2—Now that we have enabled the third dimension, open the *Rotation* settings for the layers roof, floor, left, and right. On roof and floor set their *X Rotations* to 90 degrees. On left and right, set their *Y Rotations* to 90 degrees.

Step 3—Switch from the *Active* camera to the *Top* camera. Move the left and right layers to the corresponding sides of the solid roof or floor layers. Then move the front and back layers to their corresponding positions. You should see a box shaped like the one in the preceding figure.

Step 4—If you are not pulling your hair out yet, that's good but we are not out of the woods. Switch to the *Top* camera where you'll notice that your roof and floor are stuck somewhere in the middle; we placed them correctly horizontally and on the Z axis, but we have not correctly placed them vertically. Move the roof and floor to their appropriate places. If you are new to After Effects' 3D controls, take a couple of minutes to check the various camera angles in order to make sure that things are lined up correctly.

Step 5—Go to *Layer > New > Null* and flip on the Null Object's 3D switch. Position the Null layer to be in the middle of the building.

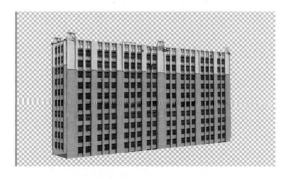

Done—Switch to the *Rotation* tool and, I mean this literally, take your building for a spin.

Completing the Scene

Step 1—Create a new *composition* that's the same size as our sidewalk; it's huge, I know, but we are going to change this later. This is only temporary until we set up our scene as a whole; when we start keyframing, we'll bring it down to the output size. Drag in your street and sidewalk layers.

Step 2—*Parent* the street layer to the sidewalk layer and turn on the 3D switches.

Step 3—Nest your building *composition* in our new *composition*. Make sure that you turn its 3D switch and its Continuous Rasterization Switch and it will function as one 3D object.

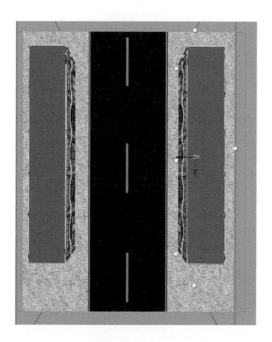

Step 4—Position your buildings along the street, and switch to the left or right camera views to make sure that your buildings are sitting on the ground, as opposed to through the ground.

Step 5—Go to *Layer > New > Camera*; you can use the default settings for now. Also, now is a good time to change the *composition* settings to the matching output settings.

Done—The camera has settings for *Point of Interest* and *Position* so adjust these until the camera is facing the way you'd like it to. Then set keyframes for the camera's Z position or any of its operators and bring the scene to life. Add in more elements to improve the overall realism—more buildings, people, cars, traffic lights, etc.

The Options

Step 1—In Motion, import the sky, street, and sidewalk elements and place them on the screen where you'd like them. Remember that the group they are in should be converted to a *3D Group*. Create a new *Camera*.

Step 2—Import our building.psd image, place in a new group, and convert to a 3D object. Since groups are like Pre-Compositions, don't worry about Layer Parenting issues. Use the *Rotation* tools to get our building in the correct perspective, with each wall having its *Rotation* set like it was done in the After Effects tutorial. The left and right walls should be at a 90 degree rotation on the Y axis, and the front and back should be rotated to 90 degrees on the X axis.

Done—Import the skyline element and set back in space along the horizon line. Add in any other buildings you'd like to add to the scene, the more the merrier. Add *Filters > Blur > Zoom Blur* to some of the background elements to increase the illusion of space.

PRO*files*

Colin Stackpole: VFX Artist

Colin Stackpole is a senior visual effects artist who's worked in New York City for over a decade on various high-end commercials, television, and film projects. He has mastered the complex Autodesk Flame and Inferno systems. Colin's style matches his love for creative effects and having met the slickness of the world of contemporary advertising.

1. Describe your job or position in filmmaking and how you got there.

 I work in the digital special effects side of postproduction as a senior visual effects supervisor on set and as a lead Inferno artist at a VFX company in New York City.

 I actually fell into this career, so to speak. A friend of mine would visit me while I was living in Hawaii and I would take time off surfing. He saw my art and drawings and thought that I would be good at his profession, which was digital effects. At the time he worked for Discreet Logic, now owned by Autodesk, as one of their demo artists. I came to New York with him as a Flame assistant and landed a job within a week of being here. That was 12 years ago and I'm still planning my escape from New York! Within 2 years I was a lead artist on Discreet Logic Software! Within 6 years I was running my own company.

2. What was the one moment when you knew for certain that this was going to be your career?

 I knew this was going to be my career about a month after I was hired in New York. I loved working in postproduction and I found that I was able to grasp the software very quickly. I love the problem-solving aspects of my job. No one really writes a book on how to create the effects clients ask for. It's up to you to use your tools to create the director's or agency's vision and there is a multitude of ways to create that effect. Doing it efficiently and cleanly is paramount.

3. What software (or equipment, whichever is more applicable) do you use?

 I work exclusively on Autodesk's Inferno and Flame packages.

4. What movie do you wish you worked on? In what capacity?

 I wish I had worked on the **Lord of the Rings** trilogy. I actually sent my reel down to New Zealand and they were interested but regrettably I never committed myself to getting to Weta since my prospects in New York City at the time were incredible.

5. Is there a shot technique used in that movie that really made an impression on you?

 In the **Lord of the Rings** films I was very impressed with the motion control work that was used when filming the miniatures and how the compositors created amazing cityscapes and vistas using a multitude of passes for a single shot. The shots were intricately planned so there was no room for error. Brilliant work!

6. Where do your ideas come from? What inspires you?

 I get a lot of my ideas from having discussions with other artists. I'm a big fan of a free exchange of ideas and techniques. If I can learn something new everyday then I feel I'm doing my job well. I can learn from the masters as well as the night crew guy. You never know who will give you a nugget to help make your job go a little smoother.

7. Share a visual effects technique that you use with our readers. Tell us why you like it so much. This can be anything from something that you do in a visual effects software package, editing software package, on something on the set, in camera, anything you'd like to share with the readers.

 One thing I can offer up to those intending to journey into VFX is to study the shot they're working on. Notice the grain pattern, the lighting, the color…. You can create the greatest effect on earth but if it doesn't match up to what is originally in the shot then the viewer will be taken out of the reality you are hoping to create and everything looks fake. It's amazing what grain and camera weave do to give life and that filmic look. Contrast and color are key as well. Make sure that your blacks match. America

loves to turn up the brightness on their TVs, which can make flaws pop like mad.

8. Is there a resource that you use, like a book, magazine, or Web site, to get ideas for techniques?

 For resources I read Cinefex magazine, although they explain a lot less about how to do things as to just reporting on what a postproduction house did. I also log on to FXGuide.com. They have excellent tips and tutorials for a multitude of software packages, including Flame and Smoke. Autodesk is also a great resource for Inferno-related tips.

9. If you were going to give our readers a homework assignment, what would it be?

 If I were to give the readers a homework assignment I would say… READ YOUR MANUALS FROM COVER TO COVER! And always have it handy.

10. Do you have any career advice for up-and-coming filmmakers?

 Some words of advice to up-and-coming filmmakers would be to ignore the competition. Concentrate on what you have going on and make it your own. Thinking about what the next guy is doing takes you away from what you need to be doing. Also, work hard! There is no substitute for this! A few years of putting in the dues can lead to a lifetime of rewards!

7

DIGITALLY PROCESSING YOUR FOOTAGE

Many trailblazing directors have tried to offset process their footage with sometimes great or catastrophic results. Luckily, digital processing allows for experimentation at only the cost of time (instead of the actual footage).

Folks with needs in this area have been satisfied by the ability to cook their footage digitally.

On the other end, many digital alchemists have been trying to do the impossible—magically turn DV into film. Visual effects software may not be able to turn video into film but there are a wide range of options and techniques available for using software to improve the quality of your footage, giving it a custom and surprisingly film-like look.

Basic Color Correction

Color correction can mean a number of things, but generally what we are looking at is technically referred to as color grading. The following tutorial looks at a piece of footage and balances it.

 The After Effects Professional Bundle comes with Synthetic Aperture's Color Finesse Plug-in, which is a totally professional high-end color correction tool. Apple's Final Cut Studio comes with the application, Color bundled, which is another alternative, but to this very basic three point color correct, Final Cut itself will do the job.

Ingredients

- The shoot we will color correct

The Effect

After Effects does not currently come with a packaged vectorscope and waveform monitor. You can get third-party plug-ins to assist you in this, but I wanted to avoid third-party plug-ins as much as possible. In this case I will do this section in Final Cut Pro (Adobe's Premiere also has a vectorscope and waveform).

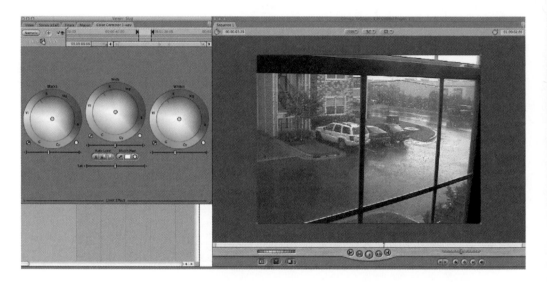

Step 1—Put your clip into the time line and apply *Effects > Video Filters > Color Correction > 3-Way Color Correction* and click the *Visual* button. Go to *Window > Arrange > Color Correction* for a preset workspace designed for color correction. Turn on *Show Excess Luma.*

Step 2—First we should adjust our black level. Using the eyedropper in the *Blacks* section of the *3-Way Color Correction* dialog, set the *Black* point. The *Waveform* monitor is used to judge levels of light and dark. Then use the arrow keys to adjust levels so that the lowest black level is sitting on the black line at the bottom of the waveform.

Step 3—Our next step is to correct any problems with white balance. Take the eyedropper from the *Whites* section and click on a spot of the frame that contains something that should be white. If your shot was white balanced properly, then you should not see any difference; if it was not then you should see a nice substantial change. Keep an eye on the icon at the top of the screen; when you have a green check, you've got a balanced image.

Step 4—Let us turn our attention to the actual colors now; the *Vectorscope* is designed for helping us figure out our colors. In this situation, our colors are well within the safe levels for our image. A little too safe, as the image could really use some saturation. Our goal is to get the spikes of the graph out without exceeding the boxed color areas on the graph. At the bottom of the *3-Way Color Correction* dialog there's a slider for *Saturation*, turn it up. It doesn't have to be extremely high, but it could be higher than it is.

Done—Now that our image is nicely exposed and color balanced, use *RGB Balance* to adjust the levels of each color in the image. Watch the *RBG Parade* window to see how the changes being made are affecting the image. This tutorial is just a quick intro to color correction; you could spend a great deal of time tweaking and fine-tuning your colors.

Color Treatments

In the old days, your DP would often have to use filters to create color treatments on your footage or engage in some kind of processing of the final negative. While this is cool, if the director decided later that it was not what he wanted, it would be a little too late. On the digital end, we can hot swap filter treatments, experiment, and decide in a nondestructive way.

Ingredients

- The shoot you'd like to treat

The Shoot

Light and shoot your footage as you would normally; we'd like a nice shot, just in case our treatment doesn't work out.

The Effect

Step 1—Import the shot into After Effects and create a new *composition*.

Step 2—Apply *Effects > Color Correct > Hue/Saturation* and reduce *Master Saturation* until the image is almost black and white.

Step 3—Create a new *Solid* layer; for this example, we'll do a blood-red wash, do pick a very strong red. Set the layer's *transfer mode* to *Multiply*.

Done—To deepen the red, duplicate the *Red Solid*; because it's on *Multiply*, it'll multiply it with red again. Try experimenting with other transfer modes.

For wild color treatments, delete the two red solids and apply *Effects > Color Correct > Colorama* to your solid layer.

The Options

This effect can also be done in your editing software.

Step 1—Import the footage into Final Cut Pro and apply *Effects > Video Filters > Image Control > Desaturate.*

Step 2—In the Viewer, choose *Matte > Color Solid* from the *Generators* menu. You'll see a color solid in the Viewer window, choose the *Controls* tab and set the color in the color picker.

Done—Control-Click the solid layer and go to its *Composite Mode* and choose *Multiply*. Just as in After Effects, you can experiment with various colors and composite modes.

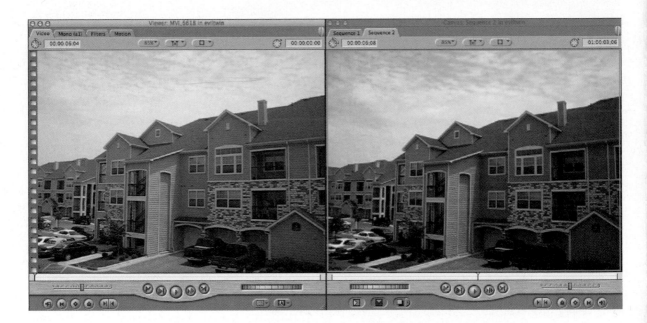

Film Looks

There are plenty of expensive third-party plug-ins that do some lovely work. I'm going to take you through the "basic" recipe for a digital film look using common bundled effects.

Ingredients

- The shot you'd like to use for the film look
- If this is something you'd like to try on a long project that is being edited, edit the piece first and then apply the effect only to the final piece rather than all the dailies. Otherwise, you'll be rendering for a year.

The Shoot

On the shoot, do the best job that you can of lighting it correctly and exposing it well, keeping in mind that should, for some reason, the effected video not work out, you want a nice looking shot that's usable. The better the source material, the more options we'll have with our film look.

The Effect

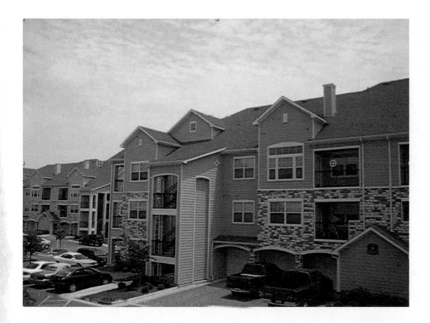

Step 1—This is a variation of the classic After Effects Film-Look recipe I learned in my very first class in the software. Import your shot; the one I am using here is pretty unimpressive.

Step 2—Duplicate the shot and eyeball off the top layer.

Step 3—Highlight the bottom layer, apply *Effect > Color Correction > Hue/Saturation*, and reduce the *Master Saturation* to –100. The shot should now be black and white. If not, you probably highlighted the wrong layer. If the shot is extremely gray, apply *Effect > Color Correction > Levels* and adjust the shadows, midtones, and highlights to increase the level of contrast.

Step 4—Turn on the eyeball for the top layer. Wow! Just kidding. We did not do anything to the top layer so we should not see any effect at all. Here's where it gets cool. Change the top layer's transfer mode to *Multiply*. Already the darker shot looks richer, although right now it's too dark.

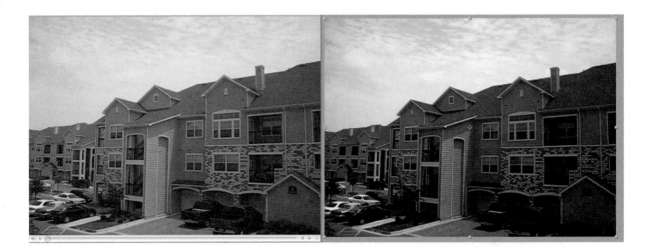

Done—Duplicate the top layer and change its *transfer mode* to *Color*. Cut the *Opacity* of the middle layer (the one set to Multiply) to around 65% (this number will vary shot to shot). If the shot's still too dark, adjust the *Brightness* on the bottom black and white layer. To make the colors pop even more, add *Hue/Saturation* to the top *Color* layer and increase its *Master Saturation* to 25. In the before and after shots shown earlier, you can see a huge difference when the film look is applied. You can use this recipe as a template and try your own variations.

The Options

Although it doesn't have as many options, Final Cut Pro can do the same trick.

Step 1—Import the shot into Final Cut Pro, duplicate the shot and move one to the track above, and turn off its visibility.

Brightness and Contrast (Bezier)
Color Balance
Color Reduce
Desaturate
Gamma
Gamma Correction
Gradient Colorize
HSV Adjust
Levels
Proc Amp
Reduce Banding
Sepia
Threshold
Tint
YIQ Adjust
YUV Adjust

Step 2—*Apply Effects > Video Filters > Image Control > Desaturate* and *Effects > Video Filters > Image Control > Levels,* turning the *Contrast* up to 20.

Open 'MVI_6618'
Open in Editor
Open Copy in Editor...
Reveal in Finder
Duration (00:00:06:08)...
Make Independent Clip
Item Properties ▶
Send To ▶

Cut
Copy
Paste
Paste Attributes...
Remove Attributes...
Ripple Delete

✓ Clip Enable
Speed...
Composite Mode ▶
Dupe Frames ▶

Uncollapse Multiclip(s)

Reconnect Media...
Media Manager...
Capture...

Normal
Add
Subtract
Difference
✓ Multiply
Screen
Overlay
Hard Light
Soft Light
Darken
Lighten
Travel Matte – Alpha
Travel Matte – Luma

Step 3—Turn the visibility of the top layer back on. Control-Click the top layer and choose *Composite Mode > Multiply.*

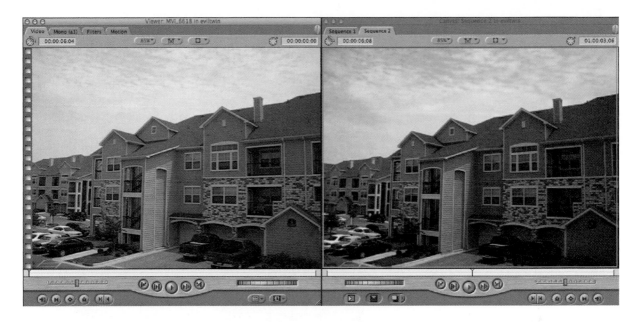

Done—Lower the *Opacity* of the *Multiply* layer to about 60%, dupli-
cate the *Multiply* layer, and move it to the track above (you should
have three tracks now). Change the top layer's composite mode to
Normal and apply *Effects > Video Filters > Image Control > HSV
Levels*. Increase the *Saturation*. Not bad for not having to leave your
editing software.

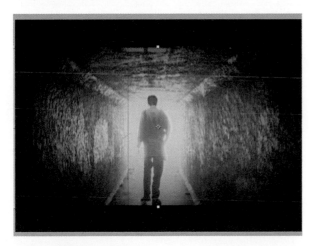

Damaged Film Looks

Compact discs have clarified the sound quality of music to such an
extent that not much later than its acceptance as the mainstream for-
mat for music there was a movement of folks longing for the cracks and
buzzes of vinyl. The world of film has had a similar sway in tastes; as we
get more and more digitally precise, people miss the vignettes, noise, and
dust of the movies of old.

Ingredients

- The shot you plan to use for your classic film treatment

The Effect

Vignettes

Step 1—Import your footage and create a new black *Solid* layer.

Step 2—On the *Solid* layer, create an *Elliptical Mask* and check *Invert*. Adjust the *Mask* according to how much of your shot you want your vignette over.

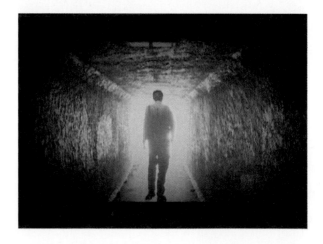

Done—Open up *Mask Feather* and increase the feather size to around 150 pixels or more depending on the size of the shot. Switch the transfer mode of the shot to *Multiply*. Now you have your vignette.

Dust and Scratches

Step 1—Adding dust and scratches to footage usually involves some time spent with some of After Effects' more difficult parameters; however, here's an easy, handy technique to try out. Make a new *composition* in After Effects and add a black *Solid* and *Render* it out. Name it dust.mov.

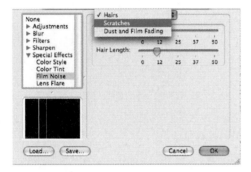

Step 2—Open the dust.mov in QuickTime Pro. Go to *File > Export*; when the *Movie Settings* window opens, click on the *Filter* button. Open *Special Effects* and click on *Film Noise*. Go through the settings for *Hairs*, *Scratches*, and *Dust and Film Fading* and adjust the amounts of each you'd like for your dust and scratches effect.

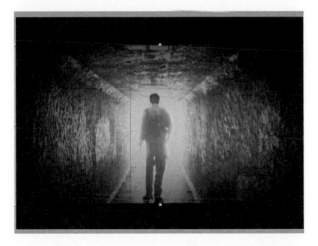

Done—Import our dust.mov QuickTime into After Effects and put it on the layer above the footage. Change the *transfer mode* of the dust layer to create the look you want (black or white dust and scratches). Keep your dust.mov QuickTime in your elements folder as you will definitely have use for this over and over again.

TV Look

Step 1—Import your footage and create a black *solid* layer. Rename the black *solid* layer "Interlace".

Step 2—Apply *Effects > Transition > Venetian Blinds*. That's right, this horrible spawn of the early eighties has another use besides being one of the ugliest transitions ever! Set the *Transition Complete* parameter to about 40% and change the *Direction* to an angle of 90 degrees. The *Width* should be low, like one to three pixels.

Done—Try adding the glassurface.psd, which was created for our *Screen Replacement* tutorial, to the layer above our "Interlace" solid. Also, consider changing the *transfer mode* of the *Interlace* solid layer to adjust how much of the effect you want to see. I included two examples: a subtle effect using *Soft Light* and a more obvious one using *Overlay*.

The Options

Vignettes

⊚	V2	🔒	🖨	Color Solid		Color Solid
⊚	v1 V1	🔒	🖨	disintegratingman		disintegratingman
◀	A1	🔒	🖨	disintegratingman		disintegratingman
◀	A2	🔒	🖨	disintegratingman		disintegratingman
◀	A3	🔒	🖨			
◀	A4	🔒	🖨			

Step 1—For the Vignette option, let's use Final Cut Pro. Import our footage into Final Cut Pro and place it on the time line. Go to the *Generators* button and choose *Matte > Color Solid*, making it black.

Step 2—Apply *Effects > Video Filters > Matte > Mask Shape* and use the preset for *Oval*. Turn on *Invert*. Adjust the *Scale* until it looks to be the right size.

Done—Apply *Effects > Video Filters > Matte > Mask Feather* and crank it up nice and high. Go to the *Motion tab* and reduce the *Opacity*.

Dust and Scratches

Done—Create your dust and scratches on black like mentioned previously in the Effect section of this tutorial. Import it to Final Cut, place it on a layer above our footage, and change its *Composite Mode* to *Multiply* for a very obvious effect. Use *Overlay* for something more subtle.

TV Look

Step 1—To do this we'll need to use a motion graphics package such as Motion. Import our shot into Motion and use the *Rectangle Tool* in a new *Group* above the shot. After you draw the rectangle go to the *Inspector* menu, check on *Fill*, and set the *Fill Color* to black.

Step 2—In the *Library*, go to *Filters* > *Stylize* > *Line Screen* and apply it
to the *Rectangle*. Set the *Angle* to 90 degrees and set the *Stretch* to .3.

Done—Right click the Rectangle layer and go to *Composite
Mode* > *Soft Light* for a subtle effect or to *Overlay* or
Multiply for a more obvious effect.

Predator-Style Infrared Treatment

This look may feel dated now, but it is a look that was very popular in its time, and it's something that folks, even today recognize instantly. So here's a way to recreate the look through the eyes of the **Predator**, that can also be used for a general infrared/tech-paranoia treatment of footage.

Ingredients

- The shot you plan to use for your infrared treatment

The Shoot

Normally this kind of look is reserved for some form of alien point-of-view shot. Naturally it benefits from being shot in this manner.

The Effect

Step 1—Import your footage, apply *Effects > Stylize > Find Edges*, and click the check box for *Invert*.

Step 2—Apply *Effects > Color Correction > CC Toner* and set *Highlights* to blue, *Midtones* to red, and *Shadows* to black.

Step 3—Duplicate the layer and draw a *Mask* around the tree in the distance. Increase the *Mask Feather* so that it creates a glow

around the edge of the tree. Go to this new layer's *CC Toner* settings and change the *Midtones* to green and the *Highlights* to red. Duplicate this layer.

Step 4—In our new layer, delete the mask around the tree. Create a new *Mask* on the trees on the left side of the frame. Increase the *Mask Feather.* Change the new layer's *CC Toner* settings to make the *Midtones* yellow and the *Highlights* blue.

Done—To complete the look, try applying the interlace effect from our *TV Look* tutorial. Set keyframes for your *Mask Paths* so that they follow the objects you've masked as the footage moves forward.

The Options

Step 1—Import our shot into Motion, apply *Filters > Stylize > Edges*, and set the *Intensity* to about 20.

Step 2—Apply *Filters > Color Correction > Levels* and *Filters > Blur > Soft Focus* to improve the look.

Step 3—Apply *Filters > Color Correction > Colorize* and set your colors to red and black.

Done—Duplicate the *Group*, and on the duplicate create a *Mask* around the tree in the background and switch the red to blue, yellow, or green. In the Mask controls, increase the value for *Feather*. Repeat this process for the other areas of the frame you'd like to have another color beside red. When you have finished, set keyframes so that our masks follow our footage forward.

Rotoscoping Techniques—The A Scanner Darkly Look

Rotoscoping refers to shots that go through a frame-by-frame technique that often involves hand drawing or tracing. The film **A Scanner Darkly** was shot with live actors, edited, and then broken down frame by frame and animated. Here's a technique that will achieve a similar result without intensive frame by frame drawing.

Ingredients

- The shot you plan to use for your rotoscoped treatment

The Effect

Step 1—Import your footage into After Effects, make a new *composition*, and put ducks.mov shot in the time line.

Step 2—Go to *composition* > *Make Movie*. Because some Photoshop effects are not available to us in After Effects, we have to process the shot there. Go to the Output Module Settings and choose *Format* > *Photoshop Sequence*. Hit *OK*. Make sure that when it returns to the *Render Queue* that you set the *Output To* somewhere where you've made a folder because when you click *Render* it will make an individual file for every frame of the video.

 Creating an **Action** is one of my favorite features in Photoshop. You will often find yourself in a situation where you have a series of steps that you will have to repeat on entire folders of images. This is where the use of **Actions** can really improve your workflow.

Step 3—In Photoshop, open the first image. Go to the *Actions* Panel and when it opens click on *New Action*. When you create a New Action, you should name it first. Let's call ours *Scanner Darkly*. Click the Record button. Now Photoshop is recording what we do.

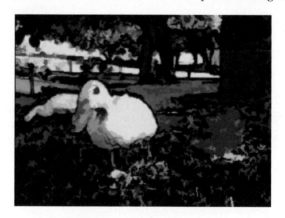

Step 4—Go to *Filter* > *Filter Gallery*. Apply *Brush Strokes* > *Accented Edges*. Set the *Edge Width* to 1, *Brightness* to 0, and *Smoothness* to 3. At the bottom of the Filter Gallery create a new effect layer. Apply *Artistic* > *Cut Out*. Set the *Number of Levels* to 8, *Edge Simplicity* to 0, and *Edge Fidelity* to 3. These are very variable depending on your footage. Then go to *Image* > *Adjustments* >

Hue/Saturation and turn the *Saturation* up to about 60. Click the stop button on the Action. Close the file and *don't* save it.

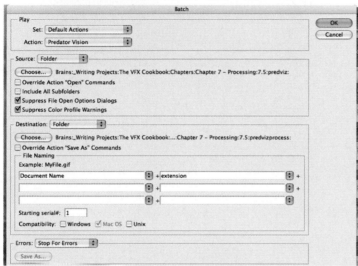

Step 5—Go to *File > Automate > Batch* and, in the Batch dialog box, set the *Source* to *Folder* and choose the folder that holds the rendered stills from After Effects. Go to *Destination* and choose a folder you've already made for this or create one. Then hit *OK* and kick back and relax as Photoshop processes your images.

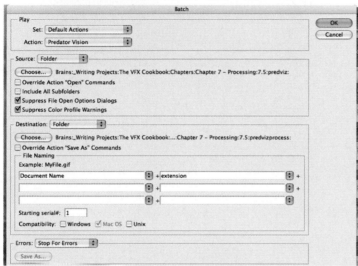

Step 6—Go back to After Effects, choose Import, and pick the first image of your processed sequence from Photoshop. Check *Photoshop Sequence*. This is how After Effects will know to bring it in as one movie instead of one still.

Step 7—Drag the new movie to the new *composition* icon. Apply *Effects > Color Correction > Auto Levels*. Then apply *Effects > Color Correction > Hue/Saturation* and put it up to about 30. Now the colors should really start to pop.

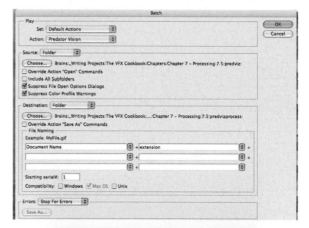

Done—Apply *Effects > Stylize > Find Edges*. Check on *Invert*. Set *Blend With Original* to 87%. This setting will enhance the edge detail, so judge the percentage you should use based on the amount of edge detail you need. Now you may want to try out adding in some hand-drawn elements to your frames, keeping in mind that if you do so you have to draw it in that manner on every frame that shot appears in.

The Options

Step 1—You can use just about any compositing or motion graph-
ics program to apply the effects after you perform the Photoshop
process at the beginning of this tutorial. In Combustion, import
the shot into a new *Workspace*.

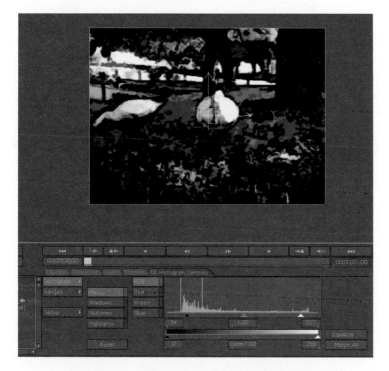

Step 2—*Add Operator > Color Correction > Histogram* to our shot.
Bring the *Highlights* arrow and *Shadows* arrow more toward the
center to even out the lights and darks and to add some contrast.

Step 3—Add *Operator > Color Correction > Discreet Color Corrector* and increase the *Saturate* to around 250.

Done—Duplicate the footage and apply *Operators > Stylize > Find Edges* to the top layer. Go to the *Find Edges* tab and click on *Invert*. Then highlight the footage again, go to the *Composite Controls*, and set the *Transfer Mode* to *Soft Light* and the *Opacity* to 88%.

Stabilizing and Destabilizing a Shot

Sometimes you are stuck working with a shot that is just too shaky to use because it looks like the cameraperson had about a gallon of coffee or, in today's reality-TV climate, sometimes you, as a VFX artist, have to actually add some shake to a shot. It helps add authenticity to a shot, especially one where there's an effect already taking place. Here's how to handle both situations.

Ingredients

- Two shots: one to use for the purpose of stabilizing and the other to be destabilized

The Shoot

This is a situation where if you can avoid having to do either of these on the post side then take the necessary steps to do so. However, if you end up with this problem, here's how you can fix it.

The Effect

Stabilizing Your Shot

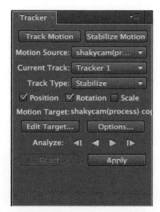

Step 1—Import your footage and open the *Tracker Controls* window. Push the *Stabilize Motion* button and check on *Rotation*.

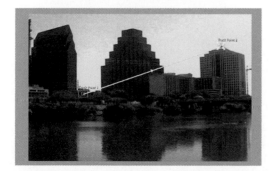

Step 2—When stabilizing a shot for *Position* and Rotation you will need two tracker points. Set the trackers in the positions demonstrated previously. Then click *Analyze Forward*.

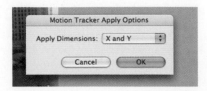

Step 3—If your track analysis was successful, click *Apply*.

Done—Now when you play the footage back you should see that your shot holds much more steadily. When you watch you'll get a peek at what it's actually doing; it's repositioning and rotating the footage to keep the points we set stable. You may need to do a slight increase of *Scale* to keep the shot from having any black in the frame.

Destabilizing Footage

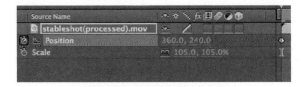

Step 1—Import the footage you want to add some shake to and set *Position* keyframes at the beginning and end of the time line. Increase the *Scale* slightly (to about 105%).

The **Wiggler** is a handy tool for adding that little bit of randomness that is often needed in animation, but is time-consuming to keyframe. It boasts a wide variety of options and all you need is two keyframes. You can adjust the *Frequency* to control how often there's a random kick and the *Magnitude* to control the range of how far off the original keyframe path you want the variations to be.

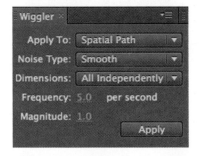

Step 2—Open up the *Wiggler* window. Create a highlight around the two *Position* keyframes. Set the *Wiggler Frequency* to 5.0 per second. Set the *Magnitude* to 8. Then hit *Apply*.

Done—You'll now see some of the random values that the *Wiggler* added between your *Position* keyframes. The shot should be nicely hand-held looking. To emphasize the effect further, add keyframes for *Scale* at one point to simulate a zoom in.

The Options
Stabilizing Your Shot

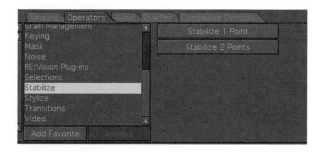

Step 1—Import the shot into Combustion and go to *Operators > Stabilize > Stabilize Two Points*.

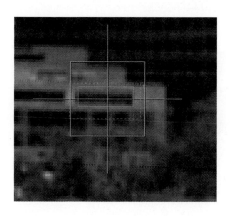
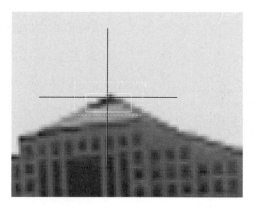

Step 2—You now have crosshairs; move them to the areas of the screen that represent the kind of motion you want to remove. In other words, if the camera shakes from side to side, then choose points diagonally, as shown previously. Enable *Position* and *Rotation*. Click the tab for *Tracker*.

Step 3—Check on *Position*, reposition the two trackers over the points you want to track, click *Select All Trackers*, and then hit *Analyze Forward*.

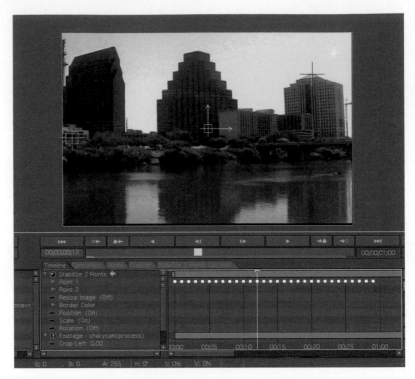

Done—Click the *Off* button and then return to the *Timeline* tab. Play back your now stabilized footage.

Destabilizing Your Shot

Step 1—Import the shot you'd like to add some shake to, open its *Transformation* tab, highlight all the *Position* parameters, and control click to *Add Key*.

Step 2—On the time line, every 10 frames or so click to add more keyframes. Select them all and click *Math Operations*.

Step 3—In the *Math Operations* menu, click *Randomize*. Set the amount of randomization to 15.

Done—Back at your time line make sure that your scale is slightly over 100% to crop out any black that may creep into our frame. Now your footage should have the feel of being drunk at Times Square on New Year's Eve.

PRO*files*

Mark Ezovski: Director, Editor, Motion Graphics Designer

Mark Ezovski's work has been called "remarkable and accomplished," "fascinating," and "important." He is described as "someone to watch closely." A 12-year veteran of the NYC television and indie film scene, Mark received his MFA at the University of South Florida where he studied the techniques of experimental filmmaking. His documentary **The Absolute Truth About Pro Wrestling** (producer, director, editor) was a festival favorite worldwide from India to Canada to Washington state; it won the Best Venue Film award at Toronto's ReelHeart International Film Festival in 2006. Currently, his dramatic feature film directorial debut **Across Dot Ave** is screening in festivals across the globe and is nominated for Best Feature at the International Film Festival, England. He also recently completed editing the indie feature **The Longest Yardsale**, which was named Best Low Budget Feature at the Houston Film Festival. He has worked on countless cable TV reality series and independent documentaries.

1. Describe your job or position in filmmaking and how you got there.

I work primarily as a freelance editor and motion graphics artist, but now I am getting involved in writing, producing, and directing. I have formed a production company called Two Avenues, LLC with the goal of creating realistic character-driven dramatic features. We finished our first film **Across Dot Ave.**, which is currently making the rounds at film festivals.

Since I was a very young kid I have always felt a creative spark and am always looking for a way to bring it to fruition, so all of these outlets serve the same purpose for me. After I finished film school in the mid-1990s, I began working in documentary film as an editor. In school, I had shot and edited with film, so I had no real computer experience. In the professional world I had a lot to learn, but I caught on quickly. As I gained more experience with digital technology, my interests broadened and I began to work with audio, graphics, and motion graphics. Now I am going back to the basics with writing, producing, and directing. It's all related in a very logical way, in my mind at least.

2. What was the one moment when you knew for certain that this was going to be your career?

I don't think there was a moment of clarity where I discovered my career path; I think it kind of discovered itself. I started off as an English major in college and although I loved literature, I was looking for something a little more fun to do for a job, a little more creative and hands on. I took a sculpture class as an elective and I really enjoyed the process—sort of quiet contemplation as my hands worked over the clay. It was more organic and intuitive a process than dissecting the written word. That class led me to take more art classes. I wound up making a couple of neat little experimental films and I think that process sort of combined the things that I liked about literature with the things I liked about art—it was hands on but also analytical. Discovering that process was the final straw as far as leading me into film and digital video.

3. What software (or equipment, whichever is more applicable) do you use?

I'll use whatever software is in front of me. I like making things happen. You can bang in a nail using a rock or you can bang it in using an expensive hammer with an ergonomic grip. At the end of the day, the nail is in and that's all you need, so I try not to get too caught up in software or technology per se. Generally, I will edit video with Final Cut Pro and create motion graphics and effects in After Effects with Photoshop and Illustrator as support. I also think it's important that you become familiar with the popular software that is being currently used. Now that Adobe has Premiere in the CS3 suite (and on Macs especially) I thought it was important to get some experience with it. I know that some

client is going to expect me to be able to use it since it is now readily available. I need to become more familiar with Motion for the same reason—if a client has the Final Cut suite, they might decide they no longer need to keep After Effects around.

As for shooting, the Panasonic DVX is the hot affordable camera right now. It has a pretty decent hi-def image quality for its price point. We shot the **Across Dot Ave.** feature with that camera and were happy with the picture. I also treated it with the Nattress G Film filters for Final Cut Pro, which I love. They give a really great "film look" and have a myriad of controls so that you can get the exact feel that you are going for.

4. What movie do you wish you worked on? In what capacity?

It's really difficult to say what movie I would like to have worked on, as I have a lot of favorites, all for a wide variety of reasons. Okay…hmmm…since I have to pick…and it's not even a particular favorite of mine, but it just sounds like it was a lot of fun—I would have loved to work on the original **Star Wars** in the art department, building the space ships, Death Star, etc. From what I understand, they pieced all of those things together from model kits, the kind you'd get at the hobby shop. They took all of the parts for battleships and airplanes and just mixed and matched and came up with an all time classic production and special effects design. The realness of those space ships makes them so great, in a way that so many digital models just can't replicate. I love working with computers, but sometimes real objects just do the trick. I hate how they went back in and updated some of the effects in the old **Star Wars** films, but that's an answer for a different question.

5. Is there a shot technique used in that movie that really made an impression on you?

It's not the same movie, but there is a particular production and editing technique, not so much a shot technique, that Stephen Soderbergh employed in **The Limey** and other films that has truly inspired my work. Basically, he takes dialogue that would normally take place in one location and scene (seated at a table during the day, for example) and strings it along over several locations/short scenes (sitting at a table during the day, then driving in a car at twilight, then walking on a street at night). The dialogue is cut such that it feels like a continuous conversation, even though the time is compressed and the locations change. As far as I see, the purpose it serves is twofold. This ellipsis makes time pass more quickly and takes you to the next place with a powerful forward

trajectory and also creates an illusion of repetition as though the same conversation is taking place several times, in full. I think it's an exciting narrative and visual device.

6. Where do your ideas come from? What inspires you?

Life inspires me, stories in the news inspire me, looking at media inspires me. I get ideas from everything—bad TV, good movies, past experience, news Web sites, photography, art, and music; the list goes on. I watch people interact and see how they do it and compare it to how I'd do it. I think too much about behavior—"Why did he do that? Why did he say it *that* way?" There is value to be found in observing all the things around you. It aids in shaping the way you think creatively, the way you create stories, and the way you think about cinematic and visual concepts and aesthetics.

7. Share a visual effects technique that you use with our readers. Tell us why you like it so much. This can be anything from something that you do in a visual effects software package, editing software package, on something on the set, in camera, anything you'd like to share with the readers.

I think anything a filmmaker can do to connect the audience to reality and a real experience will benefit his or her work. Whether it's consciously or subconsciously, I think the audience is always seeking this connection. Imbuing elements of reality into the visuals, characters, story, etc. help to create this connection. With that said, I use jump cuts a lot. I see them as a counterpoint to reality. In the same way that using "soft" will help in fully illustrating "loud," juxtaposing visual and narrative dissonance with elements of visual and narrative reality is a very powerful cinematic tool. This style of jump cutting is a perfect illustration of the dream state or the unquiet and harried mind. Mix in some creative color grading and you have a recipe for powerful visual and narrative statements.

8. Is there a resource that you use, like a book, magazine, or Web site, to get ideas for techniques?

For Mac people, the Apple.com discussion forums http://discussions.apple.com/ are amazing. They are populated by a wide array of talented professionals working in all realms of the business who think about the uses and limitations of software in a variety of ways. It's a great resource not just for software, but for workflow and technique advice as well. I have had my life saved by getting questions answered there on a number of occasions!

Creativecow.net is the same kind of situation, a great forum as well but it doesn't focus on Mac software. I go there for Avid and After Effects questions. Recently, I have been spending time on videocopilot.net, just browsing the many tutorials they have available for all different software, especially After Effects. I am always on the lookout for new and different techniques to add to my repertoire.

9. If you were going to give our readers a homework assignment, what would it be?

I don't like movie title sequences that stand alone and are not integrated into the narrative of the film. Even if they are beautifully designed and visually striking (refer to the title sequence of David Fincher's **Se7en** with its jumpy "spliced" titles) in my aesthetic, they don't serve the film as well as they could if they were joined into the narrative of the film. Today's assignment, class, is to find a film with a stand-alone title sequence and then design a style of editing and an effects treatment that will enable that same title sequence to be incorporated into the narrative—perhaps the title cards are now intercut with narrative visuals and the narrative visuals take on a jumpy and "spliced" effect to help marry them to the titles. Be creative!

10. Do you have any career advice for up-and-coming filmmakers?

My only advice to up-and-coming filmmakers is "keep learning and develop your cinematic vision." Watch things, read things, work on things, try things. Gain perspective from all that you learn and think about it in terms of the kind of work you want to do, even if on the surface level it would appear to have no connection to it at all. The truth is that creating media, no matter what kind, has a relationship to other media. You might have to dig a little to find the connections, but once you do, it is interesting how informative they can be—watching a certain movie might impact your editing style or even working on a commercial might impact a script you are writing. Absorb it all and find as many ways as you can to use it.

8

HORROR EFFECTS

This is the first of the chapters that will relate directly to a genre. Horror as a whole has always relied on low budgets and various effects. Bigger budget horror films somehow seem to find a way of just not working well, mainly because they are either copying too much or slicking up too much.

Now as much as we the proponents of digital special effects might try to talk directors out of corn syrup and red food coloring, there is something that can be said for effects that work. However, lo-tech solutions such as a fake blood recipe can be enhanced greatly using computers to fix some pretty big problems.

In the 2000s we have seen a shift back to the 1970s ultra-low budget splatter film, sometimes referred to as "torture porn." With all this need for blood splatters, mutant faces, and dismemberment, it is more important than ever for indie-horror filmmakers to utilize the time- and budget-saving techniques covered in this chapter.

One of my favorite examples is from when I first started teaching, a student who confronted me with some horror film production problems. He had an issue with very expensive contact lenses, designed to give his cast members monster-esque eyes. Rather than blow a small fortune on props, there are great VFX solutions to issues like this.

Evil Eyes

Distorting the familiar into a monster is a tradition of the horror film. Here we will take an actor and give him a pretty disturbing transformation. The human eye is one of the most distinctive features a person has and it's also how we can tell if they have been transformed into a zombie.

Ingredients

- Footage of an actor whose eyes we are going to replace
- Large resolution still photo of one of the actor's eyes, preferably a digital macro lens close-up

The Design

Step 1—In Photoshop, open up the still image of the actor's eye, or the wideeyed.psd. Make a *Selection* around the pupil and copy and paste it to its own layer.

Step 2—Create a new layer below the pupil and fill it with a *Radial Gradient*. The gradient should be a light pink to a dark red-brown. Create another new layer.

Done—Using a variety of brushes, add bloody streaks to a new layer between our pupil and the gradient background. Use dark reds, dark purples, and browns. Periodically switch to the *Burn* and *Blur* tools. For great free brushes, I recommend taking a look at Dave Nagel's Photoshop brushes at http://photoshop.digitalmedianet .com/ in the downloads section. Merge the background layers together, but keep the pupil separate.

In Photoshop, any image can be defined as a brush tip. This is great for creating realistic textures. Select any part of your image and go to *Edit > Define Brush Preset*. You will be prompted to name this new brush. If you are working with a color image that you'd like to use as a brush, it will be converted to grayscale before it is defined.

The Effect

Step 1—Open the prezombie.mov shot in After Effects and put it in a *composition*. Create a new, white *Solid* layer, rename it "Eye Cutouts," and make two masks on the *Solid* layer so that there is white covering both eyes.

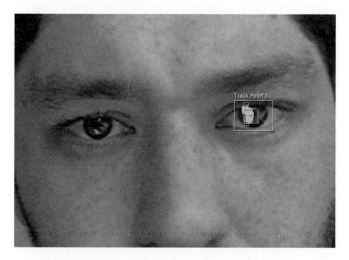

Step 2—Highlight the prezombie.mov layer and open up the *Tracker Controls* window. Click *Track Motion*. Using one of the highlights in our actor's eye, track the motion of the actor's face and then apply it to our "Eye Cutouts" layer.

A **Track Matte** is for the purpose of cutting a hole in one layer and then filling it with another layer. To use a track matte, the layer that defines the cut out area must be directly above the layer that has the pixels you want to remove. Animated track mattes are called *Traveling Mattes*. When you assign a track matte, it will automatically shut off the visibility of the matte layer. Track mattes can either be determined by a layer's alpha channel or by the luminance of its pixels.

Step 3—Highlight the prezombie.mov layer and toggle to its *Modes* and set the "Eye Cutouts" layer to be the *Track Matte* for the prezombie.mov layer. Now you should have two holes cut out where the eyes were and these holes should follow the eyes for the duration of the shot.

Step 4—Import the paintedeye.psd as a *composition* into After Effects. Apply *Effects* > *Blur* and *Sharpen* > *Vector Blur* to the background layer. Set the *Amount* to 10.

Step 5—Go back to the prezombie *composition*. Drag in the paintedeye *composition* onto the layer below the prezombie.mov layer. *Scale* it down to about 30% and move it so that it fits to the eye socket hole we made. Duplicate it and do the same for the other eye. You may need to darken these replacement eye layers slightly to match your footage.

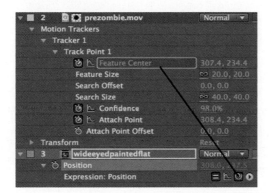

Step 6—We will now need to get our replacement eyes to follow the same movement we tracked before to make our Eye Cutouts. *Option-Click* the *Position* keyframe stopwatch for one of the painted eye layers. This will create an *Expression*. Drag the pickwhip from the expression to the *Feature Center* parameter under the tracker in our prezombie.mov layer. Repeat these steps for the other eye. The anchor point for each layer should be close to where the *Feature Center* for the track was done.

Expressions can be used to make one parameter dependent on another when you can't use a layer *Parent,* or want to create a complicated relationship between the two other than strictly parenting. Parenting only affects *Position, Rotation,* and *Scale.* Expressions are a fascinating part of After Effects; this is where you can tweak almost any effect to do whatever you'd like it to. However, you will have to learn how to write expression, which would take a whole book to explain. Start with After Effects' help file. In the meantime, you can do what we just did earlier to make expressions where certain parameters are affected by others using just the pick-whip.

Done—To complete the look, add an *adjustment layer* with some darkening and desaturation. You may also want to add in some *Fast Blur* to the two eye layers to help them blend in. Try setting keyframes for the *Mask Opacity* on the Eye Cutouts layer's two masks to animate the transition from the normal eyes to zombie eyes.

The Options

Here's a scaled down, quicker version done in Motion.

Step 1—Import the prezombie footage into Motion. Also, import the paintedeye.psd created in Photoshop from the Design step.

Step 2—Apply *Behaviors* > *Motion Tracking* > *Track Motion* to the actor's left eye.

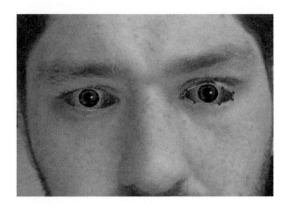

Step 3—Create a new *Group* and import the paintedeye.psd from Photoshop. Put it in the new group and Scale it down to about 30%. Apply *Behaviors > Motion Tracking > Match Move*. Under *Source* choose the tracker we made for the prezombie.mov layer. Add an *Image Mask* to the paintedeye.psd.

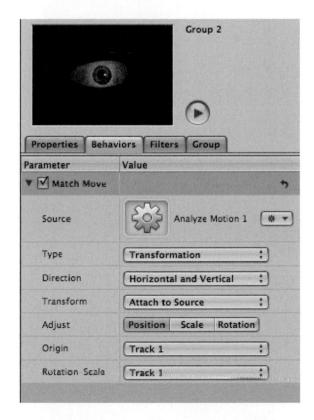

Step 4—Duplicate the *Group* that you added for the paintedeye.psd. Move it to the right eye and readjust the *Mask* to fit the shape of the new eye. The *Match Move* effect should have come with the move and not be in need of much adjustment.

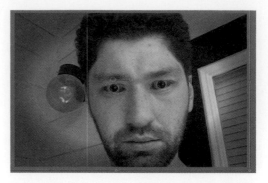

Done—Don't be fooled by Motion's tracking controls having a simplified interface; it's still pretty powerful. Try adding a vignette and our dustandscratches.mov treatment to your shot.

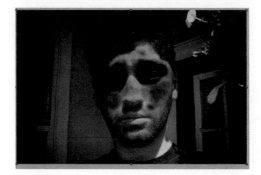

Zombie Faces

Think of this as kind of the opposite of those tutorials that show you how to use Photoshop to make a model appear to have perfect features. What I will take you through here is how to make someone look absolutely frightening.

Ingredients

- A shot of the actor whose face will receive our monster make-up

The Design

Step 1—Make a still frame of the first frame of the picture of our actor. Open it in Photoshop and make a selection of the actor's head. Copy and paste it in its own layer.

Step 2—Duplicate the face layer and make a *Selection* of the skin on the face, without the eyes and mouth. Go to *Image > Adjustments > Hue/Saturation* and lower the *Saturation*. Merge it down with the face layer when you are happy with it. Your actor should look scary, but not monster—scary at this point, more like mime—scary.

Step 3—Select, copy, and paste the eyes to their own layer and use *Image > Adjustments > Color Balance* to make them very red; we're getting there, although we want something a lot scarier than **The Lost Boys**.

Step 4—Use the *Burn* tool to darken all the area around the eyes. Also, darken random areas around the face. In addition, use the *Paintbrush* with a scattered brush set a dark red in *Multiply* mode to add scarring and the look of filth.

Step 5—Make a marquee selection around the brow and go to *Edit > Transform > Warp*. Bulge out the brow area to give our zombie that caveman look.

Step 6—No zombie worth his or her salt lacks random facial holes. Use a brush set to black in *Multiply* mode. Lower the brush's *Opacity* to around 80% and paint a small, triangular shape. Then use the *Blur* tool to blend it in.

Done—This is an area where you do not have to adhere strictly to what I'm talking about; if you get a sudden inspiration, try it! Have fun with this, be creative, and we have *Undo* for a reason. When you are done, merge all the layers for the zombie face mask down and you can delete the background layer; we don't need it anymore.

The Effect

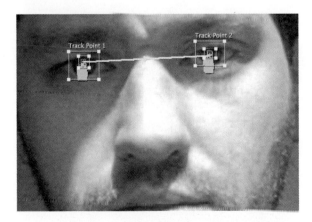

Step 1—Import the mutantface.mov and facestill.psd. Put them in a new *composition* with the facestill.psd on top. Select the mutant-face.mov and open the *Tracker Controls* and track *Position*.

At this point you might be wondering when to use which motion tracks.

Position—Usually when you are using a motion track, its primary purpose is for position. This will follow a designated area, and you can attach something to this track.

Rotation—A rotation track is best used in addition to a position track. When the camera turns on an angle, essentially when it rotates, the position tracker will not turn unless it has another point.

Scale—A scale track is for when the camera's position relative to the item we are trying to track zooms or changes. So, should our camera man suddenly zoom in on something, our replacement graphic should scale accordingly.

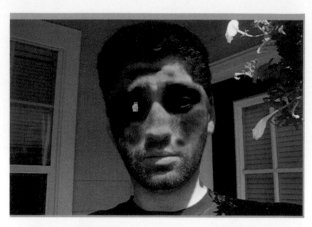

Step 2—Use the *Pan Behind* tool to match our face mask to about where the track point was. We should now see our new face moving with our zombie.

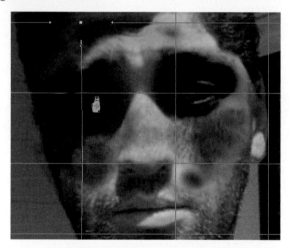

Step 3—This next step is optional; if you'd like to make our monster's face pulse in a creepy way, add *Effects > Distort > Mesh Warp*. At the beginning of the time line hit the stopwatch for *Distortion Mesh* and every 15 frames or so make a subtle shift in mesh and then back.

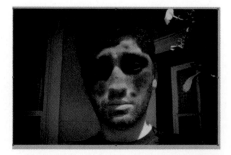

Done—To finish the shot I applied a typical horror film treatment to an *Adjustment Layer*, which combines a saturation reduction with increased darkness and contrast.

The Options

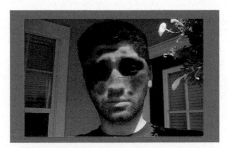

Step 1—In Motion, import the mutatingface.mov footage and facestill.psd. Put the facestill image over the mutatingface.mov.

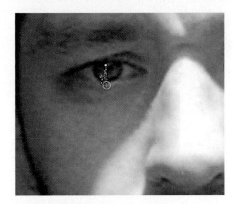

Step 2—Apply *Behaviors > Motion Tracking > Track Motion* to our mutatingface.mov footage. The highlight of the left eye appears to be a great tracking point.

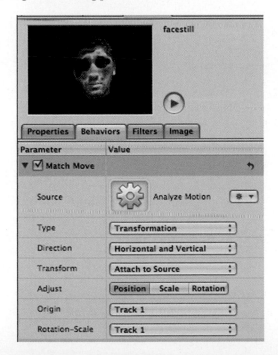

Step 3—Add *Behaviors > Motion Tracking > Match Move* to our fac-estill.psd image and select *Analyze Forward* data from mutating-face.mov footage. Scrub through your footage, the zombie mask is now attached.

Step 4—To get our pulsating animation to work, use *Filters > Distortion > Disc Warp*. Open up the *Keyframe Editor* for *Disc Warp* and bring the amount for *Radius* up and down. Remember, anytime you edit keyframes in Motion, you have to hit *Add Keyframe* to get a new one.

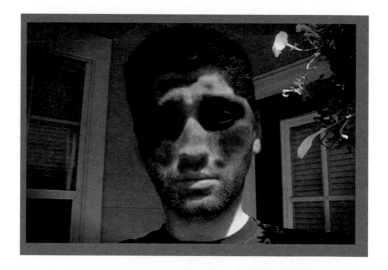

Done—To finish the shot add a vignette, reduce the saturation with *Behaviors > Color Correction > Saturate*, and amp up the contrast with *Behaviors > Color Correction > Contrast*.

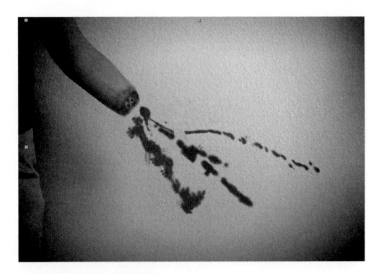

Digital Dismemberment

Sooner or later, in most good slasher flicks, someone's got to lose a limb. Here's a way to subtract an arm, finger, or leg with a little careful planning and some VFX magic.

Ingredients

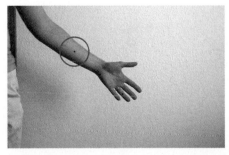

An actor with the limb that will be removed (in this case we are removing an arm from just below the elbow). To save yourself some grief, use a marker or piece of tape on our actor's arm to use as a track point.

Above is a clean shot of the wall background. It can be a still.

The Design

Step 1—Make a still of the first frame of our armwithtrackpoint.mov. Open it in Photoshop. Make a selection of the lower arm (using the *Quick Selection* tool, it should only take a few seconds). Then switch to the *Patch* tool to replace our lower arm with the wall.

 Beginning with Photoshop, CS3, Adobe introduced a new selection tool—the **Quick Selection** tool. Now I know what you are thinking, *another* selection tool. That is what I thought. However, after trying it out, you'll quickly see why this tool was added. Combining aspects of the *Magic Wand* with a tool that works like the *Paintbrush* you can quickly paint a selection as it will automatically find defined edges.

Step 2—On a new layer, use the *Eyedropper* tool to find a skin color and *Paintbrush* to paint over the very end of the arm. This will serve as a background.

Step 3—Use a variety of brushes with a scattered or splotched look to paint over the skin color area you've just created. Use reds, purples (for the appearance of bruising), and browns to create a realistic looking bloody stump. Periodically switch to the *Burn* and *Blur* tools to blend.

Step 4—Make a new layer and pick a nine-pixel soft brush and with a gray, paint two circular shapes. Go over this with some splattered/ink-style brushes mixing reds, browns, and very dark ochre and yellow. Just as described earlier, switch to the *Burn* and *Blur* tools to darken and blend.

Step 5—*Merge* the bones and bloody wound layers. On our background still, make a *Selection* around the area of the arm from where the wound begins to the elbow.

Done—Create a new layer and, in a deep crimson, paint a few blood splatters emerging from our stump. To get some good splatter brushes there are various free splatter brush sets on the web. Save it as woundedarm.psd.

The Effect

Step 1—Import the armwithtrackpoint.mov, wallbg.psd, woundedarm.psd (*as a composition*). Put the armwithtrackpoint.mov in a new *composition* and open the *Tracker Controls*.

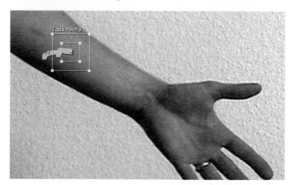

Step 2—Click *Track Motion*. Put the *Tracker Controls* over the dot on the arm and track the motion.

Step 3—Put the wallbg.psd on the layer below the armwithtrack-point.mov footage. Create a *Mask* on the armwithtrack-point. mov layer that will cover the area below the track point. Size it so that it removes the hand from the duration of the shot.

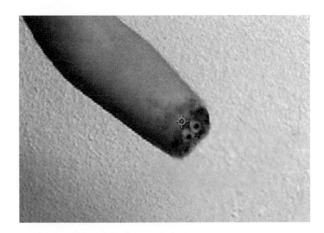

Step 4—Drag and drop the arm layer from our woundedarm.psd. Use the *Pan Behind* tool to put the *Anchor Point* of this arm layer right where the wound ends.

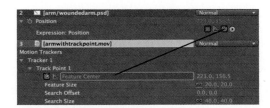

Step 5—*Option-click* the arm layer's *Position* tool. Drag the pick-whip to the armwithtrackpoint.mov layer's *Motion Trackers > Tracker 1 > Feature Center*. Now scrub your footage; the new arm should be well attached.

Step 6—Drag the splatter layer from our wounde-darm.psd to sit above the wallbg.psd layer and the armwithtrackpoint.mov layer. Set its *transfer mode* to *Hard Light*. Duplicate the layer. Set the duplicate's *transfer mode* to *Overlay*. Add *Effects > Color Correction > Levels* and darken the layer.

Done—Add a vignette and an Adjustment Layer that will desaturate, add contrast, and darken your *composition*. Try digitally dismembering all your friends and loved ones.

The Options

Step 1—Import our armwithtrackpoint.mov and our woundedarm.psd into Combustion. When it asks, set the woundedarm.psd import to the *Nested* mode. Turn off the visibility of the splatter layers for the moment. Go to the *Composite Object* for the wounded arm. Click the *Tracker* tab, set the source to the armwithtrackpoint.mov, and click on *Position*. Track the black dot.

Step 2—If your track was successful, click *Off*. Go back to the main composite and take a look. Our wounded arm should be following right on top of our nonwounded arm. We need to fix that. Import the wallbg.psd footage and put it below the armwithtrackpoint layer. Add *Operator > Mask > Draw Mask* to our "armwithtrackpoint" footage.

Step 3—Turn on the visibility of your blood splatter. Duplicate the layer and set the top one's *transfer mode* to *Overlay* and the bottom one's to *Hard Light*.

Done—Nest the entire composite and *Add Operator > Color Correction > Discreet Color Corrector.* Darken the shot, add contrast, and desaturate it.

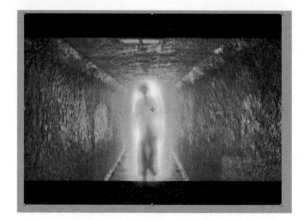

Ghostly Apparitions

Spirits are such an abstract thing that when it comes down to it, there are a ton of ways to get that message across, aside from a person who's just slightly semi-transparent. Here's one technique to help give your ghost effect a little extra punch.

Ingredients

- A shot of the actor where the actor's body is in the frame from head to toe (a long shot)
- The exact same scene without the actor; can be a still

The Shoot

In order to help get this right you'll probably need to back your tripod. Any slight change between when the actor is in frame and when he's not could make trouble for the VFX artist. However, given your frame, it's probably not a total deal breaker; it could just be a good time-saver.

The Effect

Step 1—Import the ghost.mov footage and the appbg.psd, and in a new *composition* place the ghost.mov above the appbg.psd.

Step 2—Make a *Mask* around the figure to get the ghost treatment. Once you have turned off the visibility of the background and checked that you did the mask correctly, it's easy to get confused because when you first complete the *mask* it looks like you did not do anything. Apply some *Mask Feather*.

Step 3—Duplicate your actor; on the copy apply *Effects > Color Correction > Hue/Saturation* and completely desaturate him, and

also apply *Effects > Color Correction > Levels* to increase his contrast. Turn off this layer's visibility for right now.

Step 4—Go back to the layer that has not been desaturated, apply *Effects > Noise* and *Grain > Median*, and increase the *Radius* to 8. Next, apply *Effects > Blur* and *Sharpen > CC Vector Blur* and set the type to *Constant Length*, *Ridge Smoothness* to .7, *Property* to *Blue*, and the *Map Softness* to 14.

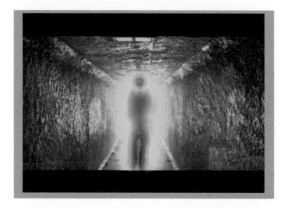

Step 5—Turn on the visibility of the desaturated layer, make sure it's above the layer we just treated, set its *Transfer Mode* to *Soft Light*, and reduce its *Opacity*. Highlight both of the QuickTime layers and *Pre-Compose* them. Move all attributes to the new *composition*.

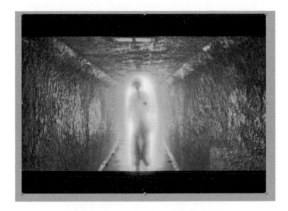

Done—With our Pre-comp, apply Effects > Blur and Sharpen > Fast Blur. Set it to be a Blurriness of 3. Also apply Effects > Generate > CC Light Rays and set a stopwatch for Intensity. Have it increase throughout the time line, the same for the Radius. Set some keyframes for center and have it move throughout the ghost's body.

The Options

Step 1—Bring the ghost.mov and appbg.psd into Motion and put ghost.mov on the layer above the appbg.psd.

Step 2—Turn off the visibility of the appbg.psd layer. Draw a *Mask* around the man and then duplicate this layer. Rename the duplicate "outline".

Step 3—On the outline layer, apply *Filters > Color Correction > Desaturate* and then apply *Filters > Color Correction > Gamma*. Set its transfer *mode* to *Overlay*.

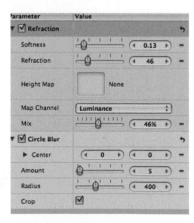

Step 4—Apply *Filters > Blur > Circle Blur* and set the *Amount* to 5. Apply *Filters > Distortion > Refraction* with low setting for *Softness* and a *Refraction* of around 46.

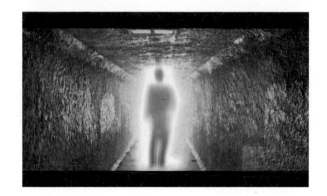

Done—Apply *Filters > Glow > Light Rays*. Adjust the *Glow* setting until it feels right, around 2. Lower the mix a little to make a more effective mix. Although slightly different from the look achieved in After Effects, I feel as though they are equally effective in getting our message across.

PRO*files*

Paul Del Vecchio: Director, Editor, VFX Artist

Paul Del Vecchio is a for-hire New York-based director/writer. He directed, produced, edited, DPed, and did the visual FX and color grading for **The Final Day**, the Grand Prize Winning short film for the **Diary of the Dead** DVD contest. **The Final Day** is now available on the **Diary of the Dead** DVD distributed through The Weinstein Company.

Del Vecchio's first feature film, **Forever**, went on to win the Audience Award for Best Feature Film at the Long Island Big Fish Film Festival in Bellmore, New York. Del Vecchio currently has a short film called **Fallout** in the Chiller TV Dare to Direct 2 Competition. He is currently codeveloping/writing/directing a pilot, **Asher**, with David R. Doumeng and Doug Frye and is working on multiple feature-length and short-form scripts and films.

1. Describe your job or position in filmmaking and how you got there.

 I'm a director and I also offer postproduction services such as editing and visual FX.

2. What was the one moment when you knew for certain that this was going to be your career?

 There were plenty of moments where I knew that I wanted to direct and work in the film industry, but the moment I knew for certain that this was going to be my career was when my last "corporate world" job laid me off. I didn't want to be there. I hated that job. It absolutely was *not* the direction I wanted to go in and so I started taking days off (my sick/personal days) while going on job interviews for directing and postproduction work. I was completely fed up with not doing what I loved for a living so I started looking for jobs in the field. I guess my old company didn't

like that. The day I got laid off, I remember sitting on a bench in the mall and going, "Well, at least I know what direction I'm headed now." I felt both relieved and scared to death. It was the kick in the rear that I needed in order to take the plunge.

3. What software (or equipment, whichever is more applicable) do you use?

 For postproduction software, I use Sony Vegas, Adobe Production Studio, and Avid Media Composer.

4. What movie do you wish you worked on? In what capacity?

 I really don't have an answer for this one because most of the movies I love and wish I worked on were done by great directors (**Terminator 2**, **The Lord of the Rings** trilogy).

5. Is there a shot technique used in that movie that really made an impression on you?

 The concentration on character and great storytelling is what draws me to those movies. Visual FX are not the event, but rather the icing on the cake.

6. Where do your ideas come from? What inspires you?

 My ideas come from everyone and everything. What inspires me is seeing people who are in a similar circumstance as me and how they overcome their boundaries and become successful.

7. Share a visual effects technique that you use with our readers. Tell us why you like it so much. This can be anything from something that you do in a visual effects software package, editing software package, or something on the set, in camera, anything you'd like to share with the readers.

 I don't have a specific technique I would like to mention, but I do think that understanding the technicalities of a shot will help you create something that's more realistic looking. Knowing how to execute a VFX shot is something that I feel is *very* important, otherwise your shot could look fake and take people out of the story or the suspension of disbelief, and *that's* the most important part, so you don't want to lose your audience.

8. Is there a resource that you use, like a book, magazine, or Web site, to get ideas for techniques?

 Everyone uses VideoCopilot but I just read magazines and internet articles to see how other people do things. Sometimes

someone has an easier/better way of doing something so it's always great to see how others do things in order to learn.

9. If you were going to give our readers a homework assignment, what would it be?

I would make the readers go out and shoot something and practice filmmaking because it's going to make you a better storyteller. I think that's important regardless of whether you're an editor, director, VFX artist, etc.

10. Do you have any career advice for up-and-coming film-makers?

Work hard, harder than anyone around you. Learn from your mistakes, and just go out there and *do work* and practice, practice, practice because that's how you're going to get good at what you do. You're not going to get good by sitting around watching movies and playing video games all day. You're going to learn and get better by *doing* so stop talking about it and go out and *do it*!

9

ACTION

Throughout the history of film, action movies have meant two things: big explosions and bigger budgets. These films are often labeled "escapist" or "popcorn" but the action genre is also well proven at the box office. In today's action film, the VFX artist is often required to do two major things: save money on expensive, hard-to-get shots and save stunt people from the various dangers of on-set disasters.

In the 1930s, most action films were geared toward period pieces, with as many sword fights as today's action films rely on gun duels. By the 1970s, the tide had turned to the rough and tumble, not afraid of bending the law cop flick. However, the 1980s gave us the Stallone/Schwarzenegger/Willis-style of over-the-top one man against international conspiracy of terrorists style that helped make the action film the dominant style in Hollywood today. By the early 1990s, another shift became apparent, the influence of the Hong Kong style of action film, which merged the genre with classic "kung-fu" genre.

To the rogue indie filmmaker, it has been a tough genre due to its need for swollen budgets. The up-and-coming director usually can't afford to blow up cars, smash windows, blast Uzis, and have hordes of doves (alright, that one we can reserve just for John Woo). Since the mid-1990s, it has become more and more common for action films to VFX over real explosions and stunts to keep movies from going way over budget. Look at it this way, there aren't too many times that you can blow a set up, should something go wrong.

Low-budget action films, such as Robert Rodriguez's **El Mariachi**, prove that with cleverness, and the tool set, it's not impossible. Also, with some VFX magic, budgets can be saved and buildings can still be blown up. This chapter goes through many common action film shots and how, with some pretty low-fi VFX techniques, a film can still come in under budget.

Vehicle Explosions

There is a little part of all of us that gets some kind of satisfaction about seeing something explode. Blowing something up, while adding much excitement to a movie, can also kill a budget. Often a visual effect of an explosion can be a little disappointing, so here are some tips on how to make it feel somewhat convincing.

In my After Effects classes my students are always asking about fire and explosions; here's one technique to make a great looking explosion.

Ingredients

- Footage of the vehicle you would like to blow up (shot with the camera on a tripod)
- Footage of the background or location where the vehicle will blow up without the vehicle there
- Stock footage of *Square Flames* from etonationFilms.com

The Shoot

Here's the hitch of the whole operation—with blowing up a vehicle using CG techniques, the closer you get to the actual explosion, the worse of a compositing situation you will end up in. All the little flaws become painfully obvious.

Now, set up your camera on a tripod. Shoot the area without the vehicle. This is often referred to as the *background plate*. Then, without moving the camera, bring the vehicle where you'd like it to be in the frame. Roll on this. What we will do is cut out the car later; this will allow us the ability to remove chunks of the car at will.

Now if there is some slight movement of the car, don't lose sleep over it because it can be fixed. However, you want to avoid a major change in the frame.

The Design

Step 1—Open a freeze frame of the carshot.mov in Photoshop. Unlock and duplicate the layer.

Done—Using your favorite selection tool, copy and paste the car and its shadow to its own layer. Delete the background layer so that the only layer we have is the car and its shadow. Save this as carintact. psd and now let's move over to After Effects.

The Effect

Step 1—Import the carintact.psd, the square flames footage, and carshotbg.mov into After Effects. Make a *composition* and put the carshotbg.mov on the bottom layer and the carintact.psd above it.

Step 2—Duplicate our carintact.psd layer. At about 1 second into the footage, split the top layer by pressing *Shift-Apple-D* or *Edit > Split Layer*. It is at this point where we will create our explosion. Duplicate this layer again.

Although it's not exactly an easy process, you could actually edit video footage in After Effects. *Split Layer* is essentially the act of making a cut. However, the After Effects interface was not designed for editing so you can save yourself the trouble of leaving After Effects to do something easy like making one cut.

Step 3—On our topmost copy of the carintact.psd layer, precompose the layer and name it window. Leave attributes in our existing *composition*. Make a mask on the back window of the car. Apply *Effects > Simulation > CC Scatterize*. This will create debris from a breaking window. Have the *Scatter* go from 0 to 10 in the course of 1 second and reduce the *Opacity* in the last 15 frames of the effect from 100 to 0.

 After Effects also has an effect called *Shatter*. It has far more range of control than *CC Scatterize* but it will take some getting used to. You are able to control the shape of the artifacts that shoot off your explosion. Use *Corner Pin* controls to place on the correct perspective plane, and even give it some 3D texture. Just be warned, to get any really useful results from this effect, you will have to dig deep into its complicated controls, which are often confusing. So for an effect like this, *CC Scatterize* gets the job done with less hair pulling.

Step 4—Move down to the copy of the layer below the one we just worked on. *Solo* this layer and *Mask* the back window again (you can copy and paste the *Mask* from the window precomp). Check on *Invert*.

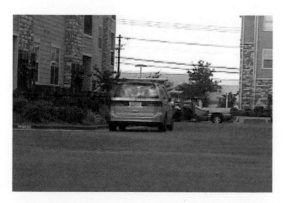

Step 5—Place the square flames footage below the layer with the window we just cut out. Apply a *Mask* to narrow down the area we will have to key and change the *transfer mode* to *Screen*.

Step 6—From the square flames footage, add in the side shots of the flames to the left and right side windows of the car.

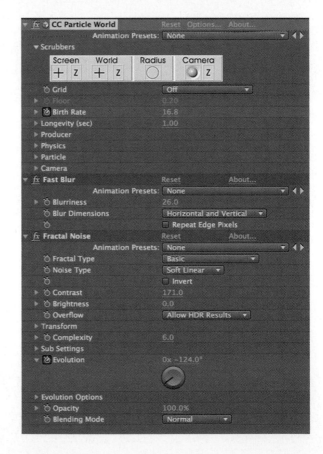

Step 7—Make a *Solid* layer and apply the effects above to add smoke to the scene. I used the standard smoke recipe, Particle Plug-In + Blur = Smoke. I also added in some *Fractal Noise* to help give the smoke some variety of color, although it might be going a little overboard. I have also included this in the provided presets on the DVD.

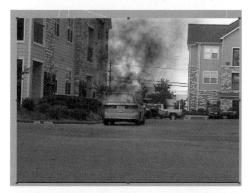

Done—Add more layers of flames or smoke if necessary. It looks pretty convincing at this point. To help sell the actual moment of the explosion, try adding a new *Null* object that has few quick jolts to its *Scale* and *Position*, and *Parent* all of the layers to this *Null* object to make it seem as if the blast shook the camera.

The Options

Step 1—Load our carintact.psd and the plate.mov into Com-bustion and let's start by adding *Operators* > *Particles* to the shot.

Shape	Line		Preload Frames 0		Tint			Weight 100%
Emission Options			Active Emitter		Tint Strength 100%			Spin 157%
In		Out	Preserve Alpha		Life 100%			Motion Rand. 100%
At Points			Ignore Motion Blur		Number 24%			Bounce 100%
Emission Angle 149°			Particle Ordering		Size 100%			Zoom 70%
Emission Range 47°			None		Velocity 100%			
Visibility 100%								

Step 2—From the *Particle Library*, open the *Natural/Organic* group and choose a grainy set from *Dust Contest*. Under *Emitter* change the *Tint* to look like our glass and the *Number* to a lower percentage.

Step 3—Nest what we've done so far into a new *Composite*.

Step 4—Now apply *Add Operator > Particles* and choose one of the settings, such as *Fire Smoke*, from the *Fire* folder.

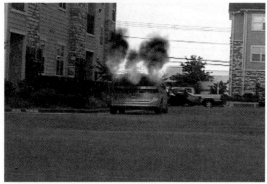

Done—Add several point emitters with differing *Fire and Smoke* settings around the car.

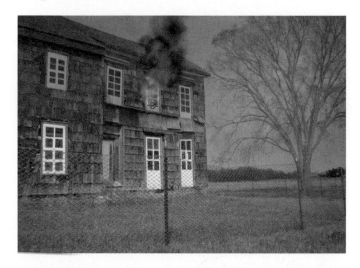

Building Fire

If I were to make a top 10 list of the most common questions from students about After Effects, "How do I make fire?" would be a contender for the number one spot. All joking aside, it makes sense; I prefer that students generate fire on a computer than try to make real ones! To

demonstrate computer-generated fire, let's create a standard movie shot of the exterior of a burning building.

Ingredients

- A master shot of the exterior of a building with windows (we are going to add the fire and smoke)

The Design

Step 1—Open the burningbuilding.psd shot, cut out the window, and copy and paste it to a new layer.

Step 2—Use the *Burn* tool to darken the window frame. Use the *Eraser* tool to make it look a little damaged, and use the *Paintbrush* with a dark black and brown to create the impression of burn damage. Lower the Paintbrush's *Opacity* to about 15–20% before you paint to make it look like it has been burned.

Done—We're going to use the window in After Effects to go in front of some of our fire and smoke layers. Save the still as burnedwindow.psd.

The Effect

Step 1—Create a new project in After Effects. Call it windowfire. Import the burnedwindow.psd as a *composition*.

Step 2—Using the *Pen* tool, create a *Mask* that goes along the inside edge of the window. After you complete the *Mask,* press MM on the keyboard to open all the *Mask* tools, check *Inverted*, and make *Mask Feather* three pixels.

Step 3—Make a *Solid* layer that is screen size and name it *fire*. The color doesn't matter as we are going to take care of that later. Move it to the layer underneath the master shot. You should see the solid through the mask you made in the window. Turn off visibility on the master shot for the moment. Apply *Effect > Noise and Grain > Fractal Noise* to our fire layer.

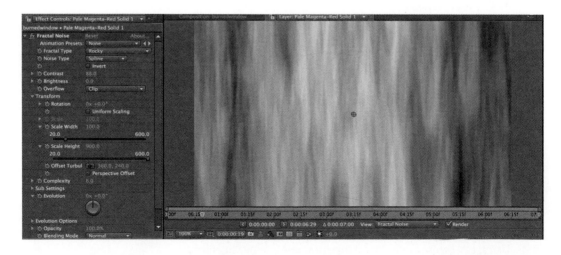

Step 4—You can try the settings I've used here or your own. Make sure you open up *Transform* and turn off *Uniform Scaling*. Make *Scale Height* at least 600 until you get long, sharp lines. Turn on

Perspective Offset; this is how we will get the flames to rise. You should see something that looks like what is shown above.

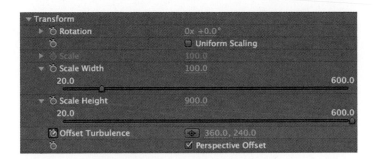

Step 5—Move *Offset Turbulence*'s crosshairs below the image in the *composition* Window. Set a keyframe for *Offset Turbulence* at the beginning of our time line. Go to the end of the time line and move the crosshairs just above our image in the *composition* Window. Scrub through your animation; your Fractal Noise flames will appear to rise.

Step 6—*Fractal Noise* alone is like peanut butter without jelly. Add *Effect > Color Correct > Colorama*. Use the preset for *Fire and Smoke* under *Colorama's Output Cycle* or come up with your own recipe.

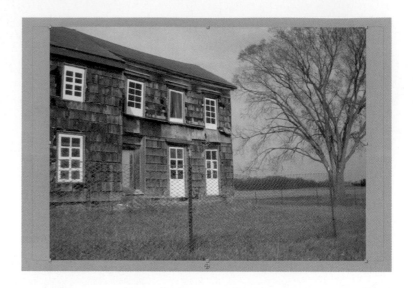

Step 7—Turn on the visibility of the master shot layer. Use *Effect > Distort > Corner Pin* and match the four corners of the fire layer to the window frame.

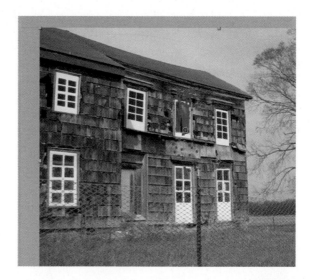

Step 8—Let's reverse an old cliche—where there's smoke, there's fire. Make a new *Solid* layer and name it smoke. Apply *Effect > Simul ation > Particle Playground*. Move Particle Playground's *Position* crosshairs to the bottom of the window frame.

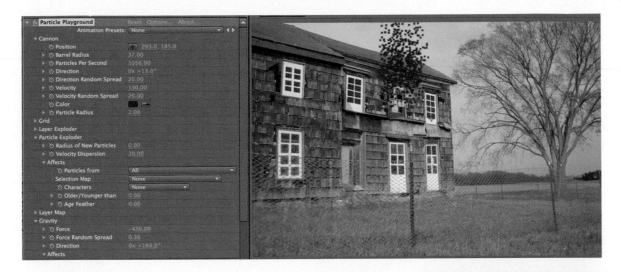

Step 9—Change the *Color* to a gray. Reduce the *Particle Radius*, open up *Gravity*, adjust the *Force* so that the particles float upward, and then adjust the *Direction* to match the way that the wind would move smoke.

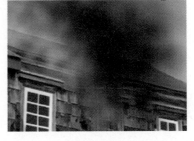

Step 10—Add *Effect > Blur* and *Sharpen > Gaussian Blur*. Duplicate the smoke layer a few times and adjust the colors and *Particles Per Second* to give your smoke variety in color and density. Try adding *Effect > Generate > Ramp*; this tool is like adding a gradient and you'll get more variety of color in your smoke.

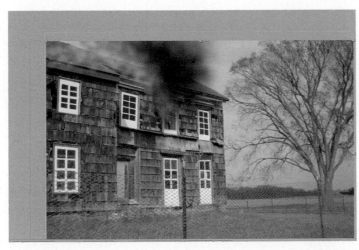

Done—Drag in the burnedwindow.psd above the window in our *composition*. You'll see that the fire peeking through the holes we made with the eraser has a nice effect and that the burning looks more realistic. Move some of the smoke layers behind and above our burned window. Try darkening the sky to make the whole area more smokey.

The Options

Step 1—Combustion has a robust array of particle effects. Create a new *Workspace* with NTSC DV settings, 2D mode, call it burninghouse, a duration of 5 seconds, and click OK. Import the master shot.

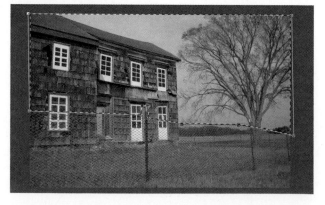

Step 2—Add *Operator > Selection > Draw Selection* to the shot and make a selection of the image anywhere in the frame there would be smoke. Highlight the *Polygon Selection* in the *Workspace* menu and increase the *Feather* to 30–35 pixels.

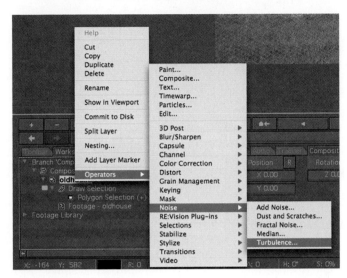

Step 3—Add a *Turbulence Operator* (right click or CTRL click on burninghouse, *Operators > Noise > Turbulence*) to our burning house. Give it a percentage of 40–50 and 8–12 octaves. Double click *Composite-Burning House* to see the result.

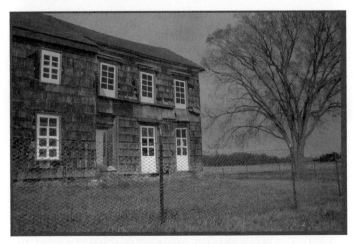

Step 4—The *Animate* switch should be in red, meaning that it's on. Go to the first frame and, under *Turbulence Controls*, give the *Time Slice* a value of 2.40. Go to the end frame and turn the *Time Slice* to 2.70. When *Animate* is on, keyframes are set automatically. Scrub through the time line to see your results; the *Turbulence Noise* that was added should make the scene appear to have clouds of smoke floating through the frame.

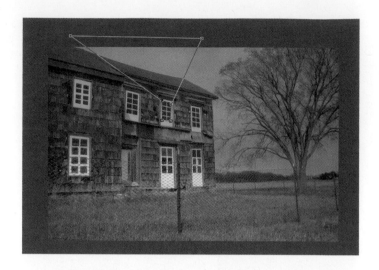

Step 5—Add *Operator > Selection > Remove Selection*. We are going to make a new selection with *Operator > Selection > Draw Selection*. Draw this selection on the inside of the window frame and include the area above it, where the darker smoke will drift.

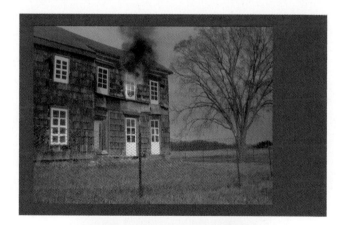

Step 6—Add *Operator > Particles* and, under *Library*, choose *Load Library*. Find *Fire.elc*. *Enable Preview* and look at the various fire particles available to you; try *Fire Smoke 01*.

Done—Grab the *Line Emitter* tool from the Toolbar. Draw a line along the bottom of the window frame to define where the fire will emit. Set the *Preload Frames* to 35–40 and then take a look at it. It is a quite believable result. Try adding in different kinds of smoke and flames and the burnedwindow.psd.

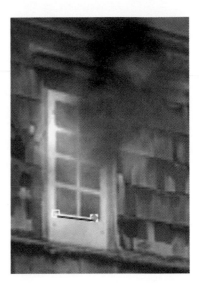

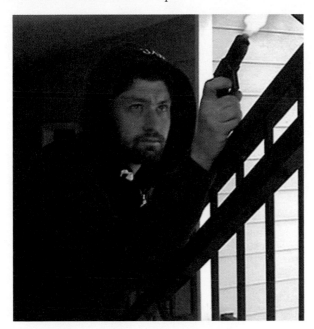

Creating Realistic Gunplay

Aside from a good gunshot sound effect, you will also need a great-looking "muzzle flash" to give your chase scene a great sense of shoot-em-up gunplay.

Ingredients

- Footage of our actor firing our prop gun
- Prop gun (rather than spend $150 on a prop gun, try spray painting a water gun black)
- Stock shot of "muzzle flashes" (the one in use here comes courtesy of detonationfilms.com, a great resource for free and low-cost special effects stock footage)

The Effect

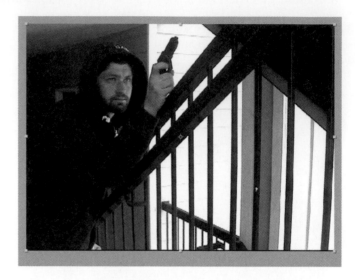

Step 1—Import our gunplay.mov shot into After Effects and make a new *composition*.

Step 2—Make sure that you have the gunplay.mov layer highlighted. Go through the footage near the trigger pulls and hit the * key on the numeric keypad every time the fingers squeeze the trigger.

 To remove a marker, you can just drag it off to the side of the screen.

 Although this text is not addressing the issue of sound, the real key to making this effect work is use of a well-synced sound effect. Those markers we just made are also great for keeping track of where the sound effects should go.

Step 3—Import the Muzzleflashes_UnitK.mov footage. Trim it down to the one you like (each flash lasts two frames) and move it to the markers we made on our shot.

Step 4—Add a *Mask* to cut out much of the black so that we only have the flash area visible. Change the *Transfer Mode* to *Screen*. Our blast is facing the wrong way, so adjust the horizontal *Scale* to –100.

Done—If you need further adjustments, use the *Pan Behind* to change the *Anchor Point's* location so it comes straight from the gun. Adjust it further with *Rotation*. Change the flash muzzle periodically to another one so that they don't all look exactly the same.

The Options

Step 1—Basic composites like this can be done easily in Final Cut Pro; put the gunplay.mov into a new *Sequence* and import Muzzleflashes_UnitK.mov.

Step 2—Step through your footage frame by frame, and hit M and the keyboard every time the actor squeezes the trigger. You can even edit your markers to include notes for later.

Step 3—Drag the Muzzleflashes_UnitK.mov to the layer above our shooter and apply *Effects > Video Filters > Key > Luma Key* to our muzzle flash.

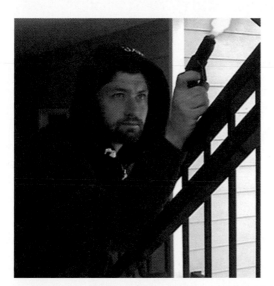

Done—Go to *Effects > Video Filters > Video > Flop* and use *Rotation* to get our muzzle flash to just the right position.

Cliffhangers

Exciting, edge-of-your-seat shots need a few things that will keep the audience hooked: danger and a sense that the danger is going to get a whole lot worse. Now we've all seen actors hanging from ledges with some crazy oncoming problem hoping that the all-important hand comes into frame to help them out.

Ingredients

- A shot of an actor hanging from something, or looking like they are hanging from something (e.g., I've used a short wall near my house)

The Shoot

The safety of the cast is always the topmost concern. Don't do anything dangerous or something that the actor doesn't feel comfortable with. To keep this simple, the actor in this shot could, at any point, place his feet directly on the ground. If needed, there are harnesses and similar types of equipment available to avoid any danger for the cast member.

The Effect

Step 1—Load the *cliffhanger.mov* into After Effects and make a new *composition*.

Step 2—My original plan was to be able to key out the grass, but because that did not work out, which I anticipated, my back-up plan was to matte it. Using the *Pen* tool, create a mask around our actor and a little bit of *Mask Feather*. Luckily, this will need to be a fast shot, so for 2 seconds (60 frames) it's no big deal to keyframe our *Mask*. Create a new keyframe for *Mask Path*.

Step 3—Since our hero is in danger of being engulfed in flames, a little of that hot light would be reflected upon him. Add *Effects > Color Correction > Photo Filter*; use the *Warming Filter 85* and a 40% density.

Step 4—Create a new *Solid* layer and rename it "flames." Apply *Effects > Noise* and *Grain > Fractal Noise*. To get that great fire look, use the settings in the preceding figure.

Step 5—Apply *Effects > Color Correction > Colorama* and choose the *Fire and Smoke* under Colorama's *Output Cycle* preset.

Step 6—To get our fire moving, set a stopwatch for Fractal Noise's *Scale*. Have it increase in size over time appropriately for your set shot; in this case I went from 85 to 124. For *Rotation*, give it a half-turn from –35 to 65. Turn on *Perspective Offset* and set keyframes for *Offset Turbulence*, starting the crosshairs low in the frame and moving upward.

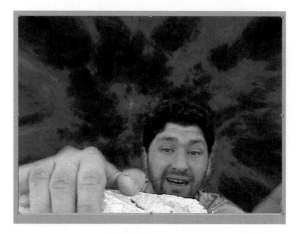

Done—Now, if I were a better actor, this shot might actually have a convincing sense of impending danger. To complete the fire look, add *Effects > Color Correction > Levels* and make it darker. Also, add *Effects > Distort > CC Lens*, which will give you some control over the fire's shape and add some sense of depth.

The Options

Step 1—Import the cliffhanger shot into Combustion and add *Operator > Mask > Draw Mask*.

Step 2—Draw a mask around our actor. Set keyframes to keep our actor cut out.

Step 3—Create a new layer, set the background to black, and add *Operator > Particles*.

Step 4—Use the *Fiery Clouds* particle and use a rectangular-shaped *Area Emitter* to cover this layer with flames.

Done—The fire particles in Combustion look great. You may want to try varying the size and amount of particles to see what looks best.

Tornadoes

As stated in previous chapters, the weather does not often cooperate. However, what if you need to create a shot with a weather event that is rarely, if ever, seen by people? Well, since they make TV shows about people hoping to grab just a few moments of footage of tornadoes the need to create one digitally is pretty clear.

Ingredients

- Large still photo of storm clouds
- Footage of the location you'd like to add your tornado to, preferably dark, with storm clouds or overcast

The Effect

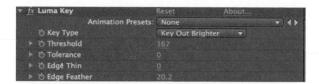

Throughout this book I recommend keeping a folder of elements you will use commonly on your hard drive. You definitely need good still shots and video of storm clouds.

Step 1—Import our footage, stormclouds.mov, and stormscroll. psd into After Effects and create a new *composition*. Put each layer into this *composition*. Turn off the visibility of the stormclouds.mov for the moment. Apply *Effects > Keying > Luma Key* to the stormscroll.psd layer and set it to *Key Type > Key Out Brighter*. Increase the *Threshold* and *Edge Feather*. We are creating a few holes in our cloud photograph to give the tornado natural inconsistencies.

Step 2—Apply *Effects > Perspective > CC Cylinder*. Adjust the *Radius* until it is the appropriate size for the background.

Step 3—Next add in some *Effects > Blur* and *Sharpen > Directional Blur* to emphasize the motion blur. Then, apply *Effects > Distort > Mesh Warp* to shape our tornado. For the sake of some sanity, precomp the stormscroll.psd layer and rename it "tornado."

Anytime you want to rename a layer in After Effects, hit the Return key on the keyboard when the layer name is highlighted.

Step 4—Turn the visibility of our stormclouds.mov back on (I've turned the tornado off for right now). Using *Effects > Color Correction > Curves*, darken and desaturate your footage. Create a *Mask* around the foreground scenery; we are going to replace the clouds in the shot with the darker and more sinister clouds in stormscroll.psd. Drag in another instance of stormscroll.psd and place it on a layer below your stormclouds.mov.

Step 5—Turn on the visibility of the tornado layer. Duplicate the stormscroll.psd that you are using to replace the clouds and put it above the tornado layer. Mask out a dark area and use this as a way to cover up the top of the tornado; it will make it look like it's emerging from the clouds rather than just dropped in there. On the tornado layer, add in *Hue/Saturation* and take it down just a little and *Fast Blur* to give it one final blur. Covering the top of the tornado is not totally necessary and is greatly dependent on the scene.

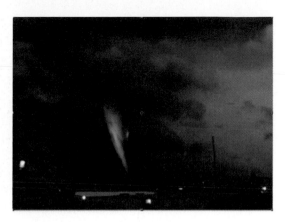

Done—To animate your tornado rotating, set keyframes for *Rotation Y* under the tornado layer's *CC Cylinder* effect; one revolution per second seems to be a believable rate for the turns. Try adding flying debris using *Particle World* and a blur; if you need your tornado to change its shape, set keyframes for the tornado layer's *Mesh Warp* effect.

The Options

Step 1—In this tutorial we will recreate the aforementioned effect playing to Combustion's strengths. Let's start by bringing the stormclouds.mov footage into Combustion. Use an *Operator > Selection > Draw Mask* to cut out the foreground scenery. Import the stormscroll.psd and use that behind the foreground elements.

Step 2—Go to *Object > New Layer*. Create a new layer, with the *Type* set to *Particles*, and check the box to set the background to be *Transparent*. Name it "Tornado." Put this layer between our replacement clouds and our foreground.

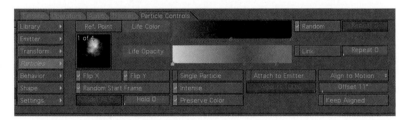

Step 3—In the *Particle Controls* tab, go to the *Library* and open *Natural/Organic*. Use the *Twister 2* setting. Use the *Point Emitter* tool to place your tornado particles on the screen.

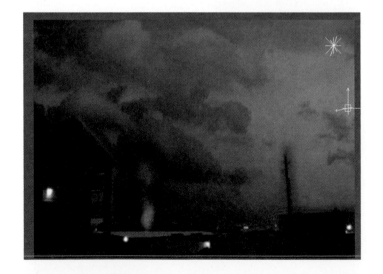

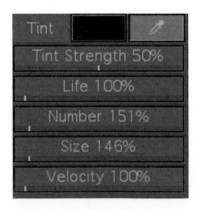

Step 4—Open *Twister 2 > shadow* and, under *Particles*, turn on *Intense*. Under *Emitter*, give it a dark blue *Tint* with a 50% *Tint Strength*.

Step 5—Apply a new *Operator* to our Tornado layer; this time we'll use *Blur > Pan Blur*. This will work in a similar manner to After Effect's *Directional Blur*. Set the *Quality* to 100, *Angle* to 90 degrees, and *Amount* to 15.

Done—In a similar manner to how we finished the effect in After Effects, duplicate the storm scroll background and use a *Draw Mask* operator to cut out a cloud to place over the top of the tornado. There you are, a fine twister.

PRO*files*

Jonah Goldstein: Director/Cinematographer

Jonah Goldstein is a notoriously reclusive Brooklyn-born director and cinematographer who surfaces occasionally for idiosyncratic collaborations with such varied artists as counterculture icon Crispin Glover, the sketch comedy group The Lonely Island, actor Kal Penn, he's the fourth member of the comedy group Chad, Matt and Rob. Chad, Matt and Rob's comic shorts have been some of the most widely watched on YouTube.com. After gaining acclaim as a sound designer and editor of motion pictures, with works screening at the Sundance, Urbanworld, SXSW, New York, Human Rights Watch, and numerous other film festivals worldwide, Goldstein shifted gears toward directing and cinematography. He began shooting digital video shorts for the Web and has since directed several music videos and television pilots. He currently resides in Los Angeles and spends much of his spare time riding the bus.

1. Describe your job or position in filmmaking and how you got there.

I am a freelance director and director of photography based out of Los Angeles. After film school, I spent a while working in postproduction in various capacities. Having started in editing provided me with a foundation for understanding how the images I shoot will come together in the editing room. Eager to shift focus to my own film projects, I collaborated with friends on short video projects that were posted online. With each project I experimented with the conventions and techniques that inspired me. As the projects grew numerous, they grew more and more ambitious—from video shorts to TV pilots to music videos. Along the way, these projects that I began doing for fun had become my life.

2. What was the one moment when you knew for certain that this was going to be your career?

Having grown up in New Jersey, filmmaking had never occurred to me as being a career option. It wasn't until my senior year of high school when a friend of mine went off to film school that it dawned on me that people do actually work on films for a living. At that moment, I started writing scripts and shooting videos with my friends. It still doesn't make sense to me that someone would choose to become a doctor or engineer over being a filmmaker. I mean, I'm thankful there are people that disagree with me, but let's face it, even at its worst, making movies is way more fun!

3. What software (or equipment, whichever is more applicable) do you use?

The Panasonic AG-HVX200A camera is a personal fave. I love having the ability to work on a 24P mini-DV camera with a memory-based storage system. The ability to have instant playback in-camera is so incredibly helpful, not to mention the fact that it eliminates the need to digitize your footage. You just import the files directly into your editing program. It has a very intuitive user interface. It is perfect for extended handheld shoots due to its light body weight. Also, the camera looks similar to some consumer cameras, appearing deceptively inexpensive, which is advantageous when shooting on the sly.

4. What movie do you wish you worked on? In what capacity?

I wish I had been able to work on Darren Aronofsky's **Requiem for a Dream** in the camera department. Just to be able to overhear the exchange between the director and his DP, Matthew Libatique, would have been an incredibly informative experience. The two are so precise in constructing their visuals because they are aware of how visual language serves as a metaphor to enhance the film. Being able to listen in on their process would have been a dream job for me. Both the director and DP commentaries on that DVD fall among the more insightful commentaries I've come across to date.

I wish I had been able to work on Wong Kar Wai's **Fallen Angels** in the camera department. It is one of the most visually beautiful movies ever made, so if I were able to overhear the exchanges between the director and his DP, Christopher Doyle, a cinematography legend, that would have been incredible. The visual grammar and style from that film have continually inspired me for as long as I can remember. It's a film where I enjoy dissecting the shots.

5. Is there a shot technique used in that movie that really made an impression on you?

Requiem For A Dream is a film composed of so many iconic shots for me that a lot of visual techniques left impressions. The camera rig strapped directly to the actors was particularly inventive. The use of an extreme close-up in the hip-hop sequences is very memorable. The shot of Marlon Wayans in prison toward the end when he screams and the entire frame around him skips. Amoeba Proteus did an amazing job with the effects, and there are quite a lot of them for an independent movie with a modest budget of $4.5 million. The one shot that stands out is in a scene where Harry is seated with his mom at the kitchen table next to a large window. The window creates a low-key lighting effect and the camera starts on the bright half of Harry's face and slowly moves to the dark side of his face as he notices his mom's teeth chattering from her pill addiction.

6. Where do your ideas come from? What inspires you?

My ideas often come from real life observations, and usually at inopportune times, such as when I'm about to fall asleep or I'm in the shower. Basically whenever writing it down is inconvenient. Locations also inspire me. Atmosphere.

7. Share a visual effects technique that you use with our readers.

Tell us why you like it so much. This can be anything from something that you do in a visual effects software package, editing software package, or something on the set, in camera, anything you'd like to share with the readers.

A very simple effect that I often use while editing is removing frames. It is a great technique to add kinetic energy to a shot. By snipping out one to four frames in small chunks in the time line, you speed up the action and make the movement more erratic and jumpy. This is a technique that I will often employ in a fight scene. Punches, falls, kicks, and crashes all hit harder with the added emphasis of missing frames.

8. Is there a resource that you use, like a book, magazine, or Web site, to get ideas for techniques?

Book-wise, I'd have to recommend Hennessey + Ingalls, which is a bookstore in Santa Monica, California, which caters to the visual arts. Most science or art museum bookstores are treasure troves of ideas. As far as the Web goes, Flickr is an enormous photography and video collection that I get a lot of ideas from. VDB.org (Video Data Bank) is a great site for films by and about contemporary American artists and provides a wealth of innovative ideas. DeviantART.com is another site for user-created art content. I also recommend checking out magazines and Web sites for both "Wholpin" and "Make." There are numerous do it yourself sites that feature instructions on how to make rigs and mounts for your camera, including a $14 steadicam.

9. If you were going to give our readers a homework assignment, what would it be?

I would have them combine two of the techniques that they've learned in a single shot. Combining these and other techniques in new and inventive ways will make their work stand out.

10. Do you have any career advice for up-and-coming filmmakers?

Don't ever be afraid to experiment, collaborate, or share your work! Don't be afraid to pick up a camera and shoot right now! Sometimes you shoot on a borrowed Hi-8 because that's what you have access to. Don't limit yourself because of budget! Make your budget work for you. The more you shoot now, the more mistakes you'll have made to learn from later. Breathtaking cinematography and special effects are nothing without a good story.

SCIENCE FICTION

Pointy ears, little green men, aliens, and robots, all I can say is *I've got a bad feeling about this*. All kidding aside, I, like many from my age group, fell in love with the sci-fi genre first through the power of the force. Science fiction has a long history with special effects and, necessity being the mother of invention, it's in constant need. This chapter goes through modern solutions for many visual effects issues that relate directly to this genre.

Although the genre has the long shadows of Trek and Wars cast over it right now, science fiction film has existed since the dawn of the medium itself. Georges Melies' 1902 film **A Trip to the Moon** not only kick-started the sci-fi film genre, it also featured some dazzling (by the standards of the day) effects shots. Unlike many other genres, sci-fi extends directly from a rich literary tradition, which it is still heavily indebted to.

Sci-fi, a high-budget genre right now, has its roots deep in low budgets. Throughout the late 1930s and 1940s the genre was tied to a B-movie reputation, but in the 1950s the big-budget sci-fi film emerged with **Destination Earth** and **The Day the Earth Stood Still**. In the 1960s the genre was transformed, with the social consciousness of **Planet of the Apes** and the stunning effects of **2001: A Space Odyssey**. However, the genre went wild in 1977 with the arrival of **Star Wars** and **Close Encounters of the Third Kind**. Throughout the history of sci-fi these films were judged more often by the quality of their special and visual effects than anything else.

By the time of the 1997 **Star Wars** rereleases, it had become clear that the next arena for the genre was inclusion of CGI VFX. As usual with the genre the success of these effects will make or break a movie.

Creating a 3D Planet Earth

Planets are a great introduction to primitive 3D shapes; in this tutorial we will make a space background and a rotating Earth.

Ingredients

- A satellite photo of the Earth from NASA's Visible Earth Images (which you can download for free from http://visibleearth.nasa.gov/)
- A space background we will create in Photoshop

The Design

Step 1—Create a new document and fill it with black.

Step 2—Duplicate the black layer, rename it "basic stars," apply *Effects > Noise > Add Noise*, and add 17% noise, with *Gaussian* and *Monochromatic* checked. Then apply *Image > Adjust > Levels* and move the *midpoint* arrow past the end of the histogram.

Step 3—Duplicate the "basic stars" layer. Make a selection of the black area with the *Magic Wand* and fill it with white using the *Paintbucket*. Follow that with the *Blur Tool* to give our space some depth and dimension.

Done—Make another new layer, name it "bright stars," use a three-pixel brush, and periodically make a larger star in a few places around the screen. Use the *Blur Tool* to blur it down.

The Effect

Step 1—Import our newly created space.psd into After Effects and the earthmap.jpg from NASA's Visible Earth at http://visibleearth.nasa.gov/. Place the two layers in a new *composition*.

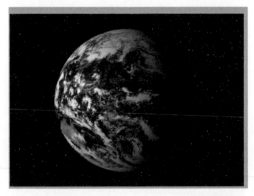

Step 2—On the earthmap.jpg layer, apply *Effects > Perspective > CC Sphere*.

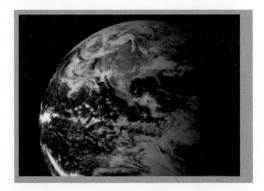

Done—Set keyframes for CC Sphere's *Y Rotation* to make the Earth rotate. For a very fun effect, try setting *Scale* and *Position* keyframes on the earthmap.jpg layer and do a zoom-out effect. You can't tell from this distance, but I started my zoom out from Texas.

The Options

Step 1—Import the space.psd and earthmap.jpg into Motion, making sure that the earthmap.jpg is above the space.psd.

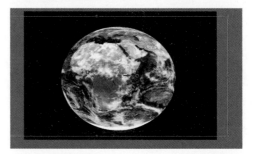

Step 2—Apply *Filters > Distortion > Sphere* to our earthmap .jpg layer. Adjust its *Radius* settings until it appears to be a complete globe.

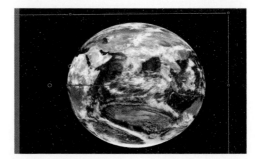

Done—An unfortunate nuisance of the *Sphere* effect in Motion is that it doesn't have full 3D *Rotation* control. So to create the illusion of the effect, set keyframes moving the X points to the right on the *Sphere* effect while setting *Position* keyframes on the earthmap.jpg layer moving to the left, which will cancel each other, leaving the earth in the middle appearing to rotate.

Alien Planets

What if we want to create our own planets? The following tutorial goes through the creation of a fly-through shot in deep alien space.

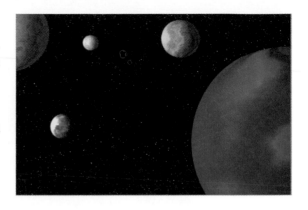

Ingredients

- The space background we created in Photoshop for a previous tutorial

The Effect

Step 1—Once you've made the space.psd from the previous tutorial, it's a good idea to keep that in a folder on your machine, as you may need it more than a few times. Import the space.psd into After Effects and make a new *Solid* layer above the space layer, renamed "planet 1."

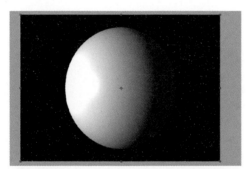

Step 2—On the planet 1 layer, apply *Effects > Perspective > CC Sphere*.

Step 3—Add *Effects > Noise and Grain > Fractal Noise*; you can use my settings in the preceding figure or you can experiment on your own. It's an alien planet so there's no right or wrong looks here, although I recommend using a blending mode other than *Normal* so that we don't lose the shading that the *CC Sphere* effect gives our planet.

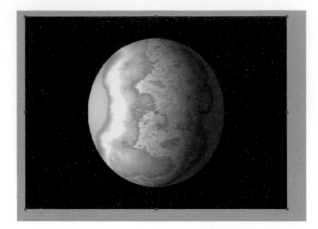

Step 4—Now to give it color, apply *Effects > Color Correction > Colorama* and/or *Effects > Color Correction > CC Toner*. Try out different looks and blending options. If you are concerned about losing the shading, duplicate CC Sphere and use it lower in the effects order.

Step 5—Duplicate the planet 1 layer four times and rename them so that the layers are planets 2, 3, 4, and 5. Turn on the *3D Switch* for each layer.

Step 6—Almost any time I work with After Effects' 3D layers I often switch to the *Top* camera view to see how things are playing out spatially. Stagger the planets out; in this case, set the furthest planet out so that its *Position* in Z space is around 10,000. Try making the closest around –350. Create a new *Camera* layer. Turn on *Depth Of Field*. Adjust the *Blur Level*, *Focus Distance*, and *Aperture* to your taste.

Step 7—Animate the *Position* and *Point of Interest* to have the camera weave through the planets. The *Position* controls where the camera is, and the *Point of Interest* controls which direction the camera is facing. Avoid having the camera directly face planets from the right left side, as it will show that they are only two dimensional. With some careful keyframing it should not be hard to do.

Step 8—This is optional, but if you think you'd like to add a Saturn-style ring to one of your planets, make a new oval-shaped *Shape Layer*. Go to the *Fill* options menu and click the red slash to tell it to have a stroke with no fill. Add *Effects > Blur* and *Sharpen > Radial Blur*, put the center in the middle of the planet, and set the *Amount* to about 7. Use a rectangular Mask with Inverted checked over the part of the ring that should go behind the planet.

Done—To give it some more dimension, try adding a light layer so that the shading is not always so even. Although it might be overkill, add *Rotation* to your alien planets.

The Options

Step 1—In Motion, import the space.psd and drag an instance of *Generators > Clouds* to its own layer above the space.psd.

Step 2—Apply *Filters > Distortion > Sphere* to your clouds.

Step 3—Apply *Filters > Color Correction > Colorize Gradient*.

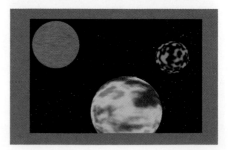

Step 4—Make more planets using this method; you can substitute the *Clouds* Generator with *Cellular, Noise,* and *Noise.* You can also vary the colorization method.

Step 5—Add a new *Camera* layer and adjust the spacing between the planets. As with After Effects, the virtual cameras in Motion work in a similar manner, so switching to the top view is very helpful.

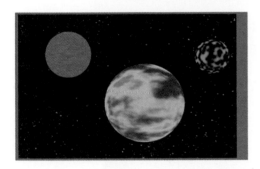

Done—Create keyframes for the *Position* parameters of the camera layer; the Z position is likely the most useful here. Open the *Keyframe Editor* window; it's quite helpful. To animate the camera's angle, set keyframes in its *Inspector* for *Angle of View.*

Star Fields and Light Speed

In this tutorial we will start by creating a moving space background and then add in a jump to warp/light-speed style animation to end it.

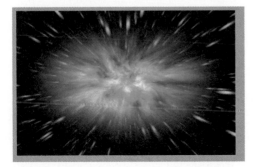

Ingredients

- The space.psd background created previously in Photoshop

The Effect

Step 1—Import the space.psd into After Effects and put it into a new *composition* set 5 seconds and 15 frames. Make its *Scale* slightly larger than 100 and give it a slight *Position* animation.

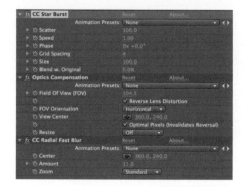

Step 2—Make a new solid and rename it "star field." *Apply Effects > . Simulation > CC Starburst,* set the Speed to 1.0 and the Size to 45". *Speed, Size and Effect > Simulaton > CC Starburst* Change the speed of the *CC Starburst* effect from –1 to 1.

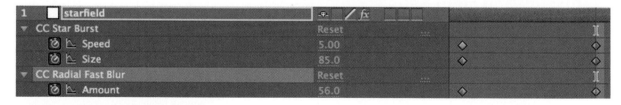

Step 3—Now that we have stars moving toward us, let's add in the hyperspeed blast. After about 2 seconds of floating stars we can start by setting keyframes to increase the speed and size of our stars. Over the course of the next 15 frames increase the Speed from 1 to 5, and the *Size* from 45 to 85. Apply *Effects > Blur and Sharpen > CC Fast Radial Blur* over the same 15 frames and have it increase from 0 to 56. This will create the stars-into-lines look.

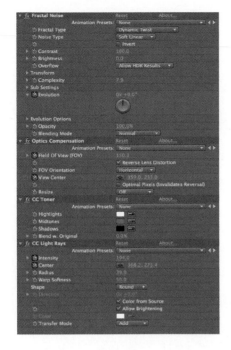

Step 4—I've included a preset for *Light Speed*, which is made up of a combination of these effects in order:

- *Effects > Noise* and *Grain > Fractal Noise* (to create the texture, set to *Dynamic Twist* and *Soft Linear*)
- *Effects > Distort > Optics Compensation* (to bunch the effect up in the center, set *Field of View* to 150 and put the *View Center* in the center)
- *Effects > Color Correction > CC Toner* with *Highlights* set to white, *Midtones* set to blue/cyan, and *Shadows* on black
- *Effects > Generate > Light Rays* set *Intensity* to 150 (to add light beams)

When you come up with a combination of effects that you like and feel like you would use again, highlight all the effects and drag them to the **Effects and Presets** window, this will create a new preset.

Step 5—At the 2-second mark, set a keyframe for *Fractal Noise's Scale*; start it small at 11 and increase it to 98 at the 5-second mark. In the final 15 frames have it go from 98 to 200. Also at the 5-second mark set keyframes for *Optics Compensation's Field of View*, start it at 150, and have it increase to 175. Start the stopwatch for *CC Light Rays' Intensity*; at the 5-second mark and at 5:15 increase it to 1500.

Step 6—To make it feel organic and lifelike, I added keyframes using *Wiggler*, for *Fractal Noise > Offset Turbulence*, *Optics Compensation > View Center*, and *CC Light Rays > Center*. Now *Pre-Compose* our light-speed blast solid and move the effects into the new *Composition*.

Done—Add an *Elliptical Mask* to our *Precomp* and set keyframes for *Mask Expansion*, starting it at the 2-second mark with the expansion set to –225 and increase it to 500 at the 5-second mark. So it blasts forward, and takes over, and next thing you know, you're at the other end of the universe.

The Options

Step 1—We have discussed the particle engines in After Effects and Combustion, so now let's address Motion's particle engine. Import our space.psd to the bottom *Group*, make a new *Group* above it, draw a tiny ellipse with the *Shape* tool, and fill it with *White*.

Step 2—Motion makes it very easy to turn any graphic into a particle emitter; with our little oval highlighted go to *Object > Make Particles.*

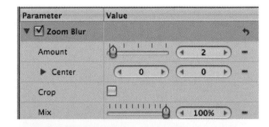

Step 3—Open the *Emitter* tab in the *Inspector* and choose *Wave* for the *Shape.* Keep the *Birth Rate* low for now, about 30. Also, add *Filters > Blur > Zoom Blur* to give our moving stars some streaks.

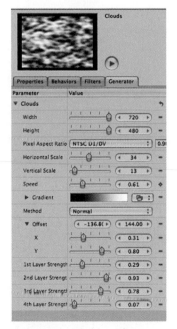

Step 4—Make a new *Group* and name it "warp window." Drag *Generators > Clouds* to our warp window group. Adjust the *Layer Strengths* until you have a texture that looks like the one in the figure. You may want to copy the settings in the figure or devise your own. Add *Filters > Color Correction > Colorize Gradient* to add color to our cloud's generator. I've used white, blue, and black.

Step 5—To give it some strong ethereal qualities, add *Filters > Glow > Light Rays*; also add *Filters > Distortion > Bulge* to give it a center.

Step 6—To animate the arrival of the warp window, put a *Circle Mask* on our Clouds and then set keyframes for the Mask's *Opacity* and *Scale*. Both should start at 0 and go to 100% over 10 frames. Also during these 10 frames set keyframes to increase the star field's Emitter *Speed* and *Birth Rate* and the *Zoom Blur's Amount*.

Done—For the final 10 frames of the animation, increase the amount of the Light Ray's *Glow* to about 5; also increase the *Scale* of the *Circle Mask*.

The Disintegrating Man

Having a character blow away like sand can become a painstaking process. Here's a quick introduction to the technique that was used in **Spiderman 3** to create the Sandman character. It's also handy for whenever you may need to make a character magically disappear.

Ingredients

- Footage of your actor for the effect
- A background plate (same shot without the actor)

The Effect

1	🎬 disintegratingman(treat).mov
2	🎬 plate.mov

Step 1—Make a new *composition*, 2 seconds long, in After Effects with our plate.mov on the bottom and the disintegrating man footage on top.

Step 2—Make a *Mask* around our actor. Add some *Mask Feather.*

Step 3—Apply *Effects > Simulation > CC Scatterize*, start the stopwatch for *Scatter* at the 15 frame mark, and leave it set to 0. At the 1-second mark, increase it to 24. Also start the stopwatches for *Left* and *Right Twist*, leave at 0 at the 15 mark, and at the 1-second mark increase the *Revolutions* to about 25 each. If you want a less obvious effect, use fewer revolutions.

Done—At the 1-second mark, start the stopwatch for *Opacity*. At the 1:20 mark, increase *Scatter* in *CC Scatterize* to 350. If you want more control over direction, you may have to use a more powerful particle engine, but this is the quickest way to achieve this kind of effect.

The Options

Step 1—We are going to take a slightly different approach in Combustion. Import the plate.mov and disintegratingman.mov footage into a new *Workspace* in Combustion.

Step 2—Add *Operator > Mask > Draw Mask* and mask out our actor.

Step 3—At the 20-frame mark, open the *Surface* options for the dis-integratingman.mov layer that we just created a *Mask* on and over the next 10 frames reduce the *Opacity*.

Step 4—Create a new layer, and at the 15 frame mark add *Operator > Particles*. From the Particle Library choose the folder called *Natural-Organic* and apply *Dust Puff*. Apply it with a *Point Emitter*. Under *Particle Controls > Emitter*, increase the size to about 385. Adjust the *Position* of the new layer so that it completely covers our actor during the puff.

Done—Just like that he's gone. If you want to try to color the puff differently, experiment with different colors and the *Tint Strength* under the *Particle Controls*.

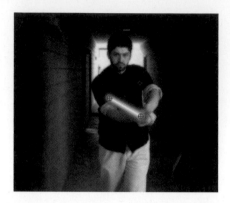

Light Sabers

Well, it is unavoidable, everyone wants to imitate a Jedi. Here's my version of this very common Web tutorial—how to act out your fantasy duel with the Sith. Please, no jokes referring to the TV series **Arrested Development**. Please note, I promise to avoid using cute little references from Jedi training scenes throughout the duration of this tutorial.

Ingredients

- A light-saber toy
- Footage of our actor using the light-saber toy

The Effect

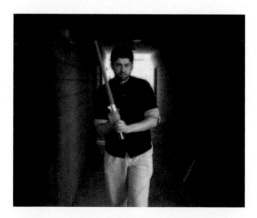

Step 1—As stated in the introduction, there are a number of versions of this tutorial floating around the Web. In this version, you will only have to worry about tracking two points instead of four and you won't need any special preset plug-ins. If you'd like to go beyond what is discussed here, videocopilot.com has an excellent version of this tutorial. Import our ls.mov into After Effects and create a new solid. Rename the solid "lightsaber."

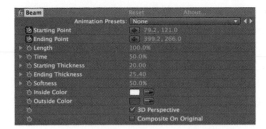

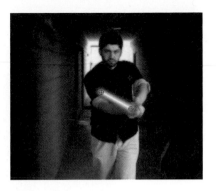

Step 2—For my prop, this $8 toy from Target totally sufficed. Apply *Effects > Generate > Beam* to our light-saber layer. Make the *Length* 100%, the *Starting Thickness* 15, and the *Ending Thickness* 20. This will make the light saber appear to be thicker as it gets close to the handle. Set the *Inside Color* to white and then choose your symbolic outer color. I always root for the bad guys, so I went with red like a Sith. Create a new Solid layer and rename it "light-saber".

Step 3—Enable *Motion Blur* by turning on the switch in the light-saber layer and the switch at the top of the time line. Open up the *Beam* effect and start stopwatches for *Starting Point* and *Ending Point*. Now, for the tedious part, use the Command-Right Arrow to go through each frame and adjust our two points. Keep the sword at the approximate same length at all times, and it's okay if one of the points goes off screen. The only time to shorten the sword is when it's pointing back, so occasionally turn off the visibility of the "light-saber layer".

Done—After this exercise, patience you'll have learned. Sorry, I did promise I wouldn't do that. Scrub through, and any place that things look off, make adjustments to the crosshairs for the *Beam* effect.

The Options

Step 1—Here's an alternate method that will free us up a bit. Open Photoshop, and with a nine-pixel, soft-edge brush, shift-click any two points on the screen, Photoshop will automatically draw a straight line between those two points. Apply the *Outer Glow* layer style, change the color to the one you want for your light saber, and increase the *Size* and *Noise*. Make a new layer and merge the two. Now we can bring this graphic into any program we want. If you like this look better than the one from After Effects, you can import this into AE. Save the file as lightsaber.psd.

▼ Distort													
Upper Left	−84.93 ,	−52.54		♦		♦	♦	♦			♦	♦	
Upper Right	203.81 ,	−104.27		♦		♦	♦	♦			♦	♦	
Lower Right	188.64 ,	59.82		♦		♦	♦	♦			♦	♦	
Lower Left	−77.91 ,	67.5		♦		♦	♦	♦			♦	♦	

Step 2—Five minutes spent in Photoshop allows us to finish the effect in Final Cut Pro! Import your lightsaber.psd into Final Cut and take the "light-saber layer" from the .psd (in FCP, .psd files come in as a sequence) sequence and place it above the ls.mov. Lock the layer for ls.mov. Open the *Motion* tab for lightsaber, and create keyframes for all four corners under *Distort*.

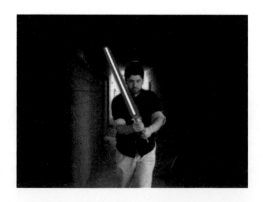

Step 3—In the Tool bar, hold down the *Crop* tool to find the *Distort* tool. Make sure that you have *Image + Wireframe* on in the *Canvas* window. Now go through frame by frame and adjust it accordingly.

Done—Check over your animation and make sure that you have everything matching up correctly. Also, before you finish make sure that you check on *Motion Blur* in the light-saber layer's *Motion* tab.

Morphing

Here's an effect that became popular with films such as **Willow**, **Terminator 2**, and **The Abyss**. This effect has no pre-CG equivalent; it was impossible without a computer. What if you have an object that must reshape and transform into another object? Well, you need to create a morph.

Ingredients

- A background plate; this kind of shot should be locked off on a tripod
- The same background, now with your first object; in our case, a plant
- The same background with the second object; in this subject, our Boston terrier, Bella

The Shoot

This kind of shot is going to be either way more difficult or impossible if it's not locked off on a tripod. Also, try as best you can, across the shots, to place objects as consistently as possible. With certain subjects that's not so easy.

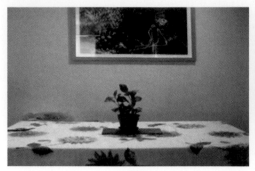

Despite my wishes, Bella refused to sit directly on the little tiles I had on the table. It's not the end of the world; however, it just means my masking will have to be more accurate (her ears are not over the picture, like I had planned, so that will change my matte strategy). Also, luckily because of how I set the shot up, her scale won't be that off if I move her back on the postside. However, try to avoid having to do these fixes if you can. Hire a less willful dog.

The Effect

Step 1—Import our three shots, start a new *Composition*, and put the morph_plant.mov over the morph_plate.mov.

Step 2—Create a *Mask* on the morph_plant.mov. Highlight the name of the *Mask*, hit enter, and rename it "plant." Also click the "Plant" *Mask's* color swatch and change from yellow to another color. This is not totally necessary, but will save you all kinds of hair pulling later, as this will get confusing.

Step 3—Put the morphb_bella.mov on the layer above the morph_
plant.mov. Go to the 1-second mark on the time line, make a *Mask*
on the morphb_bella.mov layer around Bella, rename it "Bella,"
and change its *Mask* swatch color to another color. Move Bella so
that she is now positioned over our tiles in the middle of the table.
Go to the morph_plant.mov and copy and paste the "Plant" *Mask*
to the morphb_bella.mov layer. Make sure that on this layer, the
"Bella" *Mask* is set to *Add* and the "Plant" *Mask* is set to *None*.
When you copy/paste a *Mask*, make sure that the copy lines up to
where the item you originally masked is located on the screen.

Step 4—Copy and paste the "Bella" *Mask* to the morpha_plant.mov
layer. On this layer our *Masks* should be set up *opposite* to how
we have it on the morphb_bella.mov. So the "Bella" *Mask* is set to
None and the "Plant" *Mask* is set to *Add*.

Step 5—Apply *Effects > Distort > Reshape* to both layers. This is excellent tool you hardly ever hear about anymore. It's a shame. While it has a rigorous amount of set up involved, it could be an application on its own.

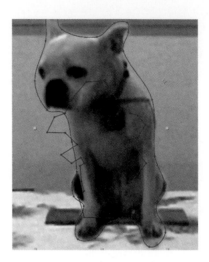

Step 6—Turn off the visibility of the morphb_bella.mov layer so that we can focus on our plant for right now. The *Reshape* tool requires at least two *Masks*: a *Source Mask,* which will tell After Effects that you want it to start at this shape, and a *Destination Mask*, which tells After Effects what shape it will become. On the morpha_plant.mov layer, set the *Source Mask* to be "Plant" and the *Destination Mask* to "Bella."

Step 7—In the *Reshape* effect, highlight *Correspondence Points.* These points tell the program what directions to go with our reshape. Option-Click to add a new *Correspondence Point* and click and drag to where you'd like it to go. In the end you want it so that the plant stretches out to fill Bella's shape.

Step 8—At the 1-second mark start the stopwatch for *Reshape's Percent*. Also at the 1-second mark, set a stopwatch for *Opacity* and start it at 100%. At the 2-second mark, increase *Percent* to around 100%. Now reduce the *Opacity* to 0. Turn on the visibility of our morphb_bella.mov.

Step 9—We will once again be doing the reverse on this layer. Set up your *Effects > Distort > Reshape* tool on this layer with the Bella mask as the *Source* and the Plant mask as the *Destination*. Set the *Correspondence Points*. Start the stopwatch for this layer's Reshape *Percent*; this time from the 1-second mark to the 2-second mark it will reduce from 100% to 0. Start a stopwatch for this layer's *Opacity*, having it increase from 0 to 100.

Done—See what's happening? The plant is turning into Bella as it disappears and as Bella appears she is turning from the plant's shape to her own. So it's kind of a very complex transition.

The Options

Step 1—Combustion 4 is packaged with the third-party Re:Vision plug-ins, which includes *Motion Morph*, which is specifically designed for this task. Let's begin by importing our footage.

Step 2—To the morphb_bella.mov layer, apply *Operators >
RE:Vision Plugins > Flex Motion Morph.* Set the *Warp "To" Layer*
to be morpha_plant.mov. Change the *Display* to *UNwarped
"From."* Go over to the *Toolbar.* You should see that the *Toolbar*
contains the following tools:

Use the *Polygon* tool and draw a shape around Bella. Rename the
shape "Bella"; the default name will be *Polygon.*

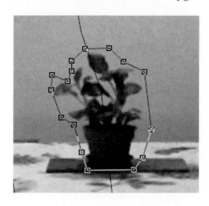

Step 3—Switch the *Display* to be *UNwarped "To."* Now make a
Polygon around our plant. Rename the Polygon "Plant."

Step 4—Return to the *Motion Morph Controls.* Now that we are all
set up, let's hook everything together. Turn on *Hold Edges, Auto
Align,* and *Smart Blend.* Set the *"From" Boundary* to be "Bella"
and the *"To" Boundary* to be "Plant." Be sure to change the
Display back to *Warped* and *Blended.*

Step 5—Go to the *Timeline.* Set keyframes for Motion Morph's
Global Shape and *Global Color* to start at 100 and go
down to 0.

Done—To make the effect more exciting, you can add more poly-
gons to function like correspondences from one to another. They
will connect automatically if you have *Auto Align* on. This effect
will create a more liquid look than the one from After Effects.

3D Spaceship Dogfight

Ah, the fun of watching the pursuit of two spaceships, locked in an intense dogfight; this tutorial is lots of fun, as it starts out like building models and ends with adding a shaky camera, **Battlestar Galactica** style.

Ingredients

- Our space background (created earlier in this chapter)
- Alien planets (created earlier in this chapter)

The Design

Space Ships, 3D Version

Step 1—The new 3D tools in Photoshop CS4 are great, but, if you want more control over a model that is not a simple 3D primitive, then you should create your 3D models in another software package, and use Photoshop for painting and creating surfaces. One quick solution is to download the super-easy to learn, free application from Google called SketchUp. Don't dismiss this tool because it's free. It's a professional three-dimensional drawing tool, and you can export .kmz files that can be painted in Photoshop. If you want to work off of the one shown above, I supplied it on the DVD; open the file called 3dship.psd

Step 2—Go to the *3D* panel and highlight the *Materials* section. Now target *material0_0* and go to the bottom of the 3D panel and open up the options for *Diffuse* and pick *Open Texture*.

Step 3—This will make a new *Smart Object*. It's basically a blank document where we will edit what will fill our 3D shape. Make a *Gradient* that fills the document. Use *Filter > Noise > Add Noise* (Gaussian, Monochromatic) to create some static on the surface. Then go to *Filter > Blur > Motion Blur,* and put in a high enough value to smear the noise effect to the point it looks like brushed metal. After this, it's up to you how slick or how beat-up and dirty you want your ship. I used the *Burn* tool, and I added *Filter > Texture > Craquelure* to give the surface some dimpling. When you are done hit save.

Done—Change any of the other textures you would like to adjust in this way. Save this file as a .psd and we can import it into After Effects as a *Composition Cropped Layers* and leave it so that Live Photoshop 3D is checked on.

Space Ships, 2D Version

Step 1—If you've ever built a model airplane, this will seem familiar to you. We need to create all the flat 2D panels for our spaceships. Create a new layer and use the *Gradient* tool. Start with black and white.

Step 2—Let's turn this into a surface, apply *Filter > Render > Fibers*, and then *Filter > Texture > Craquelure*. After that, use the *Blur* and *Burn* tools to give the surface variety.

Step 3—Afterward, switch to a large brush and some browned splotches. It'll give your ship some much-needed roughness.

Step 4—Duplicate our texture layer and turn off the visibility of the original. Rename the copy "wing." Make a *Path*, in a triangular wing shape. Turn it into a selection, inverse it,

and hit delete. Now we should have an image that we'll use for our wings.

Step 5—Duplicate our texture layer again. Use a path to make a polygon shape for the cockpit; make a selection from it and inverse it. Hit delete. Name the layer "cockpit panel." Duplicate it, rename it "cockpit_window," and make a new layer. On this new layer make an oval shape, fill it with blue, and apply the *Bevel and Emboss* layer style. Merge this layer and the "cockpit_window" layer.

Done—In a similar manner to this, make all the parts you think you will need for your spaceship. You'll need at least wings, a cockpit, and a hull body. Also, make at least two separate versions, one for each ship you need for your scene.

The Effect

The process described in this tutorial is fairly complicated because we are pushing After Effects into realms it was not exactly designed for; this process is likely handled easier in a 3D software package. However, if you don't use a 3D software package, this tutorial is an excellent way to prepare to use one.

Step 1—Alright, time to have some fun. Import the *Space* background and add some planets as described in the previous tutorial, Alien Planets. Check on their 3D switches, *Precompose* them, and name it "space." Set this up to be larger than normal screen size, about twice the size of DV.

Step 2—Import your spaceships as *Composition Cropped Layers*. Place these new *compositions* in our time line. Using the square "Hull" layer, duplicate it three times and make a 3D box. Do this by making three copies of it, setting two to have a *Rotation* of 90 degrees on the Y axis and the other two to have a 90 degree *Rotation* on the X axis, and drag them into position. *Precompose* these layers.

Step 3—Now let's put together our cockpit section. Bring in the cockpit_panel layer and cockpit_window layers. Duplicate the cockpit_panel layer three times. Because it's not just a box anymore, our polygon shapes have to be on angles. To get the four of mine to work together I used the numbers shown earlier. Now you could try to do it this way or you could use the *Rotation* tool and then round the numbers off, whichever works best for you. *Precompose* these layers and name it "cockpit."

Step 4—Drag in the wing layers, duplicate them three times, and now set the angles, remembering that these will largely be dependent on what angle you set the wings up on in Photoshop. Follow the numbers given previously if you are using the same as mine.

Step 5—Now that our ship is ready to take flight, put up the four camera views to check over your work. You should have five layers, our two *Precomps*, and the wings. Make sure that they all have their 3D switches on; the two *Precomps* should also have *Continous Rasterization* checked. *Precompose* all the ship layers and call it "ship1."

Step 6—Repeat the process (or should I call it an ordeal at this point?) that we just went through to create another ship. Put the two ships in a *Composition* with the space background. Make the space background sit far back in Z space by setting to about 2000. Move the ships to be in front of the space in Z *Position*. If you use the *Rotation Tool* you can move the entire ships in 3D space. Start the stopwatch for both *Position* and *Rotation* for both ships. Using these in conjunction you can definitely simulate a great chase.

Step 7—To add laser fire, create a new solid layer, apply *Effect > G enerate > Beam*, and animate its *Position*. Also, to change its appearance over time, animate the *Starting Point* and *Ending Point. Parent* this layer to the ship you want it to fire from.

Done—There's a million things to try out with this effect, but there's just one or two more that I want to be certain to highlight. Add a new *Camera* layer. Turn on *Depth of Field* and set it to be 20 millimeters. Now animate the camera floating around the action. To make it feel like **Battlestar Galactica**, use the Wiggler to add some randomness to the camera movement. Also try adding in a virtual rack focus by animating the *Aperture* and *Zoom*.

The Options

Step 1—Similar to how we set this up in After Effects, import your spaceship parts document in Motion as project and bring in all layers. Convert this to a *3D Group*, name it "ship1," and make a new *3D Group* inside of our ship group. Put the hull panel in there and make three copies; call this group "hull." Do the same for the cockpit. Finally, make a third *3D Group*, put the wing in here, duplicate it twice, and name the group "wing." Create a new *Camera* layer.

Step 2—Use the *Rotation* and camera angles to turn all the parts so that the shape looks like the ship shown previously. For the hull, set the left and right sides to have a Y axis *Rotation* of 90 degrees; the top and bottom should have an X and Y of 90 degrees. For the cockpit, the top and bottom should be set to 25 and −25 on the X axis, for the left and right, the same X axis settings, and a Y axis setting of 90 degrees. For the wings, the dorsal wing should be −90 degrees on Y, for the left wing, use −90 for X and Y, and the right wing X should be 90 and Y should be −90. Repeat this process for your other ship.

Done—Now import the space background into a separate *3D group*, call it "Space," and position far back in Z space. Now you are ready to take off; enjoy!

PRO*files*

Jerron Smith: Editor, Animator, Educator

A multifaceted artist and video producer with nearly two decades of experience, Jerron works in multiple media. He has experience in both digital video/television production and postproduction work, as well as extensive knowledge of the Web and print design industries. He serves as an adjunct instructor in the Communication Arts Department at the New York Institute of Technology and the Art Institute Online, where he instructs courses in computer graphics and editing.

1. Describe your job or position in filmmaking and how you got there.

I am a motion graphics artist. I build onscreen graphics for use in television and video productions. Basically, I enhance what can be achieved by just shooting video. I was trained initially as an illustrator but over the years worked through just about every type of gig you could do as a creative until I landed in video and really loved it.

2. What was the one moment when you knew for certain that this was going to be your career?

I'm still not sure, I might still decide I want to be a Buddhist monk or something. Actually my family is very artistic, my brother is an illustrator and my mother dabbled with art her entire life, mostly painting. So we never had a shortage of art materials and I have been drawing and painting since I was a kid. But it was when I saw **Star Wars** for the first time that I really thought I wanted to do this. So I tooled around for years, picking up

various skills and like some others kind of getting a little burned out cause I felt that so much stuff in the industry was just unoriginal. Then a few years ago I saw a movie, **Sky Captain and the World of Tomorrow**. The movie was horribly written but showed a whole new artistic way to use effects and graphics and I was hooked again.

3. What software (or equipment, whichever is more applicable) do you use?

Let's see: After Effects, Photoshop, Illustrator, and 3D Studio Max are my bread and butter applications. For hardware I just use a lot of traditional art materials and a lot of stuff I find on the street; I am always taking shots of interesting textures, spider webs, mold, anything I can use to create an unusual effect in my work. I have also been known to do some creative work with scanners and microscopes. But the fact is I will use just about any piece of software or hardware to get the effects I need. Because that is what it is about, getting the right feel and mood.

4. What movie do you wish you worked on? In what capacity?

There are two projects I wish I had worked on: The first is any **Star Wars** film and the second is **Sky Captain and the World of Tomorrow**. The effects/graphics for the **Star Wars** franchise are done by I.L.M. (Industrial Light & Magic) who have to be the best effects company in the world without a doubt. And **Sky Captain**, while a box office failure (mostly because of the really weak story in my opinion), was a groundbreaking accomplishment when it came to creating virtual worlds and artistic-looking graphics. To be honest I don't care what position I could have had on the films; while I would have loved to work as one of the CG artists, to work on either of those projects I would have been willing to be the guy who babysits the render farm overnight.

5. Is there a shot technique used in that movie that really made an impression on you?

For the new **Star Wars** films the photorealistic graphics had to be the most important part. For the second film, **Attack of the Clones**, apparently they didn't make a single piece of clone trooper armor, every shot with that clone is completely digital. That is quite a feat. And with **Sky Captain** the look and feel of the film were impressive, how every set, every environment looks hyper real, like the 1950s interpretation of what the future would be.

6. Where do your ideas come from? What inspires you?

Everything in life inspires me. I am a big believer in looking at everything you can find around you to get ideas. Art doesn't happen in a vacuum. You need to see the work of others, and I am not talking about other effects artist or designers. We still have a lot to learn from the old masters such as Rembrandt and Da Vinci. I am a student of art history and always will be, and I think my work is better for it. But also there is a lot we can learn from nature and observing the natural world around us.

7. Share a visual effects technique that you use with our readers. Tell us why you like it so much. This can be anything from something that you do in a visual effects software package, editing software package, or something on the set, in camera, anything you'd like to share with the readers.

One of the things that I am always trying to do is create a sense of depth and texture in my work. Too often computer-generated imagery looks fake and too perfect. If you can tell it is computer generated I have a problem with that. I have been known to try all sorts of crazy scanning and photography/videography tricks. I built a little covered scanning station attachment for my scanner. It was basically just a shoe box I painted white and put a piece of clear plastic over the opening. I could lay it flat on the scanner and scan liquids like mercury. My idea was always to try and give the producer something they hadn't quite seen before.

8. Is there a resource that you use, like a book, magazine, or Web site, to get ideas for techniques?

I read everything I can get my hands on. I love the computer graphics magazines that come out of the UK. Their CG work is considered more of an art form than it is here. Americans tend to focus more on the technology than the artistry involved. My favorite magazine of all time has to be 3D World, followed closely by Computer Arts and ImagineFX.

For anyone serious about computer graphics, I suggest becoming a member of the CG Society (www.cgsociety.com); they run one of the most informative Web communities around CGTalk.

9. If you were going to give our readers a homework assignment, what would it be?

Imagination exercise: More important than technical mastery is the ability to create, to think in directions that other people do not. Developing one's imagination is one of the most important endeavors for an aspiring or current CG artist.

Close your eyes, go on close them. Imagine the cutest animal you can think of. The absolute cutest and most cuddly animal to ever walk the planet is your goal here. Got it? Now imagine what would happen if he walked through a puddle of toxic waste, would it turn him into a horrible mutant or a super being? Would he use his new found powers for good or ill? In your mind form how he would change both physically and mentally, build this character in your head, and then try to create him on paper, screen, or whatever your medium of choice is.

Exercise your imagination every day.

10. Do you have any career advice for up-and-coming filmmakers?

Don't do this because you want a cool job or because you want to make a lot of money, you won't last. Do this work because it is your passion, because you can't imagine anything else with your life except creating film or video or TV or graphics or games or whatever. The people who do well in this type of thing, because it is really hard and time-consuming and heartbreaking at times, are the ones who are obsessed with it. It has to be what you love, or you won't last.

FLASHY TECHNIQUES

A movie will come out and then all of a sudden that very cool speed/ up–slow/down camera move is everywhere—commercials, music videos, TV shows!

In this day and age of the Internet, moving information around quickly, people are finding out how a VFX shot is achieved and it spreads like wildfire.

Here's the key to some of the most popular techniques that have been everywhere over the last couple years, so these will probably be so over by the time this book comes out. It's very important to expand your repertoire, so anytime you see a technique that you like, look it up and find out how it was done.

Frozen Time

This is an effect that's been around a while but has become very popular after being used recently on **Heroes**. Basically we are going to freeze one element of a moving frame. This is a low tech version of the Heroes effect. They use very complicated braces to hold live actors in place, with 3D models of the frozen objects. In this version, you can achieve a very similar effect with much less expensive readily available tools.

Ingredients
- A shot with action we'd like to freeze
- A shot we would like to run continuously with the same frame as the first shot

The Shoot

The key to this effect is having the action we want to freeze in the foreground. We do this so that there's minimal area to *Mask* out; also, you don't want the object that will be frozen to move toward the camera because it will be getting larger in the original footage and ultimately your *Mask* won't work.

It's highly recommended that this shot be done on a tripod, as a frame change can really show our hand in this illusion. Also, if you want to emphasize the effect strongly, choose an action that has an immediate physical response. Like here, for example, I'm throwing a rubber ball up; the viewer knows that the ball should return by falling right back down, but it doesn't, it hangs there, thus emphasizing the freeze.

The Effect

Step 1—Import our ballshot.mov and put it into its own After Effects *composition*. Duplicate the shot and rename them "background" for the original and "ball freeze" for the copy. Trim the "ball freeze" so that it begins at 2:14, where the rubber ball has gotten as high as it will go.

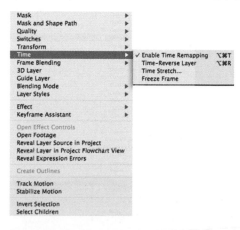

Step 2—On the "ball freeze" layer, create a *Mask* around the left-hand side of the screen. Increase the value for *Mask Feather*.

Step 3—On the "ball freeze," go to *Layer > Time > Enable Time Remapping*. When using the Time Remap functions, you can keyframe the speed of the shot down to the exact frame you want. We will use it to freeze our ballshot footage. Set a keyframe at marker in the time line 2:14 for the correct time, 2:14. At the 3:20 marker, set another keyframe for Time Remap, but it will also be set for 2:14. So for the 1 second and six frames we will see the ball frozen in the air.

Done—By 3:20, I leave the frame. So after I'm gone, we can let the ball fall now. So go to the marker for 3:29 and set the Time Remap tool to the time of 2:28. Now, after I have left the frame, the ball falls. Time froze, then resumed.

The Options

Step 1—Import the ballshot.mov to Final Cut Pro. Drag and drop it to the time line, drag and drop another instance of the shot to the layer above it, and trim the copy on V2 to begin at 2:14.

Step 2—On the copy of the shot on V2, apply *Effects > Video Filters > Matte > Four Point Garbage Matte*. Use the matte to isolate the left-hand side of the screen.

 Time Remapping is one of the most exciting tools in After Effects. Using either the graph editor or the layer, you can speed up and slow down a piece of footage at will. In this example we are using it to freeze a shot for a few moments, but that's just the beginning of its capabilities. If we wanted the rubber ball to float up and down, we could set keyframes sending it backward and forward in time. Looking at your time graph, the height of the keyframe on the left-hand side is the keyframe's place in the full time line of the shot, so if you haven't done anything with time remap, it should appear as a diagonal line increasing in height over time as pictured.

If keyframes have been added that keep the line consistently straight, as pictured here, the shot will freeze for as long as the graph's line height is not increasing.

In the graph that follows, you'll see something like a triangle, so from 0 to 4.5 it's going forward in time (but at twice the speed); when it hits that keyframe there in the middle, it reverses (still at twice the speed).

Something like this will create a looping, stuttering effect.

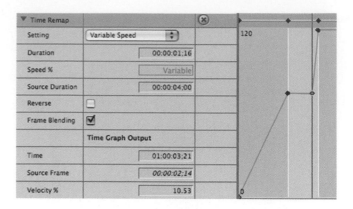

Done—Go to the *Motion* tab for the ballshot footage on V2 and change the *Setting* to be *Variable Speed*. Go to the 3:20 mark on the time line and Option-Click to a new keyframe, in the time graph for *Time Remap*. Set this keyframe to be 2:14 at 3:20; the graph should have a straight line, representing the time that the shot stays frozen. Because the last keyframe is automatic, it'll resume the shot on its own after 3:20.

Time Remapping

Popularized in many music videos and films, the speed-up/slow-down effect commonly seen got particular attention in the film **300**. Thanks to digital VFX tools, it's easier than ever to speed up and slow down the footage.

Ingredients

- The shot you'd like to apply the Time Remapping effect to

The Shoot

For this effect to get its best result, you should use a shot that has a lot of movement, followed by a stop. In this example we'll use a hand-held shot as the cameraperson moves up to the actor and then holds on his face.

The Effect

Step 1—Open our time-remap.mov into After Effects and put it in a new *composition*. Enable *Frame Blending* and *Motion Blur* and turn on our layer's switches for each. Go to *Layer > Time > Enable Time Remapping*.

Step 2—We land at our actor's face at around 5:15, so that the audience gets a good sense of the speed up we need to compress that time, so set a *Time Remap* keyframe at the 20 frame mark to 5:15. It is helpful to jump over the *Graph Editor* and apply *Easy-Ease*, which will smooth our transitions from speeding up to slowing down.

Step 3—At 5:20, set a *Time Remap* keyframe for 6:15. This will give a real slow down, stretching a 1-second period of time over the course of 5.

 When **Frame Blending** is enabled, it achieves this effect by one of two methods. If you go to *Layer > Time > Frame Blending* you will see that you have three choices: Off, **Frame Mix,** or **Pixel Motion**. When you use any kind of Time Remapping effect, the computer must generate frames if you slow the footage down; conversely, if you speed it up, it must eliminate frames. If Frame Blending is Off, After Effects will not attempt to smooth out this change to the footage and the result will be kind of a jerky, stuttering effect. You may want this effect.

However, in many cases you won't want this to occur. In that case, you can apply **Frame Mix**. This mode will generate new frames by mixing frames that already exist. For example, if After Effects has to make four new frames between two existing frames it will do so by creating four frames that will gradually blend the first and last existing frames.

The other option is to use **Pixel Motion**. What this mode does is analyze the two frames and rather than just blending them, it creates new frames by judging the two existing frames and generating new frames in between using motion vectors to generate frames that more naturally generate new frames between the existing frames.

Either mode of **Frame Blending** will increase your render times, although **Pixel Motion** will be much more of an increase to that render time than **Frame Mix**.

Step 4—We can also add something to the shot that it doesn't have, a pull out. Go to the end of the time line and change the last keyframe from the time it has to 0:00. This will force it backward; if we use the graph editor to make that last keyframe an *Easy-Ease* keyframe, the transition will be smooth.

Easy Ease can be found in the *Animation > Keyframe Assistants* menu. Here you will have options for adjusting how your keyframes behave. **Easy Ease** smoothes the motion so that when an animation parameter approaches the keyframe it adjusts it; it's not a sudden harsh change. **Easy Ease In** and **Easy Ease Out** can be employed when you only want to smooth out either going into a keyframe or coming out from a keyframe.

Done—To add some extra emphasis to this effect, I've added *Effects > Time > CC Wide Time*. This leaves frames as artifacts on other frames. Turn on *Geometric Motion Blur* and make *Forward Steps* 2 and *Backward Steps* 1. Also consider adding *Effects > Blur > CC Radial Fast Blur* set to *Zoom*. If you apply this during pull in and pull out, it will really amp up the feeling of speed.

The Options

Step 1—Import our *Time Remap* shot into Combustion and then add an *Operator > Timewarp*.

Step 2—Go to the tab labeled *Timewarp Controls* and, under *Interpolation Controls*, set it to *Trail* under *Method*. Give the *Pre* and *Post Trails* a Sample of 4. This will blend our frames.

Step 3—The number value for *Timing* refers to the frame that is currently being shown. Add a keyframe at the beginning of the time line and set to 0. Go to the 20 frame mark, add a keyframe, and scrub the *Timing* to 160. You should see a large bump upward in your *Timewarp Controls* graph. Keep an eye on that pesky value for *Duration*. Make sure it stays at the 8-second mark. Also keep an eye on the dotted line; if it goes below into the dark gray area, your footage is showing in a negative (reverse) speed.

Done—At the 6:20 mark, add a keyframe and set the *Timing* to 180. At the end of the time line, change the keyframe from a timing of 240 to 0; this will force the shot to play back in reverse. Try adjusting the values for Pre and Post Trail to get more out of that effect.

Wall of TV's

In this tutorial we will create a wall of TV screens along the lines of the one shown in **The Matrix: Reloaded**'s architect sequence.

Ingredients

- Just the shots you would like to use in the monitors we will create

The Design

TV Screen

Step 1—In Photoshop, make a new document; using one of the *Film and Video* presets, you can decide the output size. Select the *Custom Shape Tool* and choose the preset rounded frame. Put it in *Paths* mode. Make the shape and use the *Direct Selection* tool to extend the interior rounded rectangle to make it closer to the edge of the outer rounded rectangle. Call this layer "screen one".

Step 2—Load our new path as a dancing ants selection and create a dark green and black gradient in it. Add the layer styles for *Bevel and Emboss* set to *Outer Bevel* and use the *Hard Chisel* under *Technique*; for the gloss contour, try *Ring-Double*.

Done—Make a new layer and merge that to the screen one layer. Now we'll make an inner panel. Use the "*Magic Wand*" to make a selection inside the TV. Go to *Select > Modify > Border* and select 12 pixels. Make a new layer and make another green and black gradient. Apply *Bevel and Emboss* and give it a high *Depth*. Merge this layer to the "screen one" layer. Save this as screen_prepped.psd and close Photoshop.

Floor

Done—Create another Photoshop document for the room's floor. Fill the background with black and apply *Layer Styles > Pattern Overlay*. Choose the *Marble* pattern with a blend mode of *Lighten*, with a 44% *Opacity*. Save this as floor.psd.

The Effect

Step 1—Import the surveillance.mov footage, our Photoshop screen_prepped.psd, and the glass_surface.psd (from Chapter 5's *Screen Replacement* tutorial; I told you to hang on to that file!) into After Effects. Make the "screen one" the top followed by the glass and then the footage. Flip on the *3D* and *Collapse Transformations* switch for each layer.

Step 2—*Precompose* this *composition* and name it "tv1". Reduce the scale to 25% and duplicate the *Precomp* eight times. Now you'll have nine instances of our *Precomp*; set it up in a grid like shown. Turn on the rulers and set up some guides to make the grid look even. Now turn on the *3D* and *Continuous Rasterize* switches for all nine *Precomps* and *Precomp* the nine tv1's. Call it tv-grid.

Step 3—Make four copies of the tv-grid *Precomp*; *Precompose* those and call this latest pre-comp-center panel. Set its Scale to 45%, duplicate it twice, and move one to the left and one to the right. Rename these left panel and right panel. Move their *Anchor Points* to the middle of the side that lines up with the center panel. Rotate the right panel on its Y axis 45 degrees and rotate the left panel on its Y axis to –45 degrees. Turn on the *3D* and *Collapse Transformations* switches.

 The sun icon switch can refer to either **Collapse Transformations** or **Continuous Rasterize.**

Continuous Rasterize is employed when you've imported vector graphics (such as drawings from Adobe Illustrator). Because After Effects is designed for video, it needs to rasterize the images. If you use vector graphics and would like to scale them over 100%, turning on the switch for **Continuous Rasterize** will maintain their quality. If the layer doesn't contain vector graphics, the switch now will control **Collapse Transformations**.

Collapse Transformations is used when you have a precomposed or nested composition inside of the composition you are working in. It's for the purpose of designating the layer render order; normally After Effects works bottom to top while rendering, as this will usher the nested comp to the front of the line. Also, if **Collapse Transformations** is engaged, After Effects will render the precomp's effects and masks first and then the contents inside. However, to most users this doesn't really factor into the equation.

For most users, **Collapse Transformations** is engaged when a precomp has 3D layers; if the user would like to keep the 3D elements in 3D space, then **Collapse Transformations** should be engaged. If **Collapse Transformations** is turned off, it will be treated like a 2D layer. Also, if a precomp has a transformation of scale, that is cancelled out by its role in the composition it is currently in; using **Collapse Transformations** will maintain the resolution.

Step 4—Import the floor.psd. Turn its *3D* Switch and turn its X axis so that it's at around –90 degrees. Add *Effects > Generate > Ramp* and give it a gray to black ramp; make it so that the floor disappears in the black as it gets closer to our TV wall. Do this by turning *Blend With Original Layer* to 16%.

Step 5—Duplicate the center, left, and right panels. Move the copies above the original three. Select all six and, for what I promise you is the final time, *Precompose* them. Apply *Effect > Distort > CC Lens*. Set the *Size* to 100 and the *Convergence* to 0 at the beginning of the time line; at the end of the time line, set the *Size* to 160 and *Convergence* to 76.

Done—To create a zoom-out effect, go to the beginning of the time line and create a new *Camera*. Start the stopwatch for its Z *Position*. Make its Z *Position* somewhere around 15; when you are up this close make slight adjustments to the *Camera* layer so that we begin the shot framed on just one screen. You may have to cheat a little by changing the position of the *Precomped* panels. If your image looks distorted here, go back through your series of *Precomps* and check that you've turned on *Collapse Transformations* for each *Precomp*. At the end of the time line, set the Z *Position* to around –3000. There you have it, your zoom-out effect.

The Options

Step 1—Let's begin with importing our surveillance.mov (bottom layer), glass_surface.psd, and screen_prepped (top layer) into a new *Group* in Motion. Set it to be a *3D Group*. Name this *Group* "screen1" and use the *Scale* property to make it 25% of its original size.

Step 2—Duplicate it eight times so that you have a total of nine. *Group* these nine into a new *3D Group* "9tvs."

Step 3—Make four copies of this "9tvs" *Group* and *Group* them into a new *3D Group* called "center panel." Duplicate the center panel *Group* twice and name those copies "left" and "right" panel. Rotate the "right" 45 degrees on its Y *Rotation* axis and the "left" *Group* –45 degrees on its Y axis. *Group* these three panel groups into a new *3D Group* called "tv grid."

Step 4—Duplicate the tv grid *Group* and *Group* the two tv grid groups into a final *Group* called "tv wall." Import the floor.psd into a new *3D Group* and angle it to 90 degrees on its X axis. Apply *Filters > Color Correct > Gradient Colorize*, give it a black and white *Gradient*, and adjust it's *Opacity* so that the dark marks on the floor fade off as they get closer to the TV's.

Step 5—Apply *Filters > Distort > Fisheye* to our "tv wall" *Group*. Set a keyframe for the *Fisheye* effect's *Amount* at the beginning of the time line. Set the *Radius* to .3 and *Amount* to 0. At the end, decrease the *Amount* to –6.

Done—To create the zoom-out effect, make a new *Camera*, with a keyframe at the end and the beginning of the time line, using the Z *Position* of the *Camera* to control the zoom.

Dancing Buildings

This technique comes from music videos where inanimate objects dance to the beat of a song and here we'll create that effect.

Ingredients

- The shot that has the items you'd like to have move to the beat
- A piece of music, preferably percussion heavy

The Effect

Step 1—Create a new *composition* in After Effects and import our dancingbuildings.mov and put it in the time line. Open our audio file, hh.aif, and drag and drop it into the time line.

Convert to Audio Keyframes will read a sound layer and generate number values based on the volume of the audio. So when you look at a sound layer's waveform the peaks will translate into higher values. I made an example of this by superimposing the waveform of a sound to the graph editor's presentation of the Audio Amplitude keyframes that were generated from it.

So as you can see this is great for any situation where you would have an effect that is reliant on sound sync.

Step 2—Highlight the audio layer and go to *Animation > Keyframe Assistant > Convert To Audio Keyframes*. This will create a new *Null* layer called *Audio Amplitude*. The keyframes on this layer will be data based on information gathered from its audio waveform.

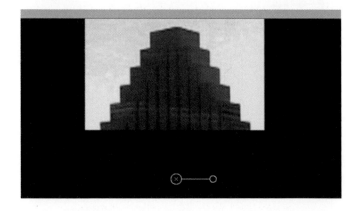

Step 3—Duplicate the footage layer and *Mask* out the center building's top half. Rename the layer "center building".

Step 4—On our "center building" layer apply *Effects > Distort > CC Bender*. Set the *Top* and *Base* crosshairs to the top and bottom of our masked area. For style, choose *Marilyn*. Option-click the stopwatch for *Amount* and drag the pickwhip from *CC Bender* to the *Both Channels* slider under *Audio Amplitude*.

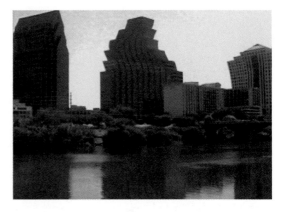

Done—Repeat this process on the other two tall buildings in the frame. On the other two, experiment with using a different style under *CC Bender*. This look is very cartoonish and fun and will spice up an otherwise dull shot.

The Options

Step 1—Import our dancingbuildings.mov footage into a new *Group* in Motion. Also import our audio file.

Step 2—Duplicate the *Group* and use a *Mask* to *Mask* out the top of the center building. Apply *Behaviors > Parameter > Audio*.

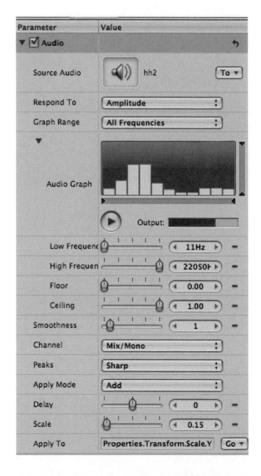

Step 3—Use our hh.aif as the *Source Audio*. Go down to *Apply to* and choose *Properties > Transform > Scale Y*. While still in our *Audio Parameter Behavior* go to *Scale* and scrub it to .15. This will make our building bounce up and down.

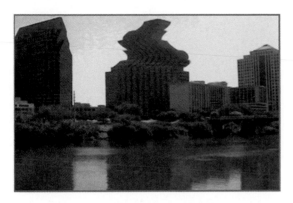

Done—Now repeat the process on the other two tall buildings in the frame. Experiment with some of the distort effects to get a wavier dance out of the buildings.

Low-Low Tech Bullet Time

In **The Matrix,** the famous freeze followed by the 360 degree spin maneuver has become widely used. Because the effect relies on having a circular-shaped rig with quite a few cameras, here's another version of this effect that relies on a jump-cutting technique. Although it doesn't exactly resemble the true look of bullet time, this low-tech version has gained its own reputation, having been used on a number of indie films and TV commercials.

Ingredients

- Locked-off shot of the same subject from a number of different angles roughly the same distance from the subject; you can let the footage run continuously or do each as a separate shot

The Shoot

With the camera mounted on the tripod and the subject remaining at roughly the same distance, take shots from the angles demonstrated in the following diagram.

To make your effect very smooth, you'll have to make sure that the subject is roughly in the same place in every frame. If not you'll have a rougher bumpier look, which may also be desirable.

The Effect

Step 1—Import the fakebulletime.mov footage into After Effects. Put the shot into a new *composition*. Scrub through the footage and hit *Edit>Split Layer* before and after each time the camera moves from one angle to another.

Step 2—In the time line options palette, make the *In*, *Out*, and *Duration* columns visible. Set the duration for each shot to three frames. To line everything up, set the *In* time for each layer to match the *Out* time of the layer below.

Done—*Pre-Compose* this comp. To add a slickness to this shot, try adding *Effects > Time > CC Time Blend FX*, and set the *Instance* to *Paste, Transfer* to *Blend, Accumulation* to 25%, and *Clear To Current Frame*. This will diminish the roughness of it a bit and create some nice effects.

The Options

Step 1—Import our shot into Final Cut Pro using the *Blade* tool before and after every *Camera* turn. Hit *Close Gap* as you go.

Step 2—Trim the duration of each shot down to three frames.

Done—Put this sequence inside a new sequence and apply *Filters > Video Filters > Time > Trails*. Put the *Duration* up to .13 and the *Echoes* up to 4. This will create an overlapping frame look like we did in the After Effects version of this tutorial.

PRO*files*

Bryan Wetzel: Editor

Bryan Wetzel is a New York-based commercial editor. He began his career in 2000 as an assistant at Go Robot. Under the tutelage of award-winning editors Adam Liebowitz and J.J. Lask, he worked on major campaigns for IBM, Miller Light, and Snickers to name a few. In 2003, at Lask's new company PS260, Bryan became a full-fledged editor, working on commercials for Visa, M&M's, and the Tribeca Film Festival. He is now employed by Blue Rock Editorial, where he continues to cut commercial spots through agencies such as Young & Rubicam, Grey Worldwide, and BBDO as he branches out to short films (he edited the short film **Happy**, which was nominated for the 2005 Esquire Magazine Film Competition) and long form documentaries. Bryan has just wrapped shooting on his directorial debut, a short film called **Push One**.

1. Describe your job or position in filmmaking and how you got there.

 I am a commercial editor in New York City. I began as a "runner" many years ago delivering tapes to clients, as well as stocking the fridge at our loft studio, buying ice cream for the owner's wife, and walking the dogs of various clients. Eventually the owner/senior editor noticed my Photoshop and After Effects skills and began to ask me to help design title sequences and such. That led to more challenging tasks on Avid, such as laying off tapes and preparing for mix/transfer and conform sessions. Many, many late nights and weekends later I was promoted to assistant editor, which brought more learning and late nights. I learned a lot by doing cut-downs; I would take the spot that the clients fell in love with that was 33 seconds long and trim it down to the broadcast legal :30 without them noticing any change. It's not always that easy, but the challenge proved very helpful. After

a few more years, I was finally editing my own spots in my own suite.

2. What was the one moment when you knew for certain that this was going to be your career?

 I'm not sure there was an exact moment, but at some point I must have realized I was in too deep and that there was no turning back. I was working in an amazing loft in Chelsea, having all my meals paid for and getting to work on commercials shot by A-list directors. It probably sounds cushy, but when you're on your fifth day in a row working 16-hour shifts and haven't had a day off in 2 weeks, all the free food and nice couches in the world wouldn't seem to make it worth it. But somehow the opportunities that led to where I am today made it seem totally worth it.

3. What software (or equipment, whichever is more applicable) do you use?

 Avid Media Composer, Adobe Photoshop, and Adobe After Effects.

4. What movie do you wish you worked on? In what capacity?

 Hot Fuzz, directed by Edgar Wright. In any capacity.... No, really the editing in that film is amazing, as is the sound design.

5. Is there a shot technique used in that movie that really made an impression on you?

 Not so much one technique as much as just the entire edit. The use of multiple layers, freeze frames, and sound effects, combined with a great soundtrack (which is always important), makes it a real gem to watch as an editor.

6. Where do your ideas come from? What inspires you?

 I'm inspired by many things: film, music videos, music, art, and sometimes by something as simple as a crazy guy ranting on the bus. Inspiration can arise at any moment.

7. Share a visual effects technique that you use with our readers. Tell us why you like it so much. This can be anything from something that you do in a visual effects software package, editing software package, or something on the set, in camera, anything you'd like to share with the readers.

 I really enjoy working with footage that has been shot at a really fast rate of speed, which produces slow motion footage.

It allows you to really have a lot of latitude with the raw material. You can ramp up the speed or keep it slow. Jokes somehow seem more humorous in slow motion.

8. Is there a resource that you use, like a book, magazine, or Web site, to get ideas for techniques?

I watch a lot of films. And I watch a lot of director's reels to really keep up on what everybody is up to creatively, and I'm often blown away.

9. If you were going to give our readers a homework assignment, what would it be?

I would suggest taking a film trailer and recutting it as a different genre. Take a horror film and turn it into a romantic comedy . . . this will make you really dig deep and get your mind

going. It may seem easy, but more often than not you will hit a point where you realize that you don't have the perfect material for what you are trying to create, and you have to make do with what you have. Welcome to my world.

10. Do you have any career advice for up-and-coming filmmakers?

Three words: shoot, shoot, shoot. Everything, all the time, make stupid weekend shorts with your friends or do a documentary about your neighbor and all her cats. Don't have any ideas? Look on Craigslist, there's always people who need help on a film or video. And learn as many aspects of the filmmaking process as possible—cameras, lenses, sound equipment, editing, graphics, everything. And, most importantly, learn to take criticism and some rejection, cause there's going to be a lot of it.

ANIMATION

Character animation was once the territory of rooms of people hunched slavishly over a large series of light tables. The rise of digital tools has all but replaced this way of working. Now, in most cases, character animation is the work of 3D software artists.

Often though, a full 3D character is not required. Many cases call for 2D characters. Thankfully with After Effects Adobe has introduced a revolutionary tool that makes After Effects the tool of choice for many 2D character designers, the Puppet tool. I think you'll be as amazed as I was if you are not already familiar with AE's shockingly powerful new tool.

Two-Dimensional Character Animation

Here's two ways to create a 2D character in After Effects. The first way, or the "new" way, takes advantage of the Puppet tool (introduced in version CS3) to animate a character, whereas the other way, or the "old" way, is a complicated process that relies on some heavy layer Parenting relationships. I'm showing both ways because there are situations that are better situated for one method over the other. Sometimes a combination of both methods may be required.

The Effect

The New Way

Step 1—Open the character2.psd in After Effects and place our character in a new *composition*.

279

Step 2—With our character selected, click on the *Puppet Pin Tool*. This tool creates the points that we will use to control our character's movements. Now, looking at our character, place a pin point everywhere this character would bend. Each point has its own keyframe functionality. The first keyframe is set for you when you use the *Puppet Pin Tool*.

Step 3—Let's start this by doing a very basic move. We'll make Xira's tail wag. Go to the 3 frame marker. Drag the point on her tail up until her tail has swung in one direction. We don't have to start a stopwatch, since the *Puppet Pin Tool* does that for us automatically.

Done—Now go to the 6 frame marker, pick up the points on her tail and drag them in the other direction. Repeat this, many time and enable *Motion Blur.*

The Old Way
The Design

Done—Open the character1.psd document in Photoshop. Take note of how the character is broken up into separate layers. If you are not using the After Effects Puppet Tool, then every part of the character you plan to move must have its own layer.

The Effect

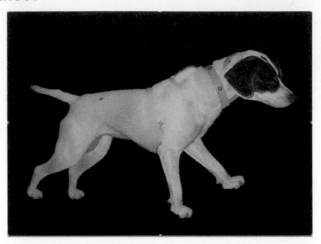

Step 1—Import our character as a *Composition Cropped Layers* in After Effects. On each layer, move the *Anchor Point* with the *Pan Behind* tool to where each body part would bend from.

Step 2—Now we have to "stitch" our character together, which we do with layer *Parenting*. It'll work like this—what is her head connected to? What is her leg connected to? Well, parent like that so her paws are connected to her legs which are connected to her torso, as well as her head and tail.

Layer Name		Parent	
head	⊘	2. torso	▼
torso	⊘	None	▼
tail	⊘	2. torso	▼
front leg right	⊘	2. torso	▼
front leg left	⊘	2. torso	▼
hind leg right	⊘	2. torso	▼
hind leg left	⊘	2. torso	▼

Step 3—Once that is taken care of, we can start to animate. Use *Rotation* and *Position* to create the tail wag animation. Turn on *Motion Blur*.

Done—Try applying the *Puppet Pin Tool* to just her tail layer. The *Puppet* tool is one of the best recent additions in After Effects since the program first arrived on the market, and there's even advantages to applying it to animation that is done "the old way."

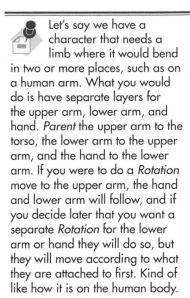

Let's say we have a character that needs a limb where it would bend in two or more places, such as on a human arm. What you would do is have separate layers for the upper arm, lower arm, and hand. *Parent* the upper arm to the torso, the lower arm to the upper arm, and the hand to the lower arm. If you were to do a *Rotation* move to the upper arm, the hand and lower arm will follow, and if you decide later that you want a separate *Rotation* for the lower arm or hand they will do so, but they will move according to what they are attached to first. Kind of like how it is on the human body.

The Digital Camera Stop-Motion Trick

With so much powerful technology at our fingertips, sometimes the charm of an old-fashioned technique is very appealing. Plus we can use technology in a less obvious way to help along these tricks. Stop-motion is the oldest animation technique in the book; it's so basic. In case you are not familiar, it works like this—grab your subject, take a picture, move your subject, and take another picture. When played back it creates an animation, like a photo flip book. The technique I am about to describe takes advantage of a feature in a digital camera that will make stop-motion that much easier.

Ingredients

- Several still photos for stop-motion animation

The Shoot

Grab your digital still camera, a tripod, and lighting, if necessary. We want the look from picture to picture to remain consistent except for the animated subject.

Now here's the trick, when you use a digital still camera, it automatically names the files. The names it chooses are usually a generic thing, such as IMG_ and then it'll have a number. When we use our software, most video programs read image sequences numerically, so the first image is the lowest number and the last image is the highest.

The Effect

Step 1—Create a new folder for your images called "Stop-Motion", copy the images into that folder. In After Effects, go to *File > Import* and choose the first image in the *Stop-Motion* folder; check *JPEG Sequence*.

Done—The files will come in a movie sequence. Put it in a *composition* (you can put it in a NTSC DV 720 × 480 comp and shrink its *Scale* to 30%). Now to gain some pretty amazing control over the footage, go to *Layer > Time > Enable Time Remapping*. Also, try out *Frame Blending*.

The Options

Step 1—After Effects and Motion have a similar procedure for importing a sequence like this; in Motion, just check *Image Sequence*. Shrink its *Scale* property down to 30%.

Done—Highlight the footage and open up its *Timing* property. Put *Time Remap* on *Variable Speed*. Then, keyframe away! Also, experiment with the *Frame Blending* options.

Bringing Inanimate Objects to Life

In this tutorial we'll use the AE Puppet tool to bring some photos to strange life.

Ingredients

- Still photo with an inanimate object (tripod)
- The background of the previous image without the object (tripod)

The Design

Step 1—Open the counter.psd image and the bananas_original.psd image in Photoshop. Make a *selection* of the bananas.

Done—*Feather* your *selection* and drag and drop the bananas into the background image. Save this new image as bananas_prep.psd.

The Effect

Step 1— Import our bananas_prep.psd into After Effects as a *composition*. Start a stopwatch for *Rotation* and set it to 90 degrees.

Step 2—Use the *Puppet Pin Tool* and set up a few points. Animate the bottom of the bananas so that it looks like they are pushing off the counter. Repeat this for the first few seconds of the animation.

Done—Start the stopwatch for the *Position* tool and move the bananas off the frame at the beginning of the time line. Then go to the 3-second mark and bring the bananas to about the middle of the frame. Right after the end of the *Position* animation, set another keyframe for *Rotation*, keeping it at 90 degrees, but a few frames later set a third one, making it 180 degrees. Now you will see the bananas take a rest, ending the animation.

The Options

Step 1—Although none of our other programs have the flexible and fun *Puppet Tool*, here's a quick way to get something similar in Final Cut Pro. Import our bananas.psd and apply *Filters > Video Filters > Perspective > Flop* to the bananas layer. Set the *Rotation* to −90 and move it off the screen.

Step 2—In the *Motion* tab, create a keyframe for *Center*. Over the course of 3 seconds, move the bananas into the frame.

Done—To animate the walking motion, use the *Rotation* tool under the *Motion* tab to create that movement. While not as lively as the *Puppet Tool* in After Effects, this is another way to get that point across.

Character Lip-Sync

One thing that has always been difficult for character animators to do is an accurate lip-sync. When it does look accurate, it's usually because of some painstaking work, so here's a method that will work with your audio to get it right.

Ingredients

- An image of a character (the character's upper and lower lips should be on separate layers than the face or each other)
- Audio file with an actor reading a line

The Effect

Step 1—Import face_prepped into After Effects as a *composition*. Import the line.aif, increase its volume by 5 decibels, and use *Animation > Keyframe Assistants > Convert to Audio Keyframes*.

Step 2—Everywhere that there are audio keyframes in the Audio Amplitude layer that overlap with the waveform from our sound layer, use *Animation > Keyframe Assistants > Easy Easy*; this will smooth them out.

Step 3—Apply *Effects > Distort > CC Bender* to both upper and lower lip layers. Put the *Top* crosshairs at the left edge of our character's lips and the *Base* crosshairs at the right edge of the character's lips. Set the *Style* to *Marilyn* and turn on *Adjust to Distance*.

Step 4—Option-click the lower lip's *Amount* for *CC Bender* to begin an expression, and drag the pick whip to the *Slider* for *Both Channels*. Repeat this for the upper lip layer.

```
thisComp.layer("Audio Amplitude").effect("Both Channels")("Slider")-20

thisComp.layer("Audio Amplitude").effect("Both Channels")("Slider")-9
```

Done—So that the two lip layers don't look exactly the same, I added a mathematical operation at the end of the expressions by clicking on the expression and typing "−20" on the lower lip layer and "−9" on the upper lip layer.

This operation should go between the end parenthesis for ("Slider") and the semicolon that tells the expression to go to the next line.

The Options

Step 1—Import the face_prepped.psd into Motion (check *As A Project*). Import the line.aif file as well.

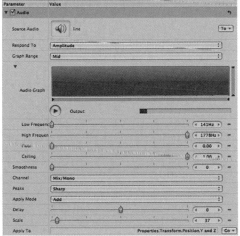

Step 2—On your upper lip layer, apply *Behavior > Parameters > Audio,* and at the bottom of its *Behavior* window in the *Inspector*

set it to *Y and Z Position* under *Apply to*. Scrub the *Scale* up to 7 and set the *Apply Mode* to *Add*.

Done—Apply *Behavior > Parameters > Audio* to the lower lip layer, and at the bottom of its *Behavior* window in the *Inspector* set it to *Y and Z Position* under *Apply to*. Scrub the *Scale* up to 7 and set the *Apply Mode* to *Subtract*. To do this in After Effects using the *Position* as our lip animating parameter would require some complex Expression tweaking to separate the X and Y Positions, but it's very easy in Motion.

PRO_files_

Felipe Matos: 3D Animator, Writer, Director

Felipe Matos is a 3D animation and computer art student who already has a film degree. He was born in the Bronx and has always loved the cinema. His first experience was with the movie **Star Wars** at a young age. In 1994–1996 he studied small studio production at Bronx Community College. This barely quenched his thirst for what he knew he wanted to do in the film industry and dropped out to pursue a career as a professional wrestler. Trained in Gleason's Gym in Brooklyn, New York, by WWE Hall of Famer Johnny Rodz, Felipe always felt the pull to come back to film. After a 2-year run as a wrestler, he went back to school and got his film degree. Since his graduation from film school he's worked for high-profile companies such as Reebok and Magnolia Films. He worked as a sound mixer and set production assistant on the film **The War Within** and as director of photography for an independent movie called **A Family Turn**. He also has started his own entertainment and multimedia company with two close friends and has had success in creating Web sites and commercials for clients in the energy drinks and apparel fields. He also has written for independent comic book companies and has three comic books he wrote in the works for publication. His ultimate goal is to write, direct, animate, and promote his own 3D animated features and live-action motion pictures.

1. Describe your job or position in filmmaking and how you got there.

Well my position in filmmaking is sort of in a state of limbo. I am pursuing a degree in 3D animation right now, but I have always wanted to be a director of movies and a screenwriter. I have worked in that capacity for my short films and as a director of photography on a couple of independent shorts. I met with several professors on which direction I should go in this business. Two professors really stood out for me—Bill Byrne and Michael Huss. Bill was my motion graphics professor and saw the potential in my motion graphics work and said I would do great in the 3D animation field. Michael was my thesis advisor and he really liked my work. He told me I had an eye for lighting and dramatic camera angles and said I should really keep at it as it would only be a matter of time before I get to the position I want—a director of films and of 3D animated features.

2. What was the one moment when you knew for certain that this was going to be your career?

The moment I knew this was going to be my career was many moons ago. My mother was very encouraging when it came to my imagination. She told me that when we used to take a cab to her sister's house to play with my cousin that I used to tell stories of space travel and battles to the drivers on the way there. She was really good about letting my imagination soar. Then one Saturday afternoon she took me to the RKO theatre in the Bronx near Fordham Road. It's no longer there but that experience made my love for movies greater. She took me to see **Star Wars**. As a child I loved what I saw but as I got older and more mature I started to see **Star Wars** as a foundation for great story telling and especially visual effects. It was during the era of the original **Star Wars** trilogy that I knew doing what I saw on the screen is what I wanted my career to be.

3. What software (or equipment, whichever is more applicable) do you use?

When it comes to software I try to look at as many as I can. But the four I use the most are After Effects and, more recently, Maya and 3D Studio Max. I love After Effects. So much can be done. At first it was a bit tough but once I got the basics down I went crazy. I've simulated space battles with 2D art and added sound effects, motion blurs, and laser blasts and people have actually asked me if that was done in 3D. Maya and 3D Studio Max are great. I lean a little more toward Maya because I love the interface. The last program I use is called Effects Lab. It's still rather new but very good. It's designed specifically for visual effects you see in movies.

4. What movie do you wish you worked on? In what capacity?

The movie I wished I worked on is Michael Bay's **Transformers**. First, I'm a huge transformers fan. I grew up on transformers. I cried when Optimus Prime died in the animated movie that came out in 1986. I would have loved to work in the animation department. The modeling of each robot was amazing. Each one had over 10,000 parts to them, each intricately designed, each with a specific function. I would play the transformations in slow motion to watch how each one moves and each part has their own moving part and so forth. It was amazing. I loved the way they all moved, and being a huge fan I would have tried to bring more of the flare from the cartoon I loved as a kid.

5. Is there a shot technique used in that movie that really made an impression on you?

There was a very interesting shot technique used in that movie that Michael Bay has used in another one of his movies. In **Bad Boys 2** when Will Smith and Martin Lawrence are having a gun fight in a house with drug dealers the camera was revolving around the action. It was one seamless shot. The way the camera would seem to travel through a bullet hole to the other side and then through a broken window and back around. He used a similar shot in **Transformers** where the evil little robot Frenzy had cornered some of the people and stood behind a pillar and the camera did the same action. The camera traveled between jars to the other side and back around seamlessly. Fantastic.

6. Where do your ideas come from? What inspires you?

A lot of my ideas come from music, nature, and just sitting back and letting ideas pop up in my head. Music plays a huge role in my conceptual thinking. Many characters I created were on the strength of a certain song. I am currently working on a story called "EINHERJAR." The way I came up with this was one night having a few drinks with buddies listening to music. We were listening to Man-O-War. "Kingdom Come" is the song that made me think of epic Norse battles and I started to research Norse mythology and came up with a very unique story with a Norse and contemporary feel. Music is my muse.

7. Share a visual effects technique that you use with our readers. Tell us why you like it so much. This can be anything from something that you do in a visual effects software package, editing software package, or something on the set, in camera, anything you'd like to share with the readers.

A visual effects technique I used that I am still using and have had great success with was one I did back in film school. For my

thesis there was a scene where the supernatural villain jumps off the roof. Now we had a green screen, but it was one not to my liking. So on the day of that shot we went to the roof of a building that my father was the manager for and set up and filmed a stationary shot of the scene without the actor in the shot for about 5 minutes. I then asked the actor to do the motion of a jump and stay in a position on his tiptoes to look as if he's gliding down. I took a single frame of the shot without the actor and placed it into After Effects. I then placed the scene of the actor doing the motion over that shot and created a meticulous mask with many points and frame by frame moved them to match his movements. As he got to the top of his motion I moved his shot up and over the background and it looked like he jumped off. I had another motion graphics teacher ask me after they saw it where did I go to use such a large green screen. I told him that I didn't and told him what I did and he was floored.

8. Is there a resource that you use, like a book, magazine, or Web site, to get ideas for techniques?

I tend to look at many resources for ideas and different ways to do things, especially with doing things in 3D animation. For instance, like being able to do the same thing over 50 different ways in Photoshop you can do the same for the 3D software. Some techniques online are easier to follow and garnish the same result I want. Web sites are especially helpful because of the free tutorials you can find.

9. If you were going to give our readers a homework assignment, what would it be?

I think a fun homework assignment would be to ask the reader to find three of their favorite visual effects from any movie and try to replicate them with software like After Effects or, if they are technically inclined, Maya. I did a whole light-saber battle with a couple of friends using After Effects. If you can do that with the simplest understanding of the software, you can do even greater things once you've mastered them.

10. Do you have any career advice for up-and-coming filmmakers?

One bit of career advice I'd give an up-and-coming filmmaker is to don't stop dreaming. Don't stop trying. Also, this has to be fun and enjoyable. The day you stop loving it is the day you quit. I once read that the day you find a job you love you never work another day in your life. A job that doesn't have you looking at your watch all day because you are so wrapped up in what you are doing and enjoying every minute of it, you no longer consider it work.

TEXT EFFECTS

In 1994 when **Seven** was released, people were not just blown away by the film itself, but also by the excellent title sequence designed by Kyle Cooper. Title sequences got a huge boost from the enthusiasm for the one seen in **Seven**.

It created a sense of anticipation for the film that would follow; just by the title sequence the audience became unnerved—like, okay what you are about to see is like nothing you've seen before.

In this chapter you will see some tutorials on how you can give your film that exciting boost that only the right title sequence can give.

Title Sequence Workflow

Even the most utilitarian, functional purpose-only title sequence can have a little style and flair and bring up the level of your production. However, there are ways of overcomplicating a title sequence without some careful considerations for the workflow. In this tutorial I will go over ways of setting up a title sequence that keeps the production moving quickly.

Ingredients

- The background images for the title sequence
- Text file with credits listed (in most situations, producers will give the designer a text file with the credits listed)

295

The Workflow

Step 1—Place the background footage in a new *composition*. Create a new *Type layer*, and copy and paste the first title from the credits.doc. Make the text layer 5 seconds long.

 After Effects has some very handy presets for text animation in the **Effects and Presets** menu. Go to *Animation Presets > Presets > Text*. Now if you just drag and drop them into your time line, that's just the very beginning. Hit **U** on the keyboard to reveal **All Animated Properties**. You can maneuver those keyframes to make them fit whatever time frame you wish. Also, if you like parts of the preset but not the whole thing, you can delete the elements you don't like. You can also stack a number of presets. I often get ideas for my effects from trying the various presets.

Step 2—Animate the title. In order for most human eyes to read a title, it has to be legible for 3–4 seconds. Which means that we have roughly 5 seconds per title, 1 second for the title to appear on screen, 3 seconds to hold in a readable presentation, and 1 second for the title to animate out.

After Effects has excellent text animation tools. To get started at the beginning of the time line, go to the 0 mark and go to your text layer and click the drop down arrow to open it. Under *Text* click the button for *Animate*. Go to *Blur*. At the 0 mark start the stopwatch for *Blur* and use 26 for the *Amount*. At 1 second, reduce it to 0. At 4 seconds, click the *Add Keyframe* button, which should repeat the 0 value, and then go to 5 seconds and increase it again to 26. Your title should come it focus, hold for 3 seconds, and then go blurry again.

Repeat this with *Tracking* and *Scale*, using the same timing, but make the values appropriate to your taste.

Animate In—Here I have used the three animation tools—*Blur*, *Scale*, and *Tracking*.

Holding—*Scale* and *Tracking* are still increasing, since they don't interfere with the viewer's ability to read the title. I added *CC Light Rays* to give it that glow behind the letters.

Animate Out—I basically will just reverse the *Animate* In settings.

Once we are happy with this we can move on.

Done—Now here comes the cool part. We know our next title is "An OKS Film." Instead of making a new *Type* layer, go to our first title and duplicate it. Go back to the *Type* file and copy the next title. Select the *Type* layer that is our copy and hit paste. It has just replaced the *Type* with our next title, and the animation is already done! Move it so that it begins where the previous title ended. Now repeat this process for the rest of the title sequence. This is a great way to get the exact same treatment and format for every title with the least amount of work involved. Cool, right?

The Options

Step 1—In Motion, import the background and create a text layer in a new *Group* above the background movie. Call this group "text." Create a similar animation to what we had in After Effects.

Step 2—Inside the "text" *Group*, duplicate our first title layer. Copy the next title from our text file, select the text in the duplicate, and hit paste. Move it so that it begins where the previous title ended.

Done—When you do this in Motion, it's not as fast of a process as After Effects; for example, when you duplicate and move a layer in Motion, the keyframes stay put until you move them by hand. While a minor nuisance, it will slow you down in more complex animations.

Text Background Integration

This technique has also been used on **Heroes**, but we've seen it a lot in TV commercials. Basically we take generated text layers and make them a part of the scene by taking advantage of 3D space. Typically, actors will walk in front, or on top of our type to make it feel more three-dimensional.

Ingredients

- Footage of actors walking in a fairly large space

The Effect

Step 1—Import our walktext3d.mov. Create a new *composition* and create a new *Type* layer; type whatever you like. I recommend a thick, bold typeface.

Step 2—Flip on our *Type* layer's *3D switch*. Rotate its *X* axis *Rotation* to about –75 degrees, position it so our foreground actress's shadow will cover some text, and our background actress will walk over it.

Step 3—Since the shot is in motion, I tracked a point to keep our text attached to the ground.

Step 4—Now that our text is tracked to footage, it will stay placed. I'll duplicate the walking3dtext.mov layer, move it above our text, and rename it "monika and shadow." On the new layer mask out our foreground actress and apply some *Mask Feather*. Start a stopwatch for the *Mask Path*, scaling it up as she gets closer to the camera.

Step 5—At the 13th frame mark, the shadow of our second actress appears over the text for the first time so duplicate the walking-3dtest.mov layer again, put it above our text, and rename it "tisha and shadow." Create a new *Mask*, which will start out simple.

Step 6—I made the *Mask* on "tisha and shadow" red, and set the *Mask Path* stopwatch. Now as she passes over the type, this will require attention frame by frame. Watch the *Mask* on her feet.

Done—The scene is now complete so check your *Masks* for anything you might have missed.

The Options

Step 1—Import our walking3dtext.mov footage into Motion and create a new group. In that new group, create our text layer. Convert the group to a *3D Group*. Rotate the type's X axis to –75 degrees.

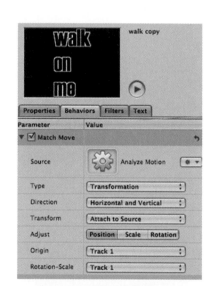

Step 2—Apply *Behaviors > Motion Tracking > Analyze Motion* to our walking3dtext.mov. Set the tracker and click *Analyze Forward*. Then apply *Behaviors > Motion Tracking >Match Move* to our text layer. Choose the tracker from our walking3dtext.mov from *Source*.

Step 3—Duplicate our walking3dtext.mov group and move it above the text. Rename it "monika and shadow." Create a *Mask* around our actress and her shadow and keyframe it so that it stays in the correct place. Be sure to *Feather* the *Mask*.

Done—Duplicate our walking3dtext.mov group again and move it above the text. Rename it "tisha and shadow." Create a mask around our actress's feet and her shadow and keyframe it so that it stays in the correct place. Be sure to *Feather* the *Mask*. That's it. It's almost the exact same process in Motion.

Horror Film Titles

There's become a pretty specific look that has dominated horror films of late combining a filthy, grimy look with slick effects. Sounds contradictory, doesn't it? Well, it somehow seems to work out; in this tutorial I'll take you through what is involved in creating a look like this.

The Design

Step 1—When creating effects for a horror title sequence you can't have enough dirty textures so here's a quick walk-through in creating one. Start with a 720 × 480 NTSC document in Photoshop. Fill a new layer with white.

Step 2—Apply *Layer Style* > *Pattern Overlay*. Use *Textured Tile*. Also apply *Layer Style* > *Color Overlay*, choose a dark blue, and change the blend mode to *Overlay*. Make a new blank layer and merge them together. Call this "bg."

Step 3—Use the *Burn* tool to darken areas around the image. Also, use the *Blur* tool to make it so that there's a mix of sharp and blurry areas around the image. Reduce the saturation by applying *Image* > *Adjust* > *Hue/Saturation* and reducing the slider for *Saturation*.

Done—Create a new layer, fill it with a dark red, and set it to the *Multiply* transfer mode. Call this layer "blood." Now go ahead and save this document, and we'll move over to After Effects.

The Effect

Step 1—Import our background.psd into After Effects as *composition*. Apply *Effects > Simulation > CC Mr. Mercury* to the "blood" layer. *CC Mr. Mercury* makes liquid blobs of the layer it's applied to. Set the *X Radius* to 100 and the *Y Radius* to 60. Set the *Birth Rate* to .5. Go to the setting for *Blob Death Size* and make it 4.00. Highlight both layers and go to *Layer > Pre-Compose* and call it "Blood."

Step 2—Type out the title of your movie in a large bold font. Make it white. Go to the blood *Precomp* layer and tell it to use the text as a *Track Matte*. It will now use the white text layer as a cutout of the background.

Step 3—Duplicate the text layer, turn of its visibility, and put it below the "blood" *Precomp*. Apply *Effects > Blur and Sharpen > Directional Blur*. Increase the *Blur Length* just enough to make sure that you can still read the movie title when it's filled with blood. Import our second background called bg.psd. Put it at the bottom of the layer order. Apply *Effects > Blur and Sharpen > Lens Blur* and *Effects > Color Correction > Levels*.

Step 4—*Precompose* the two text layers and the "blood" *precomp* and call it "title." Give it a *Position* animation; nothing fancy, maybe a 4-second move from left to right. Because a shaky-stuttering movement of a title onscreen is very popular in horror movie title sequences, open the *Wiggler*. Highlight the two *Position* keyframes and click *Apply* in the Wiggler. Also animate the *Scale* of the bg layer.

Done—To give our title a great beginning, use *Effect > Distort > Optics Compensation* to have our title slam on. There you have it, that great mix of slickness and grime.

The Options

Step 1—Let's create the same basic effect in Combustion; import your background as footage to a new *Workspace*. On the "blood" layer add a new *Operator > Draw Mask*. Draw a slightly oval shape around your red layer. In the time line, set keyframes for mask's *Scale*, going from 0 to 100 in 2 seconds.

Step 2—Import the bg2.psd footage and move it above the background.psd. Add an *Operator > Text* to the bg2.psd. Type out the movie title you'd like to use. Give the text a black *Outline* with a few pixels of *Softness* under *Text Controls > Text > Attributes > Outline*; this will appear white. Under *Shadow* give it a white shadow without any softness.

Step 3—Go to *Text Controls > Modes > Channels* and choose *Alpha*.

Done—Add some keyframes for the text's (inside the *Text Operator*) *Position*. Go to the bg2.psd layer under the *Workspace* tab, open

it, and on *Footage* apply *Operators* > *Blur* > *Gaussian Blur* and put it up 1.6. Now check your bloody fill by going back to the main *Composite*.

Three-Dimensional Text

To get that big, triumphant look, nothing does better than 3D text; here's a way to create 3D text without a 3D software package or anything other than your motion graphics software.

This is kind of an old trick now, but it's a great lesson in how layers work, and it still works well for its intended purpose.

The Effect

Step 1—Make a new *composition* in After Effects and use the *Type* tool to create a new type layer. Write out the word you'd like to use. Flip on its *3D switch*.

Step 2—Duplicate the text layer 20 times. Open up the *Position* tool and, for each layer's Z *Position*, increase in increments of two so the layer right above the one on the very bottom set that one's Z *Position* to be 2, the next one up 4, and so on until you get the top layer.

Done—*Parent* every layer to the bottom *Type* layer. Make a new *Light* layer and face toward our type. To see our text in action, go to the bottom type layer and adjust its *Y Rotation* to –35.

The Options

Step 1—The process in Motion will be very similar. Create a type layer and convert the *Group* to be 3D. Make 20 copies.

Step 2—Starting with the first copied layer, increase the *Z Position* of each by increments of two.

Done—Control your 3D text with properties for the *Group*. Create a new *Light* layer and point it toward your text.

RETURN TO RENDER

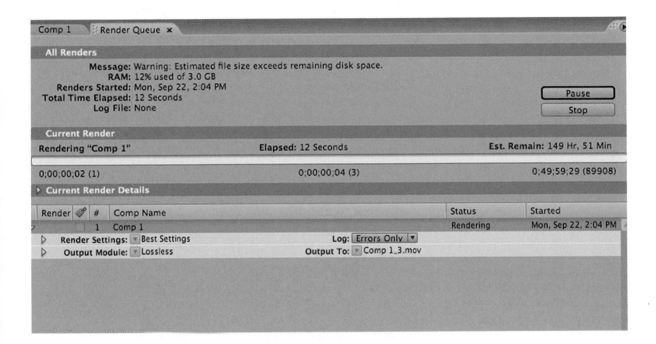

Reserved often until the end of a project, the *Rendering* process is when you create the final movie frames from your After Effects *composition*, Combustion Workspace, or Motion Sequence. You can render one movie file or multiple still image files for numerical image sequences depending on what you need.

In motion graphics, animation, and compositing software, this is reserved at the end of the project, allowing short previews during the way. In editing software, you will have the option to render as you go so you can see things more quickly.

So how do you determine what render settings to use? Well, that really depends on a couple of things; first off, what are you going to output to? What does your client expect to have the footage delivered on?

The Spec List

Before you begin any project, as a VFX artist, it is crucial that you get your client to agree to project and delivery specifications. This is so very important.

I'll give an example from my own experience. I took on a film project where I would be creating a title sequence and two VFX shots. Nothing fancy. The film was shot on lovely 16mm film and was down-converted to DV for the edit. When I took the job, I asked, as I always do, what the final output would be, expecting some sort of large film size. They told me DV. I asked a couple more times, but they seemed convinced that they would be finishing the film to DV.

Well, three weeks before a major festival, they let their DP know that they were outputting to DV for the screening and he flipped. They decided to do a transfer to an HD format, which meant that everything I created was half the size it should be for HD. They were cool about it because they knew what they had told me, but this was something that could have been prevented.

So how is this dealt with? Normally, at the beginning of a job you would have a meeting with a producer to get an understanding for what they need. Now I wouldn't suggest getting into the nitty-gritty of asking them if they want field rendering. Don't stress them out with questions that they are unlikely to be able to answer (if they can, all the better). Find out if they want to make a DVD or a tape, then what kind of tape, and where it will be shown. You will be able to figure out what specs they will need by asking these crucial questions.

Rendering in After Effects

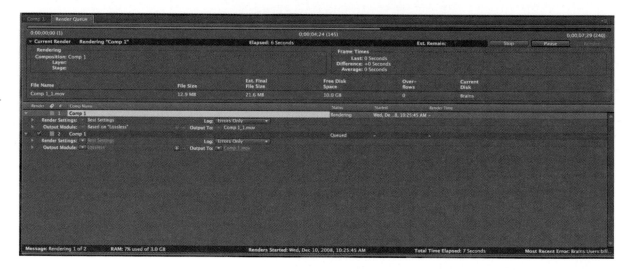

When you are ready to commit to the frames in your project, you can go to *composition>Make Move* or hit Ctrl/Cmd-M to put the *composition* in the *Render Queue*. Here is where you prepare your file for its final output. You can have a large number of *Render Items* in the render queue. Render items can be numbers of instances of the same *composition* or a bunch of different *compositions* .

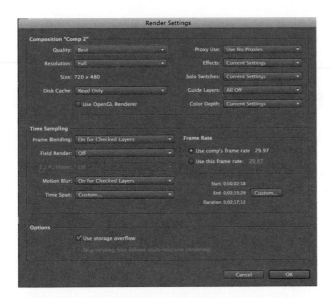

 After Effects has its **Render Queue** but it also has an **Export** option. The **Export** menu serves two basic purposes: first it's available for multiplatform concerns, such as moving your project from After Effects to other Adobe software such as Premiere or Flash, and you may also use the **Export** menu when you are in need of a quick output without the full options of the **Render Queue**.

For each item you have to set the *Render Settings*. The drop-down menu next to the heading is for presets so click directly on the setting to open the *Render Settings* dialog. These default to the setting you've used when you set up your *composition*. You may use these render settings to override the *composition* settings. The render settings apply to all nested *compositions*. However, this is not always likely to create the best results, so you are better off sticking to the *composition* settings unless you are rendering a file for a specific purpose that's not part of the final project. For example, you need to make a lower resolution file so that you can encode it quickly for the Web.

If you need to make a number of renders based on the same composition, to make more instances of the composition in the render queue, hit Ctrl or Cmd-D to duplicate. Also, if you know you made a mistake rendering and don't want to leave the render queue to rerender something, you can duplicate a completed render to make a new instance of that composition in the render queue that's ready to be rendered again.

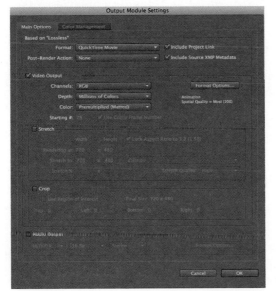

Directly below the Render Settings is the *Output Module*. This is used for settings to change the file format, compression settings such as Quicktime codecs, and modifications to file such as cropping and

stretching. Your audio settings are here too. Now, kind of annoyingly, After Effect defaults to having your audio output turned off.

The reason for this is likely twofold. First, if you have no audio in your *composition*, it will make the file size larger to have an empty audio track. Second, in most cases, audio is used in After Effects for timing and the final mix will occur in another piece of software.

When you have set the Render Settings and Output Module, you should also set the *Output To* in order to tell After Effects how to name your render and where to save it. You may click the large *Render* button. The time it takes to render something can vary, largely on how long and how intense your *composition* is.

Here are a few tips that will help speed up renders.

- Close the *composition* and *Timeline* windows. There is a rumor that if it's covered, it will speed up a render. That is not true, the windows must be closed. Now don't expect this to be a colossal difference, as on short projects it'll be just a few seconds, but on big ones it can be more significant.
- Aside from being overused throughout the industry, the *Motion Blur* effect will increase your render time greatly so use it only when needed. In general, blurring effects will slow you down.
- RAM, RAM, and more RAM. Getting more RAM is a sure fire way to improve your render times without buying a faster computer.
- *Frame Blending* will add to your render time; however, *Frame Mix* will not add as much time to your render as *Pixel Motion*. So if you don't need the higher quality results that the *Pixel Motion* mode provides, stick with *Frame Mix*.
- Keep After Effects up to date; every new version of After Effects improves render times.
- *Fractal Noise, Colorama*, and 3D layers are also known for significantly adding to render times.
- Use *Pre-Renders* for the layers you are done with. For example, on one project I was working on, I was using the *Particle Playground* effect with photos as the source. Since I knew I liked the way it looked one night before I went to sleep, I *Pre-Rendered* that layer overnight, which saved me gobs of time at the end of the project.

Rendering in Motion

If you are editing something with titles or graphics that will go over footage, save yourself the trouble of exporting the background shot, importing to After Effects, and then rendering with the footage and then reimporting to your editing software by rendering with an alpha channel.

If you use the preset under **Output Module** called **Lossless With Alpha**, any area that your graphics are not in is preserved as transparent for the next software that you will use this movie in.

Apple's Motion is designed in some ways as a slimmed down version of After Effects. All of the rendering options are contained within the *File > Export* menu. First, you must choose what kinds of files you want to make by selecting something under *Export*; your choices will be Image Sequence, Quicktime Movie, or Current Frame (still image).

After you have your Export Type chosen, you can click on the *Export Options*. The tab for *Output* will match your project settings unless you turn off the option for *Use current project and canvas settings*. On the tab for *Video/Audio* you can choose the compression type and set its quality.

The next set of options down is under *Use*. Only make changes here if you want something different than what was set up in the current project settings.

In the *File* menu you will also see options for *Export Selection*, which you would use as we used *Pre-Render* in After Effects. *Export To Compressor* will send the file directly to Apple's Compressor, a Web compression software suite.

One of Motion's best selling points is its workflow with Final Cut Pro. To send an FCP time line to Motion, go to *File > Send To > Motion Project* from Final Cut. This will launch Motion with your FCP project as in the time line. When you return to Final Cut, you will have your Motion Sequence preserved as a piece of footage with the Motion sequence's name, and the extension "*.motn.*"

Rendering in Combustion

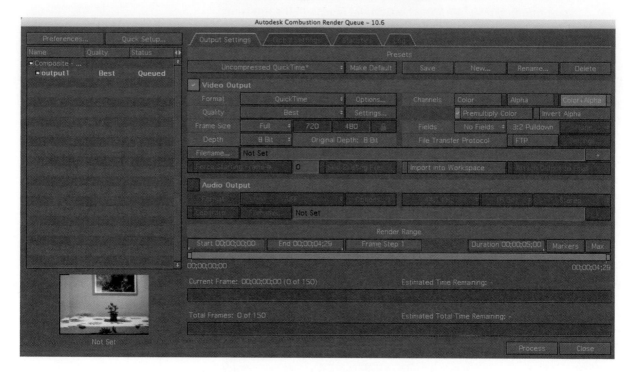

Rendering from Combustion is fairly similar to what we have been discussing. When you are ready to render, you should go to *File > Render* and the *Render Queue* will open. Under the tab for *Output Settings*, you will see all of your typical options.

There are *Presets* for common output types, and then below is our *Video Output* section. Under format you will see a list of file types with a list of appropriate options to the right of the format setting. When you are done you can proceed to click the *Process button* and let her rip.

Output Issues and Demystification

Title Safety, Action Safety, and Domestic Cut-Off

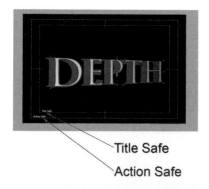

Title Safe

Action Safe

Domestic Cut-Off refers to when video is played on a TV screen; older televisions and new televisions have a varying area of how much footage from the source can be shown.

The inner box is *Title Safety*. This area will help you determine if the text you are using is within the safe area, with a comfortable margin. Use this to be certain that your text is readable and never cut off.

The outer box is *Action Safety*. This is basically the point of no return; if anything falls outside here, most televisions will not show it. Now that's not all, it is most. Some modern televisions can.

Any format that appears on a television should have the titles fall within these boxes. The area outside of action safety, the *overscan* area, might seem like a safe place to leave things the viewer should not see. However,

modern televisions can show more of this area and some older televisions can show this area if the user adjusts the settings. So the general rule now is to allow nothing that the viewer should not see in the frame.

Quicktime Codecs and Compression Standards

When you render, your first decision to make will be to make either a movie file or an image sequence. In general, image sequences are employed for two reasons: (1) if you are going to do some kind of match back to film or your footage will be used as part of transfer from film to film to a video format and (2) if you are doing some kind of postprocess like our batch processing tutorials covered earlier in the book.

Most of the time you are making a movie file. Quicktime or Windows Media Player is a general container, but each will have a huge variety of *compression* formats. Compression is the adjustment of the quality of the video for the purpose of file size and compatibility. For example, if your project is going to be DV tape in its final form, then the best thing for you to do is to use some kind of DV format rather than something like Animation. While higher in quality, when Animation is imported into your editing software, it'll need to be rendered again to match the quality of the footage that is already a part of the video. Therefore you don't gain by using an original in a higher quality.

Compression is a wide open field of possibilities, and the best thing for you to do is know what you are eventually outputting to when you *start* the project. If you are working in tandem with an editor, the best thing to do is to find out what format the editor is working on and then match your settings to that.

Now if you are going to output to a Web player format, you should use a compression type that matches your final format and then use compression software to get it to a good Web output size. These programs are Discreet's Media Cleaner and Apple's Compressor.

Square and Nonsquare Pixels

■ Square Pixel
■ Nonsquare Pixel

(D1/DV NTSC 0.9)

Pixels are different on a computer than they are on a standard television (standard definition television has taken on the new nickname SD). Computers use square-shaped pixels, and televisions will often use pixels that are more rectangular in shape, or not exactly square shaped. Pictured above is the same pixel, first as a square shape and then followed by the same pixel being corrected for D1/DV NTSC 0.9. The difference between how something looks on a computer vs how it will look on a television is the *Pixel Aspect Ratio*. In the example given earlier, the nonsquare pixel is about 10% thinner than the square pixel.

With so much variety of video formats out there, there are quite a number of different pixel aspect ratios. If you are beginning a project in Photoshop, you should match the document size and the Pixel Aspect Ratio to what your final output will be. If you plan to use this document as a *composition* in After Effects, remember that After Effects will read the *composition* setting from this document and, therefore, output this way.

Thankfully, recent versions of most software packages come to the table prepared with presets to relieve you of the most major confusion in this area. What you, the VFX artist, must always be mindful of, as you jump from one software application to another, is that you never work outside the settings you need to output to without being conscious of it. Always check to make sure that if things look wrong that it is the view setting in the software and not the actual output.

So, for example, if you are working with a format that you know the aspect ratio is 2:1, keep an eye out for anything that makes it seem stretched wand make sure that if it is that you switch things back to the appropriate size before you output.

Frame Rate

Frame rate is part of everything we watch. It is how television and movies work, basically, how many still frames are seen, usually broken down into the number the viewer sees in 1 second. Our eyes blend this fast switching of images into what we perceive as live action (this is referred to as *Beta Movement*).

Frames exist in two major types of scans. There is *interlaced* and *progressive*. Interlaced frames came into existence as a way of sharpening an image without increasing the bandwidth a TV needs to display an image. An interlaced image splits frames up by every other horizontal row so that as fields of frame are disappearing, new fields are appearing. A *field* is either the upper or the lower scan lines of a frame.

Progressive scan is not divided up into separate fields and the image is presented as a contiguous whole. When this technology was first developed, progressive scans were introduced but there was a switch to interlaced for the increased sharpness of the interlaced image. Since the arrival of computer monitors in the 1980s, the need for progressive scans increased and now many HD formats are using a progressive scan. Progressive scans will look more like film footage because a film is obviously not broken into scan lines.

On standard television in the United States, the National Television System Committee (NTSC) standard is followed, where you will see 60 interlaced fields per seconds, equaling 29.97 frames per second. Since the 1920s, movies have been shown at 24 frames per second (progressive scan). In Europe, they follow the Phase Alternating Line (PAL) standard to avoid existing inferiorities of the NTSC system and to accommodate the different power grid in Europe. The PAL standard shows 50 interlaced fields or 25 frames per second.

Color Depth (or Bit Depth)

Color Depth in computer graphics refers to the amount of bits, or single numbers, used to specify a color of a pixel. As the number of bits used increases, so increases the colors that the display can possibly generate. The color mode for video is RGB, which stands for red, green, and blue. A combination of values of red, green, and blue can generate all colors commonly visible by the human eye.

In most cases, a computer graphics artist will be dealing with 24-bit color. This is often referred to as *Trucolor*. There are 8 bits for each color, red, green, and blue, and 256 possible values of red times 256

Multimedia – Small
iPod Video
Multimedia – Large
Presentation – Small
✓ • NTSC DV
NTSC Broadcast SD
PAL Broadcast SD
PAL DV
Presentation – Medium
DVCPRO HD 720p24
DVCPRO HD 720p25
DVCPRO HD 720p30
DVCPRO HD 720p50
DVCPRO HD 720p60
Presentation – Large
Broadcast HD 720p
HDV 720p24
HDV 720p25
HDV 720p50
HDV 720p60
XDCAM EX 720p24
XDCAM EX 720p25
XDCAM EX 720p30
XDCAM EX 720p50
XDCAM EX 720p60
DVCPRO HD 1080i60
DVCPRO HD 1080p24
DVCPRO HD 1080p30
DVCPRO HD 1080i50
HDV 1080i50
HDV 1080i60
HDV 1080p24
XDCAM HD 1080i50
XDCAM HD 1080i60
XDCAM HD 1080p24
XDCAM HD 1080p25
XDCAM HD 1080p30
Broadcast HD 1080i50
Broadcast HD 1080i60
XDCAM EX 1080i50
XDCAM EX 1080i60
XDCAM EX 1080p24
XDCAM EX 1080p25
XDCAM EX 1080p30
Custom...

greens times 256 levels of blue, leaving us with over 16 million different possible colors.

RAW images and footage from Red cameras leave color depth data unwritten so that it can be adjusted later, although most consumer equipment is not quite ready to handle the range of possibilities that RAW and Red formats can provide.

Final Thoughts

I'd like to end this book by thanking you for purchasing this book, and I hope it helps you develop the skill set that you need. Since I began teaching in 2004 I realized something very special about teaching the craft of filmmaking. That is that we dream in movies. I hope that in some way that the materials within this book have allowed you the opportunity to achieve something with your own project that you were not able to get before.

I will be making available some video tutorials from the material in this book on YouTube. I will be updating information related to this project at my blog at billbyrne.net. If you'd like to contact me, I can be emailed there. Any techniques you'd like to share with me would be most welcome.

Good luck and, more importantly, enjoy what you do.

INDEX